# Entertaining
## with Southern Style

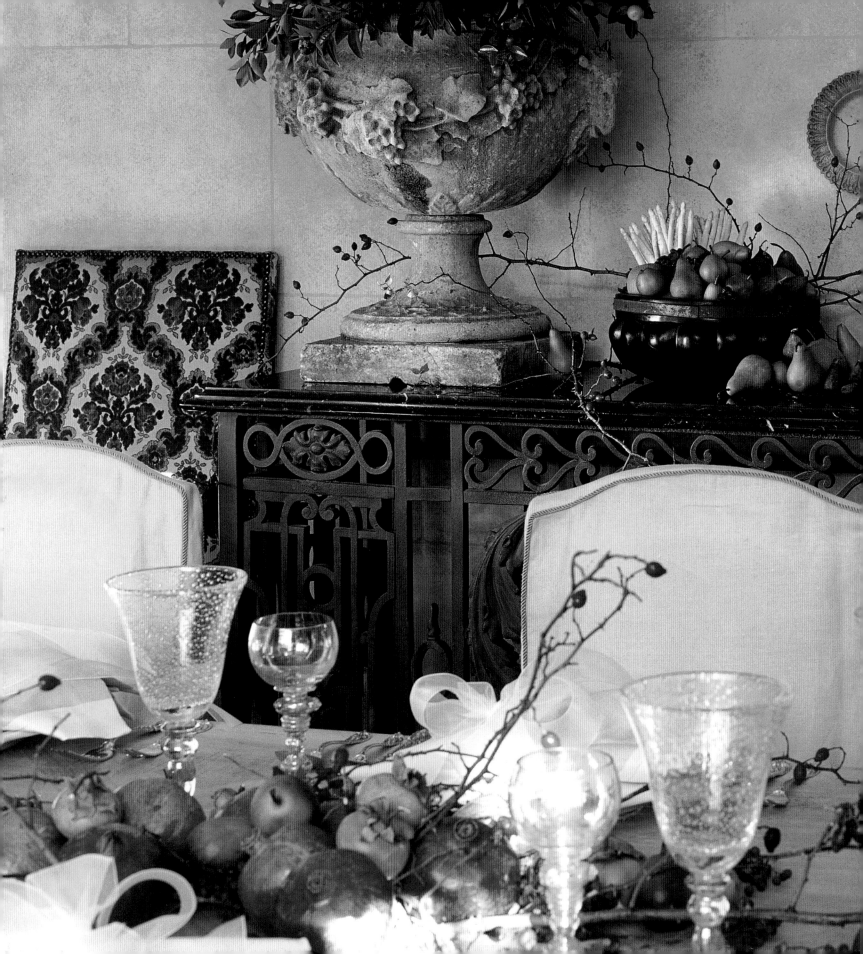

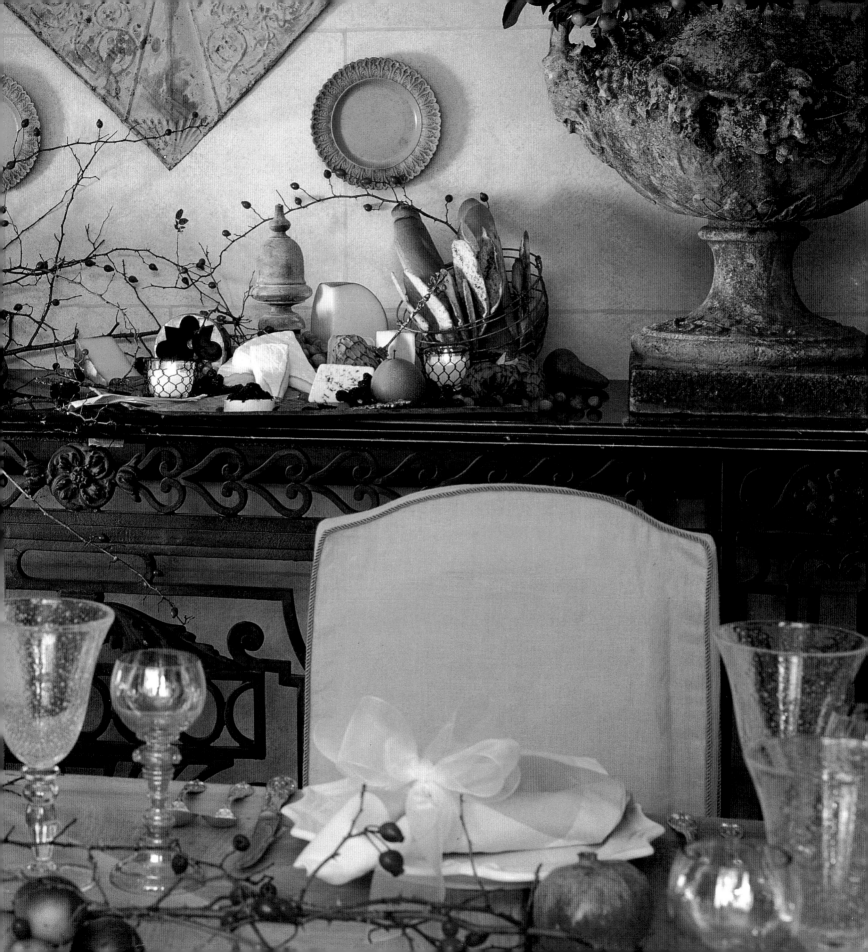

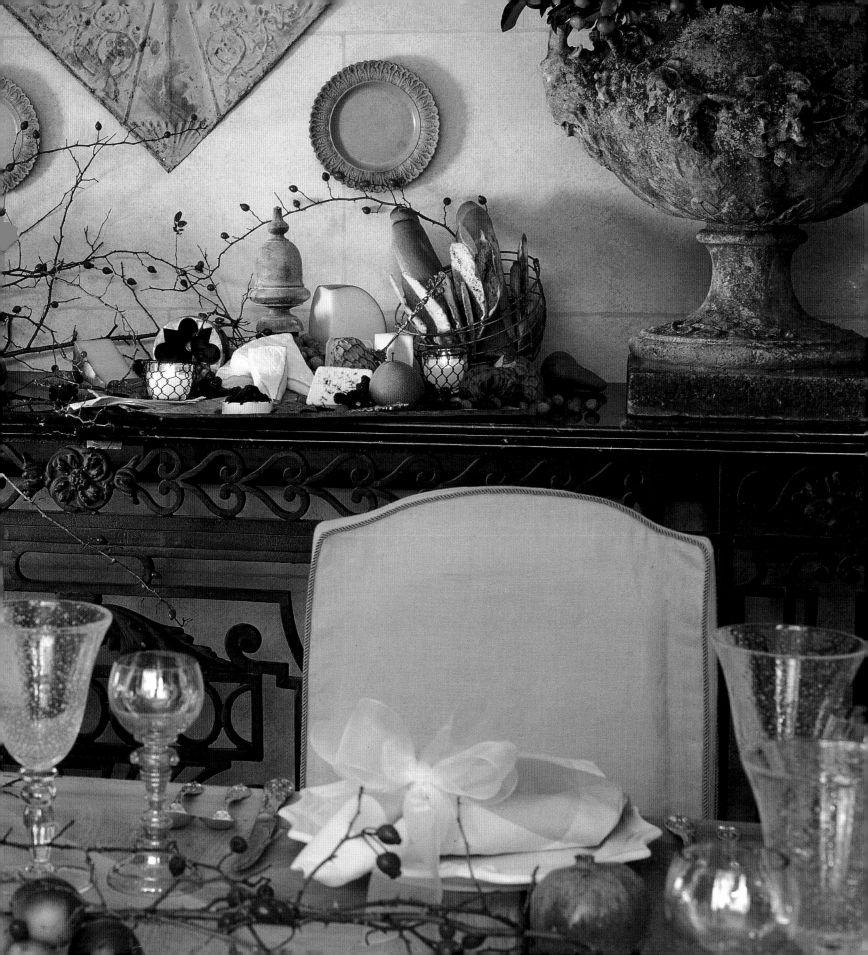

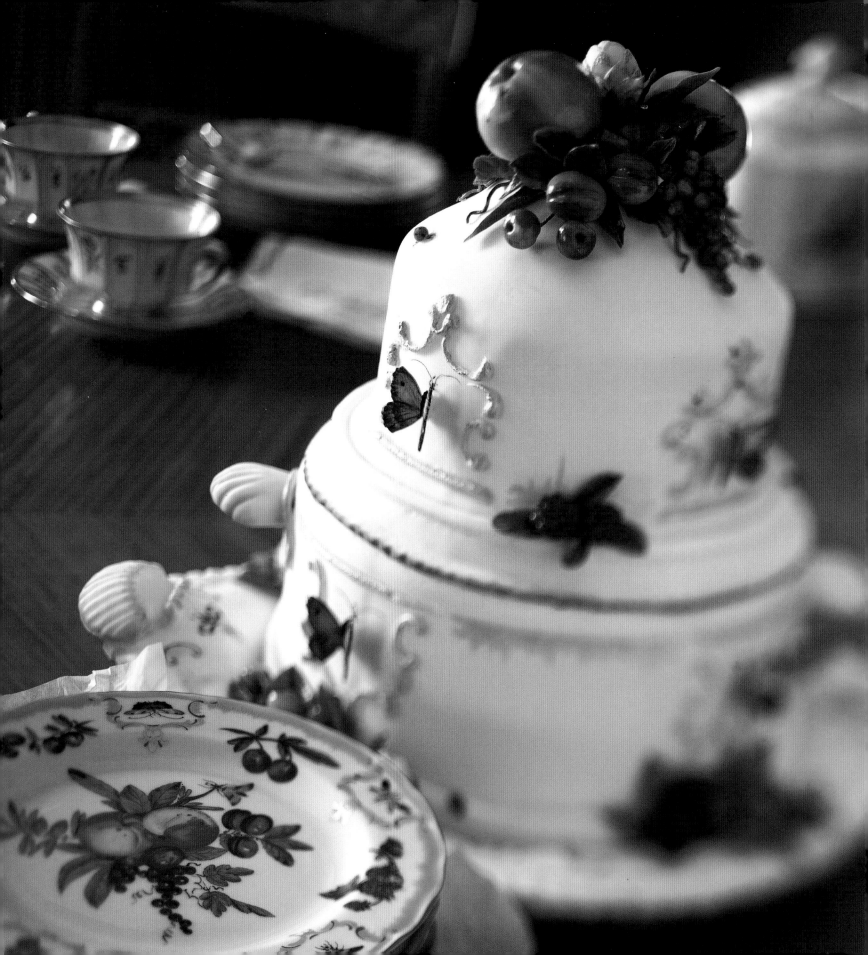

# Entertaining
## with Southern Style

by Karen M. Carroll
and the Editors of Southern Accents

A Bulfinch Press Book

Little, Brown and Company

Boston  New York  London

Pages 2–3: A wrought iron balcony railing turned into a sideboard showcases an after-dinner course of fruits and cheeses. Two urns filled with kumquats still on their branches anchor each end of the display.

Page 4: At a bridal shower, the cake is decorated with the fruit and floral motifs that adorn the bride's china.

Opposite: On Folly Beach in South Carolina, roasted oysters on the waterfront ensure that guests arrive on time for the appetizers.

Page 8: In the nineteenth century, laurels, bows, and flowers encircling initials were a popular way to imitate aristocratic crests on linens. In preparation for marriage, women embroidered their initials on everything from dish towels to tablecloths to bedding.

Pages 10–11: White plates are offset by a pair of full-blown tulips in an architectural urn and a clump of moss planted in a silver box.

First Edition

Library of Congress Cataloging-in-Publication Data
Carroll, Karen M.
    Entertaining with Southern Style/ by Karen M. Carroll with the editors of Southern accents.—1st ed.
        p. cm.
    "A Bulfinch press book."
    ISBN 0-8212-2688-6 (hc)
        1. Entertaining. I. Southern accents. II. Title.
TX731.C343 2000
642'.—dc21                                        00-025830

Book and jacket design by Blue Design, Portland, Maine (www.bluedes.com)

Bulfinch Press is an imprint and trademark of Little, Brown and Company (Inc.)

Printed in Hong Kong

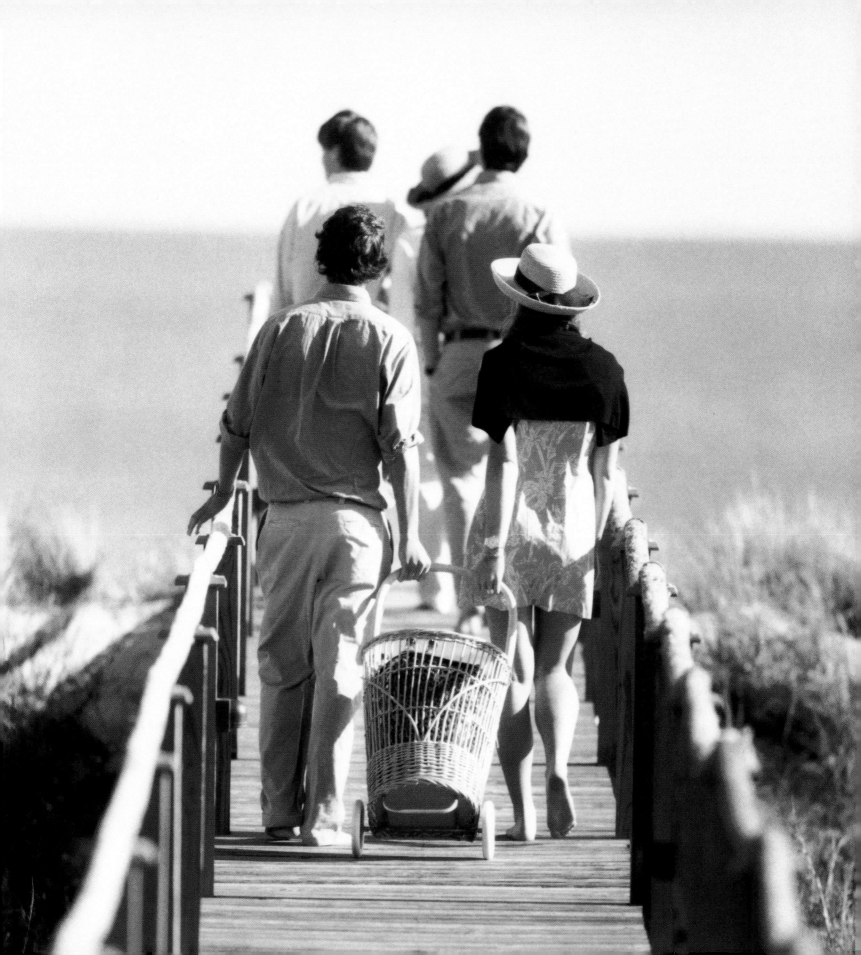

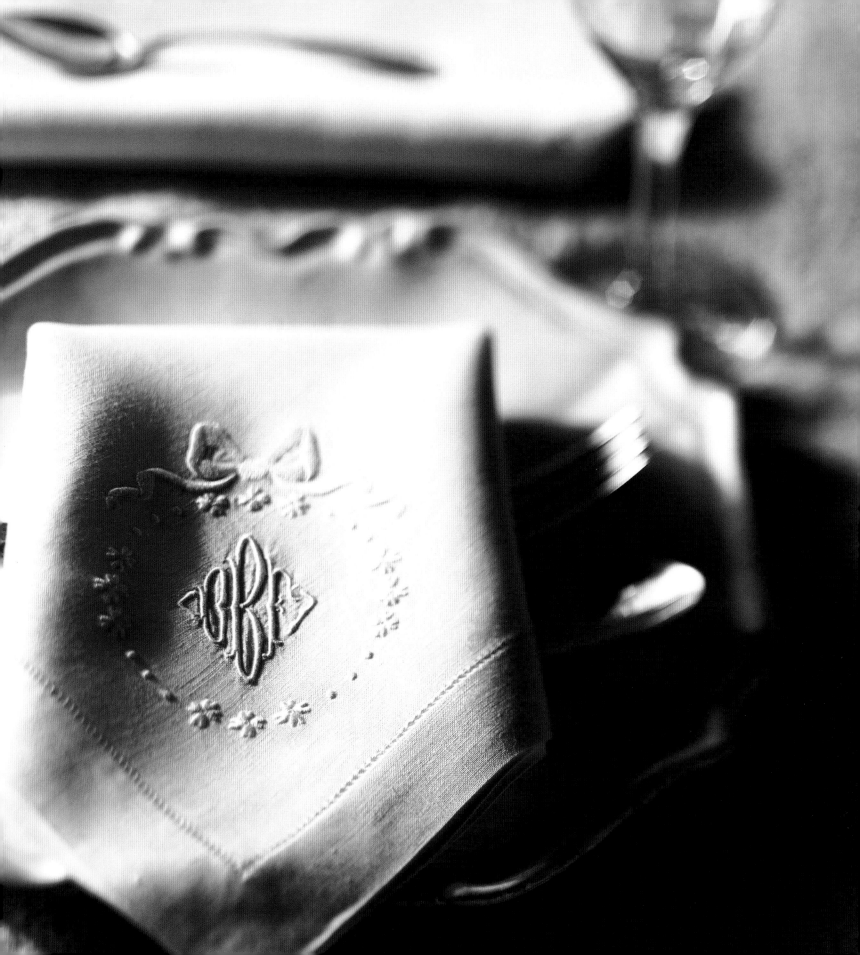

# CONTENTS

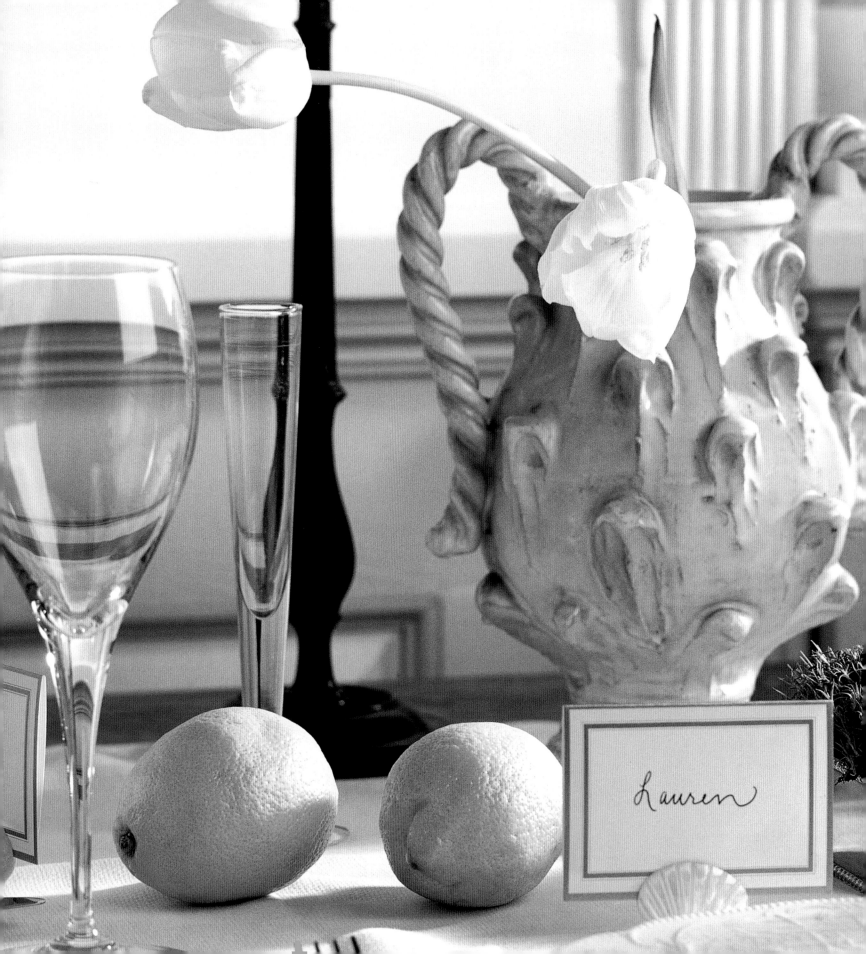

# Introduction

Since I was a young girl, I have been fascinated with the accoutrements of the table. I remember spending vacations and summers with my grand-mother in Florida. Although she was a woman of relatively modest means, she loved pretty china, silver, and crystal, and more than anything, she enjoyed entertaining, whether it was for visiting family or her

Left: Sheaves of wheat and clusters of tomatoes and roses fill a collection of silver vessels whose bodies reflect the glow of candlelight. Right: An attractive tray makes transporting tableware from the dining room to the garden easy and provides another surface for serving.

12

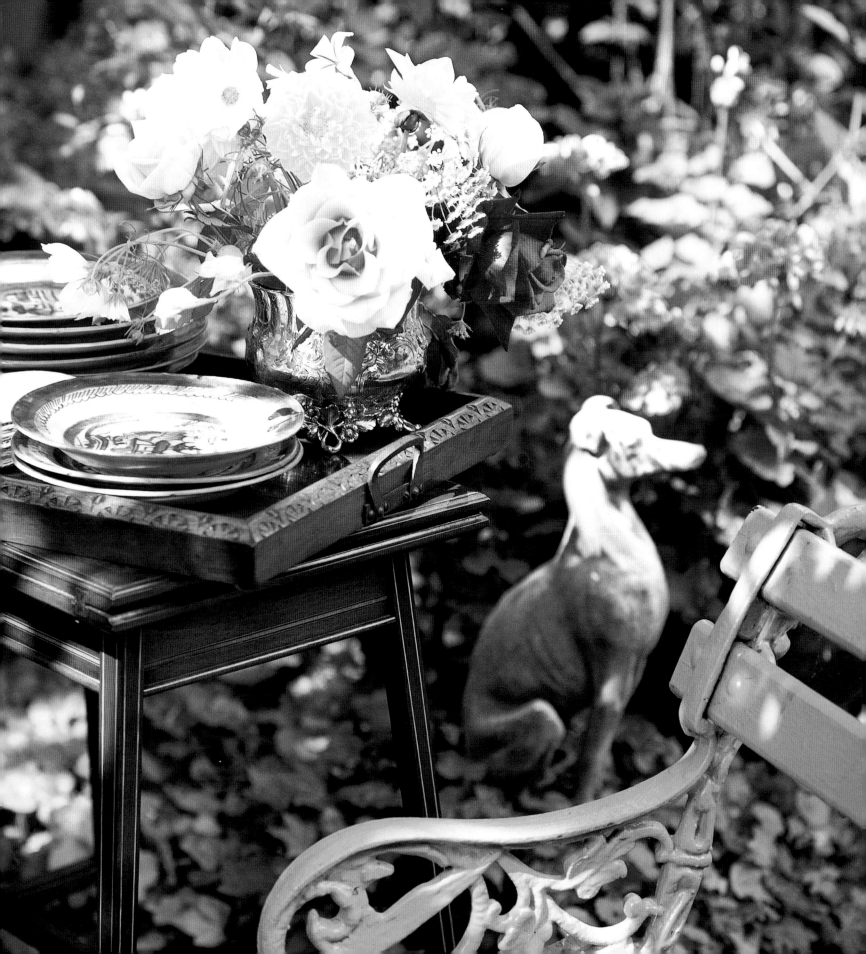

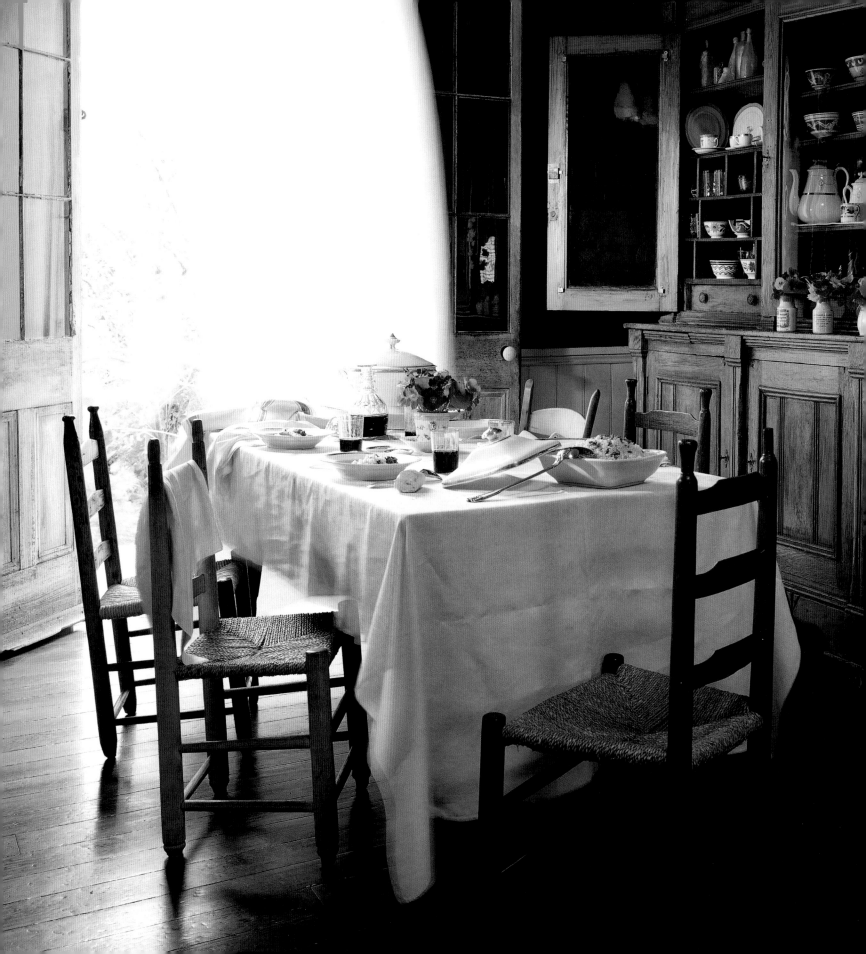

Wednesday-afternoon bridge club. To her, a table set without a white linen tablecloth was unthinkable. "Sunday best" was never relegated to just one day of the week, and company coming meant pulling out her fine things to serve traditional Southern fare: a roasted ham or chicken, fresh vegetables, and a bourbon-soaked Lane cake (which I thought at the time tasted pretty awful, but with age comes wisdom).

I seem to have come by my fascination with tableware quite naturally. While other girls my age might have been playing dress-up, I was occupied with the marvels of my grandmother's dining-room storage closet. Salt cellars, finger bowls, pickle forks, and relish dishes all seemed like wondrous, foreign objects, and I never tired of taking things off the shelves and barraging her with questions like "What fork goes where?" and "What is this used for?"

Although my grandmother is no longer living, she left behind a few boxes labeled in her handwriting as "Property of my granddaughter Karen." Today when I entertain I use the heirlooms I admired as a child and know that I am carrying on a family tradition of setting an elegant table. More important, as I have gotten older, I've come to appreciate the lessons I learned from my grandmother and my parents: a love of family; a realization that no matter how young or old they are, it is important to make others feel welcome; a satisfaction in the simple pleasure that using beautiful things every day can bring. I am lucky in my legacy, as are many others of us who have learned the art of hospitality from our families.

The phrase "Southern hospitality" is overused, but it is a cliché rooted in reality. This is not to say that everyone living below the Mason-Dixon Line is inherently gracious — or that anyone living outside the boundaries of our region is not. However, there is something unique in the way Southerners interact with one

Using collections on the table adds a personal touch to the setting. Here, antique bracelets serve as napkin rings for a host who happens to be a jeweler.

Opposite: A linen tablecloth paired with rush-seated chairs illustrates the trend toward combining rustic with fine. A collection of early-nineteenth-century pottery and porcelain is kept behind the glass doors of a cypress cabinet.

15

another. Walk through the front door of most Southern homes and you will witness a true "Come in and visit awhile" mentality. We love to throw a party and above all, we love to do it at home, because there really is no greater compliment we can pay our friends than to invite them into our personal environments.

At *Southern Accents*, we work with some of the South's most gracious hosts, talented floral designers, and creative caterers. I have learned a great deal from them, but as you can imagine, I feel a good bit of pressure when entertaining in my own home — friends tend to have pretty high expectations. One of my parties was truly memorable, but not for reasons I might have hoped. A couple of Decembers ago, I hosted an after-work cocktail party for friends and coworkers. I spent days getting the house decorated and the tree trimmed. Mantels and tables were draped with garlands of fresh greenery and lots of candles (they create a wonderful mood and with the lights down low, they hide flaws like the shelf I didn't have time to dust). On the dining-room table, I had arranged a simple centerpiece of white candles and pine boughs on a silver tray.

All was going well and guests appeared to be having a good time when midway though the party, a cry for help came from the dining room. The centerpiece was ablaze — one of the candles had burned down and set the greenery on fire. Now envision, if you will, the sight of guests circled around the table, hurling their wine and mar-

China accented with gold and silver adds opulence to the setting and is easily mixed with other colors and patterns.

16

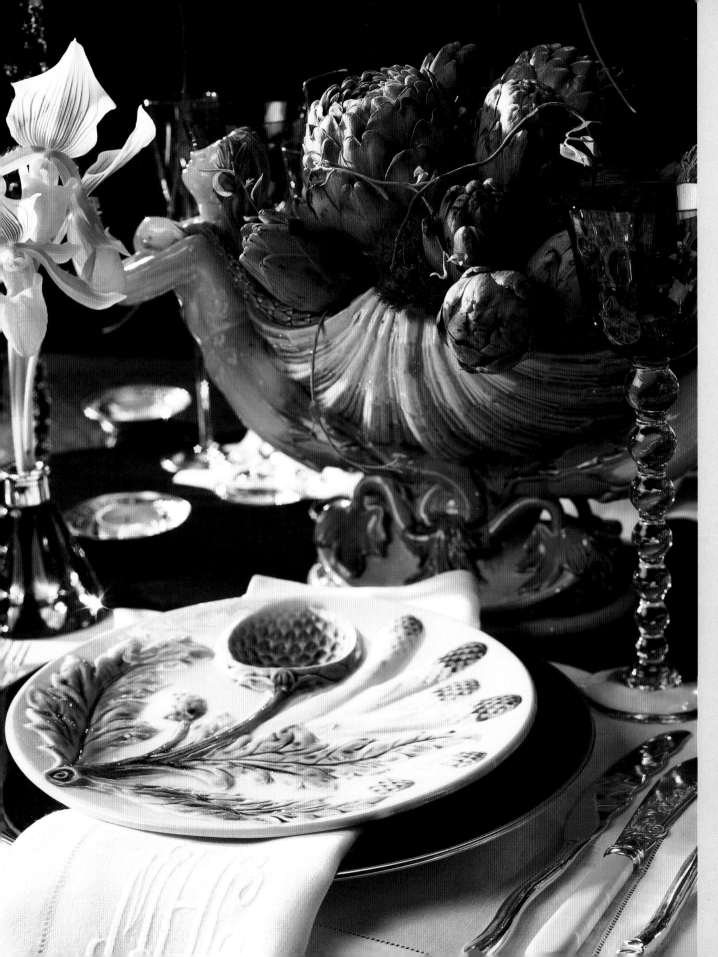

An art nouveau–inspired table combines contemporary flatware and green-hued crystal with majolica plates and antique silver. Lady Slipper orchids fill cobalt blue inkwells, and a compote filled with artichokes completes the organic effect.

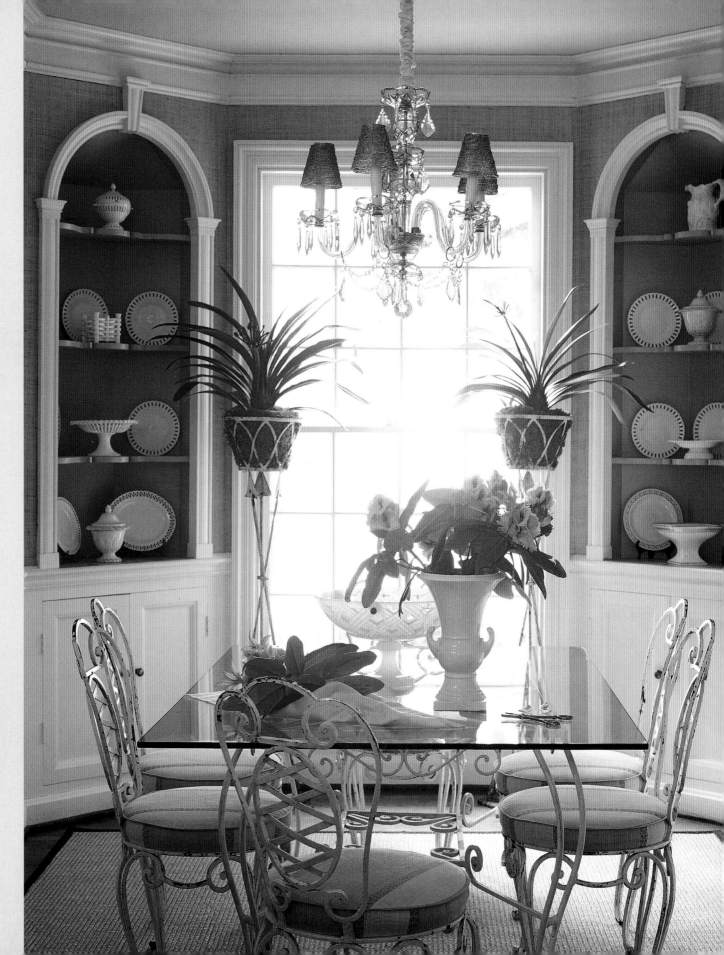

In this breakfast area, corner cabinets are both decorative and functional. They serve as architectural focal points in the room and keep creamware conveniently close for meal service.

18

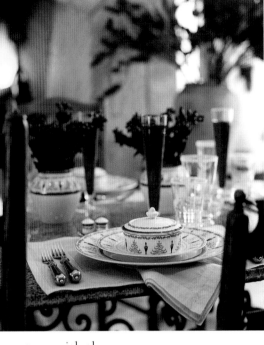

Dining fireside is a cozy way to celebrate the winter holidays.

tinis onto the centerpiece to douse the flames. Major disaster was averted, but obviously there was quite a mess. I mopped up the remains and carried my smoldering centerpiece into the kitchen.

I looked around and thought quickly. Fortunately, earlier in the week I'd had one of my very rare spurts of clever domesticity and had sugar-dusted fruit and arranged it on a cake stand. I picked up the cake stand, carried it into the dining room, set it in the middle of the table, and went on with the party. Some say that an event is a success when guests are talking about it the next day, and based on the good-natured teasing I still receive now and then, I believe I accomplished that goal.

I share this story not (I hope) to damage any credibility I may have, but rather to illustrate my philosophy of entertaining in general. First, no matter how much we plan, something unexpected will always happen. If the dinner burns in the oven, order in pizzas or Chinese food. If the centerpiece goes up in flames, look around the house and find something else that will do. Second, experienced hosts know that guests love to help out — it's an instant icebreaker, especially for shy friends. I don't hesitate to involve guests with party tasks, although I usually prefer to ask for assistance refreshing cocktails rather than to enlist a volunteer fire department. And most important, remember to relax and enjoy your own party. Go with the flow and improvise when needed. A comfortable host will ensure comfortable guests. After all, the elements of a party — food, drink, and decoration — are just props. What truly matters is that you're bringing people together in the spirit of fun.

The following chapters explore the elements of entertaining, from setting a table with personality to seasonal flower arrangements to party and decorating ideas for special occasions. I hope there will be ideas that spark a little creative fire of your own. Enjoy!

## Chapter 1

# Table Matters

The friendships fostered, romantic liaisons formed, and business deals signed over a good meal and a fine bottle of wine are countless. This is not a happy accident. We are at our most open and comfortable when sharing food and conversation with others in a relaxed, beautiful setting. The need to socialize is basic, and

Left and right: A wine enthusiast entertains guests in the inviting atmosphere of his well-stocked wine cellar. He uses menu cards to let guests anticipate the courses to come.

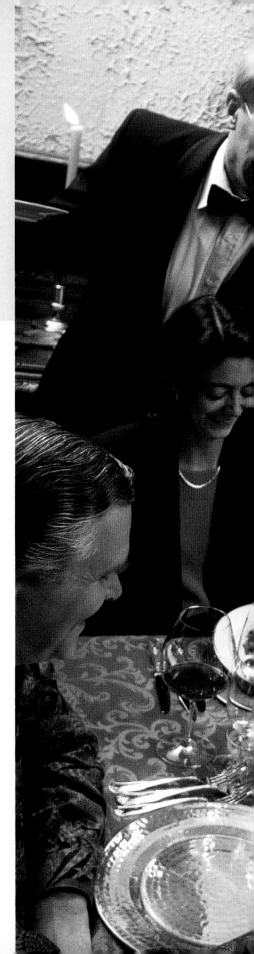

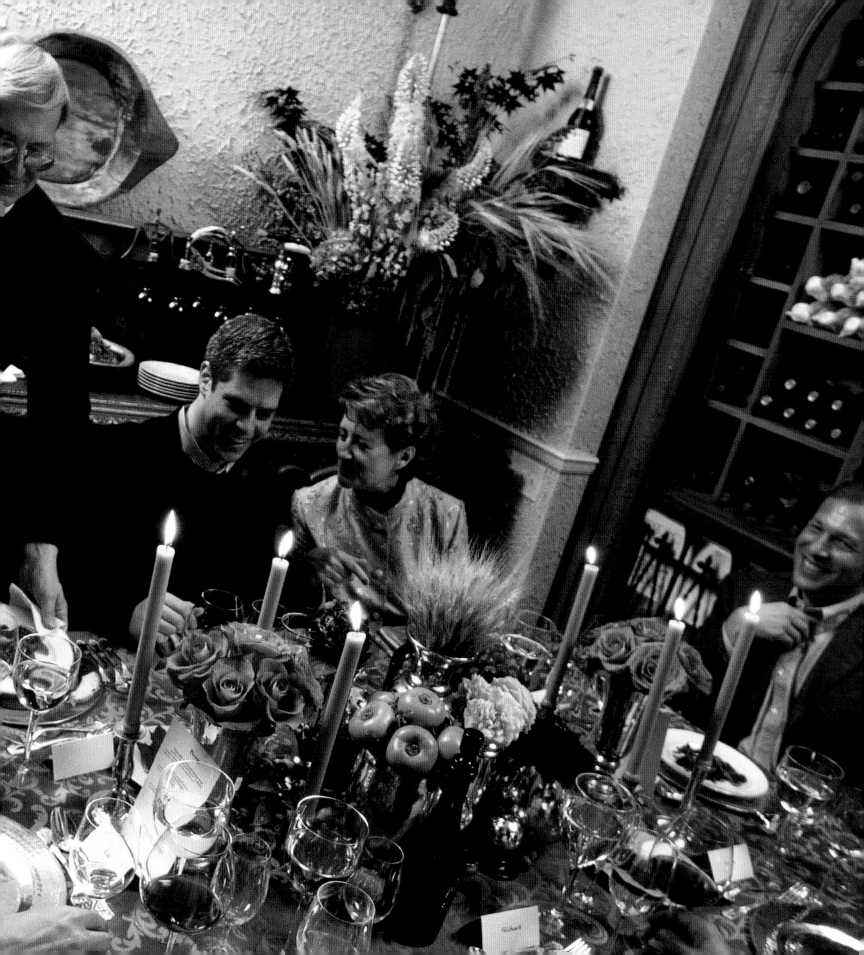

even in a world increasingly dominated by technological communication, our desire to make face-to-face connections is a strong one, perhaps stronger than ever.

# The Dining Room

Two major lifestyle directions have influenced our manner and methods of dining. Kitchens have grown in size and matured into family living rooms. The stove, refrigerator, and oven now share space with desks and work spaces, as well as banquettes, chairs, and tables used for casual meals. Television has also affected our eating habits — large, casual coffee tables and foldable trays have made moving the feast to watch a sitcom or movie-of-the-week an easy alternative, if not an especially desirable one. Both of these developments have caused some trend analysts to predict the dining room to be a twenty-first-century dinosaur. But dining rooms have the ability to evolve along with changing life patterns, so there is no need for this dire prediction to come to fruition — and what a shame it would be if it did.

Dining rooms still provide the optimum spot for hosting dinner parties and family gatherings. However, with changes in living habits, so come changes in the dining room. Creative decorating transforms the space into much more than a place to have Sunday lunch or Thanksgiving dinner. Lined with bookshelves, a dining room can become a library. A fireplace and additional seating areas such as a comfortable wing chair, loveseat, and tea table can provide a cozy spot to read a book, write a letter, or have a casual chat with a friend.

The dining room is often the most dramatically decorated room in the house, simply because it is not used as often as other spaces; it offers an opportunity to display our more theatrical

Opposite: A collection of mismatched chairs and a table before the fireplace provide a cozy atmosphere for a dinner among good friends.

Below: Cotton check slipcovers made to resemble the lines of a summer dress lighten the formality of handpainted Chinese wallpaper. Yellow is a perennially popular choice for the dining room and is thought to be an appetite stimulant.

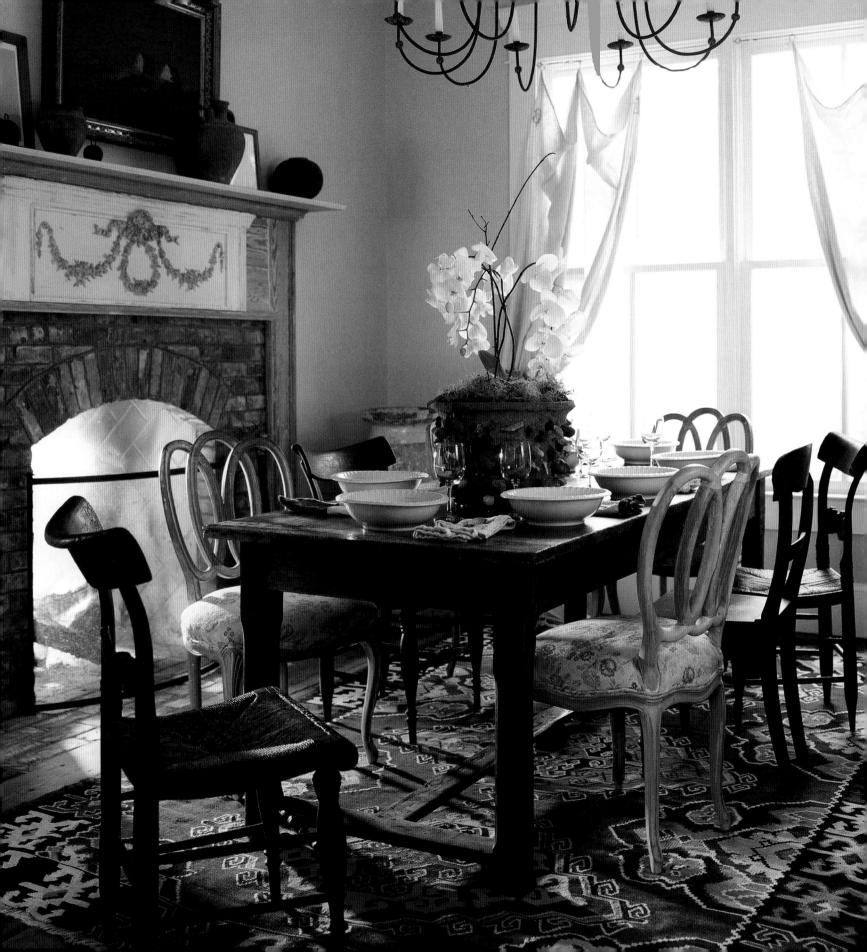

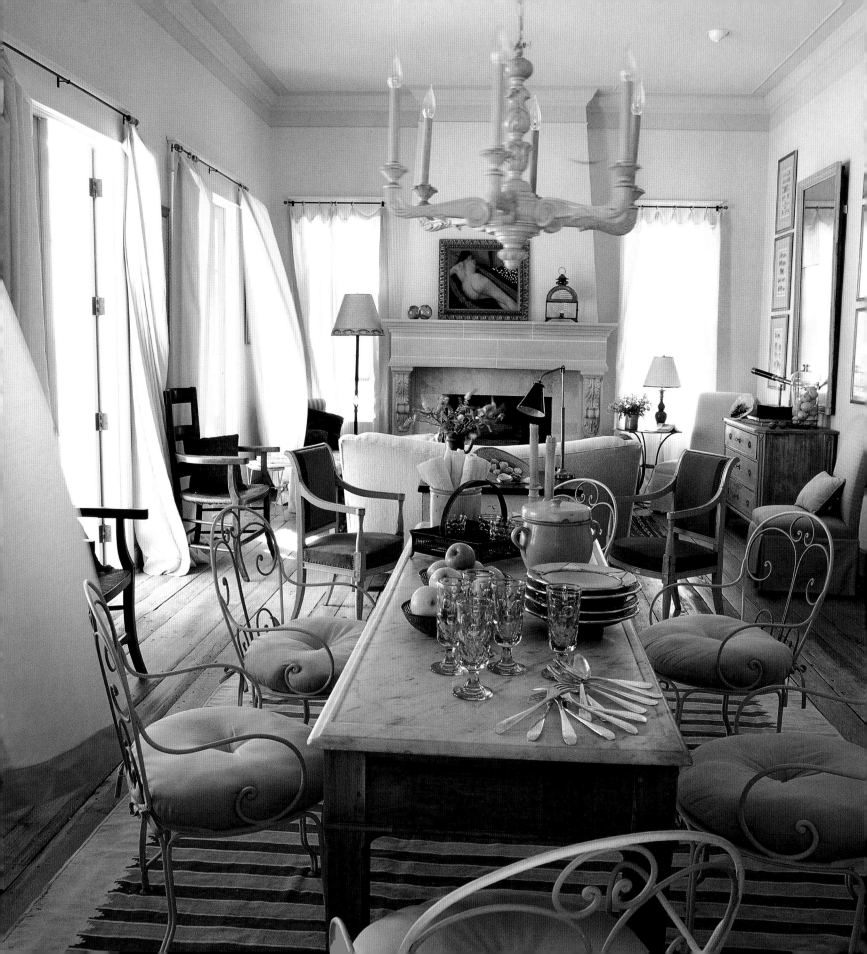

sides. Chinese red or canary yellow walls remain popular color choices — and are thought to be appetite stimulants as well. On the other hand, choosing a palette that connects the dining room to adjoining areas will provide a seamless flow between rooms. Taupe or cream walls create a soothing backdrop that can easily be enlivened with the addition of tabletop color and pattern.

Obviously, a dining room outfitted comfortably will see more use than one that feels rigid and stiff. The table will be the dominant focal point, but one that stretches on forever seems more conducive to board meetings than to conversation. Such tables evoke period films in which a couple sitting one at each end appear to have miles between them, physically and emotionally. Ideally, tables should be spacious enough to provide elbowroom for each guest, yet not so commodious as to require megaphones for conversation.

Round tables are effortlessly hospitable. They make seating arrangements a breeze and encourage dinner guests to converse with the entire table rather than just the people seated to their left and right. Some of the most engaging dining rooms are created with multiple seating options in mind. Perhaps you might use a rectangular dining table for formal dinner parties, but in the corner have a small banquette draped in white linen to be used for intimate meals, coffee, or an after-dinner brandy.

Chairs should promote lingering with enough padding to be comfortable, but should not be so deep seated that guests sit too far away from the table. And like the guests who will sit in them, chairs don't all have to be the same. It is tradition for the captain's chairs, or those positioned at the ends of the table, to be different from the others, with arms and cushier seats. Some hosts find that custom a tad inhospitable,

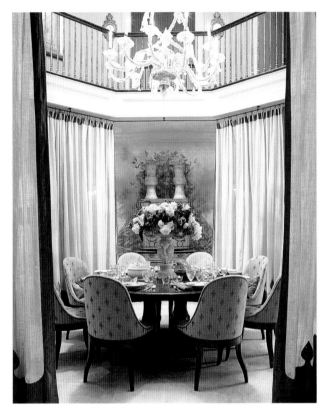

All of the main rooms flow into an octagonal-shaped dining room at the center of this house. Sheer draperies shield views into other areas and can also be drawn to create the effect of dining in a Moroccan-style tent.

Opposite: A simple marble-clad French pastry table is set with enameled Moroccan plates and bistro glasses in an airy Florida living space.

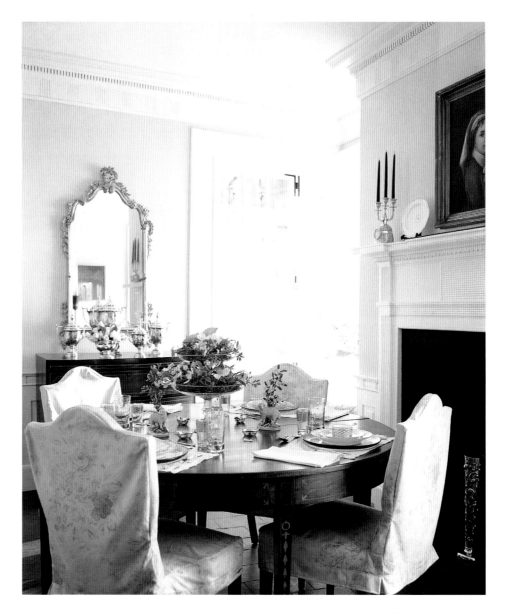

Casual cotton slipcovers make this formal dining room less formidable. Stacked glass compotes filled with moss and white flowers are complemented by pastoral figurines holding companion arrangements.

preferring to provide their guests with the same indulgences they afford themselves. Benches or settees can also be pulled up to the table, and often encourage instant camaraderie among dinner guests. Slipcovers, once reserved for summer, now show up all year long, adding color, pattern, and detail to the room.

Lighting, traditionally by chandelier, should be adjustable. Harsh recessed or canned lighting will kill the mood of a gathering. Guests don't want to feel as if they've been invited to the Spanish Inquisition, and flattering illumination will be much appreciated by old and young alike. With an abundance of candlelight and the electric lights dimmed, the mood at a dinner party can become magical.

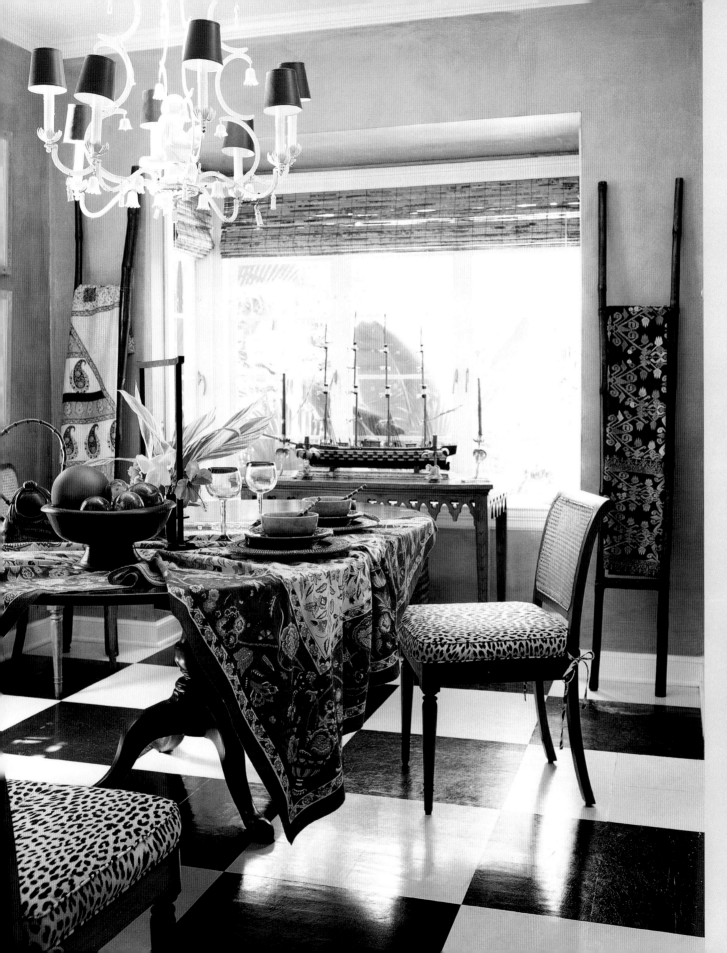

This breakfast room setting is enlivened with a sweep of burnt orange. Forgoing the traditional white tablecloth, the homeowner drapes her table with a patterned throw and uses a leopard print on her chairs to give the space an ethnic twist.

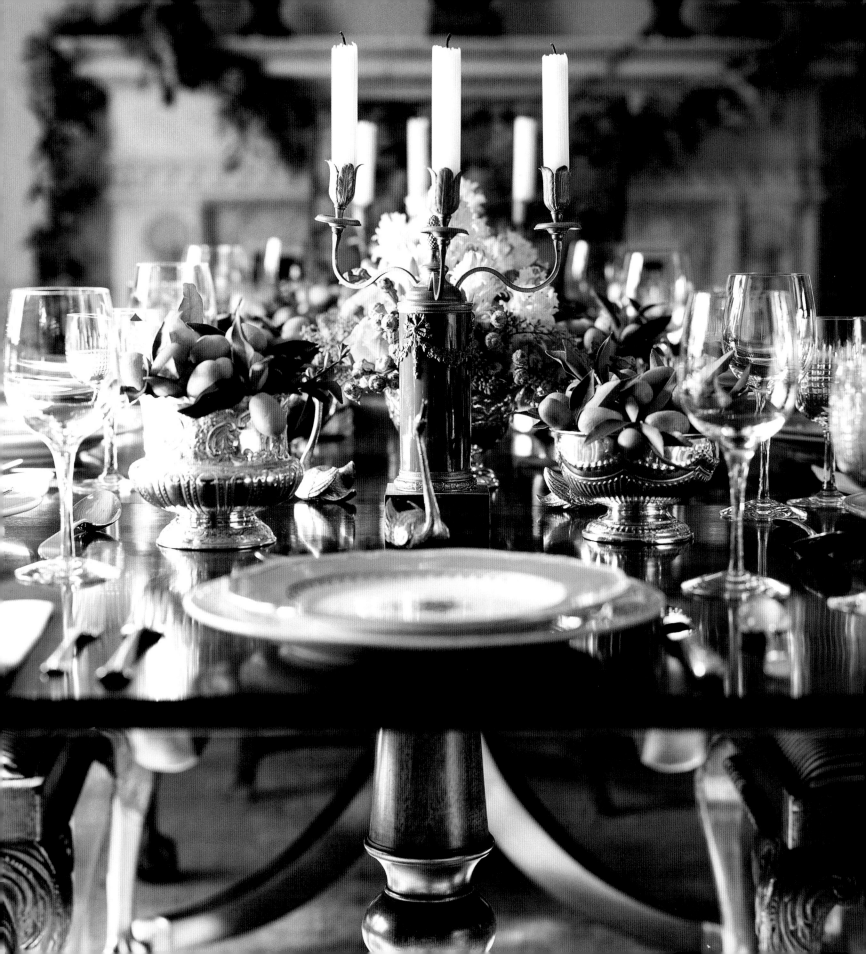

# The Dinner Party

With our increasingly hectic and yet informal lifestyles, where sweatsuits are worn outside the gym, jeans go to work on casual Fridays, and weeknight meal preparation often begins at the drive-through window, it's easy to dismiss the formal dinner party as a dying art. But what better way to reconnect with old friends — or cultivate new ones — than by lingering over a delicious meal served on a beautifully decorated table? Guests will appreciate the personal attention and applaud the effort, no matter how extraordinary or minimal. It makes no difference whether the meal has been labored over by the host, prepared by a caterer, or picked up from the gourmet grocery down the street.

In fact, one of the nicest trends in entertaining is an overall loosening of the rules. This does not mean a lapse in common sense and good manners, but instead a more relaxed attitude in putting together table settings. There is still plenty of room for tradition and formality, just an equal amount of space for personal expression. As the practice of buying suites of furniture for the living room has evolved into a more eclectic decorating style, so too goes the dining table. No longer does everything have to match, with twelve dinner plates, salad plates, and bread-and-butter plates of the same pattern — or even the same color. Just as a Chanel jacket can be worn with jeans, and a quick switch of accessories can dress a little black sheath up or down, juxtaposing tableware adds a dash of individuality and personality to your entertaining style. Mingle coordinating designs within a place setting, or use a different pattern for each course. Think of table accessories as props — items that can be

Opposite: Though the rules for entertaining have relaxed considerably, some were not made to be broken. Guests still expect to find the forks on the left and knives and spoons on the right, and flatware should always be set for use working from the outside in.

Below: For a casual buffet served from the kitchen counter, flatware is within easy reach in a small terra-cotta pot.

29

easily selected and moved around the table (within reason, of course) according to the mood and look that you want to achieve.

Ask married couples if they would pick out the same china today that they did when they first registered as brides and grooms, and nine out of ten will probably say no. (This is not based on any scientific study, but on years of asking the question while giving speeches on entertaining.) Our tastes change and mature, and what we like at twenty-five may not be what we respond to at thirty-five or fifty. Spouses, we hope, are a lifetime commitment, but tableware doesn't have to be.

This setting displays the host's knack for combining fine and casual. Brown-and-white transfer ware mingles with heirloom silver and bone-handled knives; milk-glass goblets and crystal share space on the table.

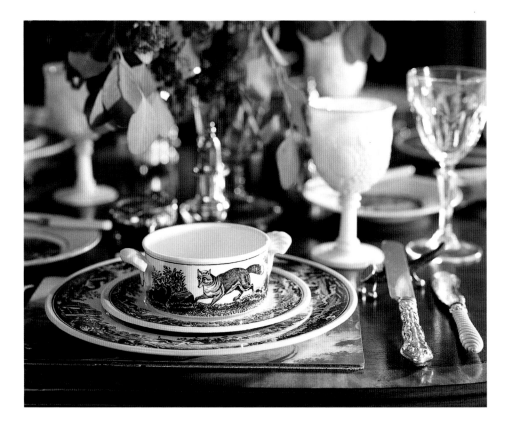

The host has placed architectural ornaments, a favorite collecting passion, on the table for interest. The monochromatic setting is enhanced by the addition of spring greens. A topiary form tops off a pot of ornamental grass picked up at a nursery.

31

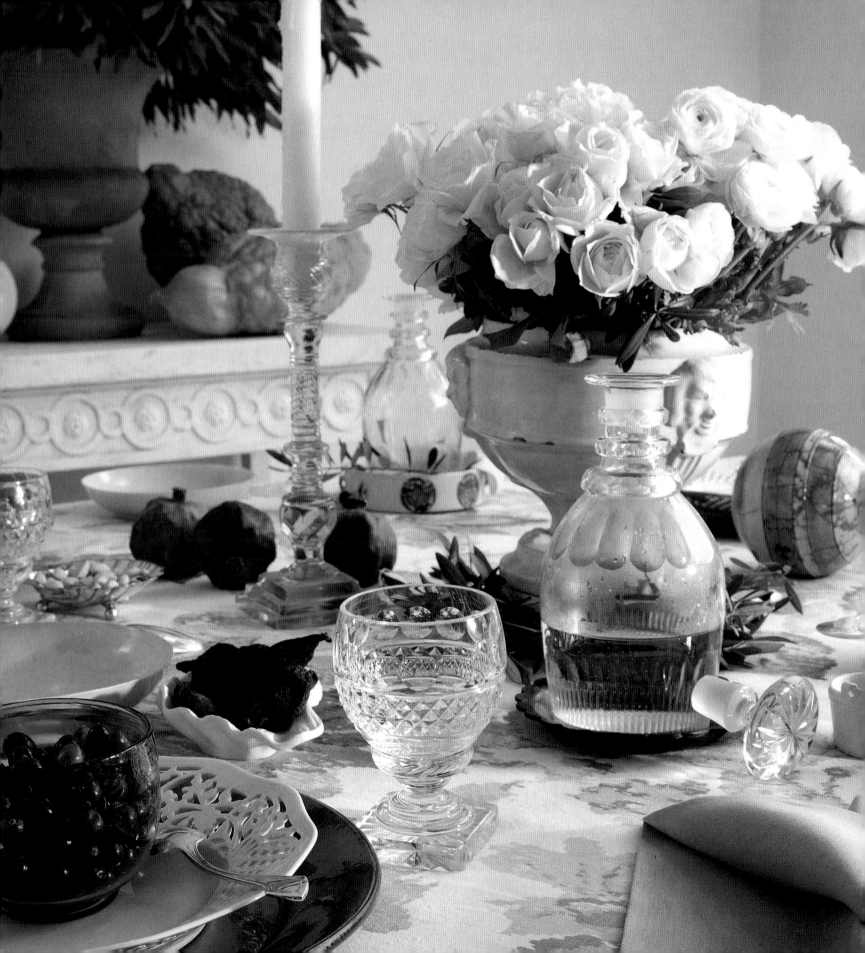

This is not to suggest that china should be disposable. Remember a young family member who will treasure it; or pack it away and who knows, maybe in a few years it will be just your cup of tea again. Better yet, think of what you can mix with it to give it a fresh new face.

Fortunately, china, silver, and glassware are no longer once-in-a-lifetime purchases — and obviously the desire to set a stylish table is not exclusive to those who are married. The trend toward a diverse look offers many additional opportunities for collecting. There is an extensive range of chic tableware on the market that is reasonably affordable, making it easy to change your table to match your mood. And if the stoneware that so fit your lifestyle years ago no longer suits, you can always trade up to the finest Limoges porcelain or wafer-thin crystal when your budget allows.

You can never go wrong with a white plate — it can go from casual to elegant with the swap of a few accessories and will show off any meal you serve to its greatest advantage. It also provides a neutral backdrop if you want to bring in other colors or patterns for interest. For example, white dinner plates can be used with blue-rimmed porcelain bread-and-butter plates and cups and saucers — or even a variety of salad plates with the same basic decoration, such as different-colored transfer-ware patterns. But white is not the only color that can serve as a canvas. Red plates can work with other red plates in graduating shades; blue plates can be paired with yellow or gold-rimmed plates. Just remember to keep complementary color tones together and choose tableware with the same degree of formality.

The interest in collecting mismatched pieces of flatware is growing as well. Fork patterns can differ from those of knives and spoons, or each place can be set with

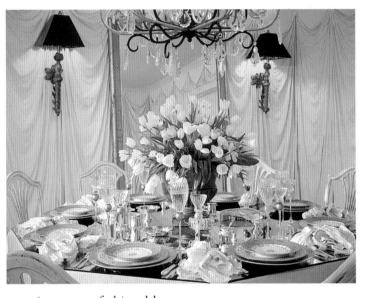

Plastered muslin on the walls gives this Richmond dining room an artistic quality. The table is covered in canvas and topped with a mirror to highlight a glittering collection of repoussé silver and contemporary stemware.

Opposite: White plates, such as these reticulated ones, can take on any color scheme. Here, they're used atop leafy-green chargers and a subtly patterned tablecloth for a soft, mossy effect. Stronger dashes of red are added to the mix with pomegranates and cranberries.

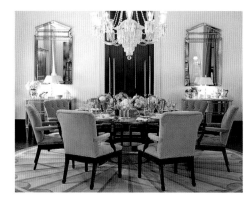

This Atlanta dining room is designed for conversation, with a round table that allows for effortless seating arrangements. The large round rug repeats the circular motif, and tufted blue chairs provide living room–style comfort.

In New Orleans, a mid-eighteenth-century French walnut armoire stores dinnerware. The windows receive theatrical treatment with Aubusson tapestry panels and ruffled taffeta. The owners covered chair seats with a light, gauzy linen for an innovative approach to slipcovers.

a different pattern. Monogrammed silver adds an aristocratic touch to the table, and it doesn't matter if the initials are not your own — it will create the appearance of an interesting, albeit imaginary, family tree. When setting the table, take into account whether your flatware is Continental, English, or American. If the silver is English or American, the hallmarks are on the back of the pieces. That's why the silver is set upright and monograms appear on the front. Silver that is French or Italian will have hallmarks on the front and therefore should be placed downward.

Colored cut glass and crystal have always been used on dining tables. But today, true oenophiles and wine-savvy hosts prefer to use clear glass for wine to best appreciate the clarity and color of the vintage, especially with reds. However, an amethyst water goblet or a green glass for iced tea is a spirited way to add color to the table and especially appropriate for casual dinners or luncheons. In any event, determine the suit-

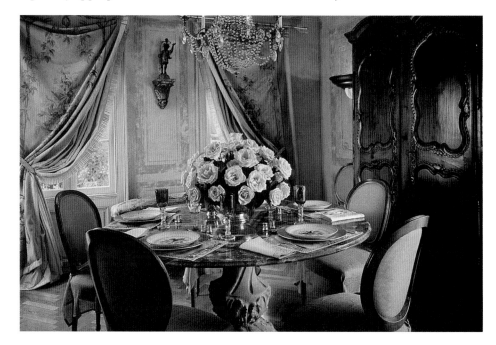

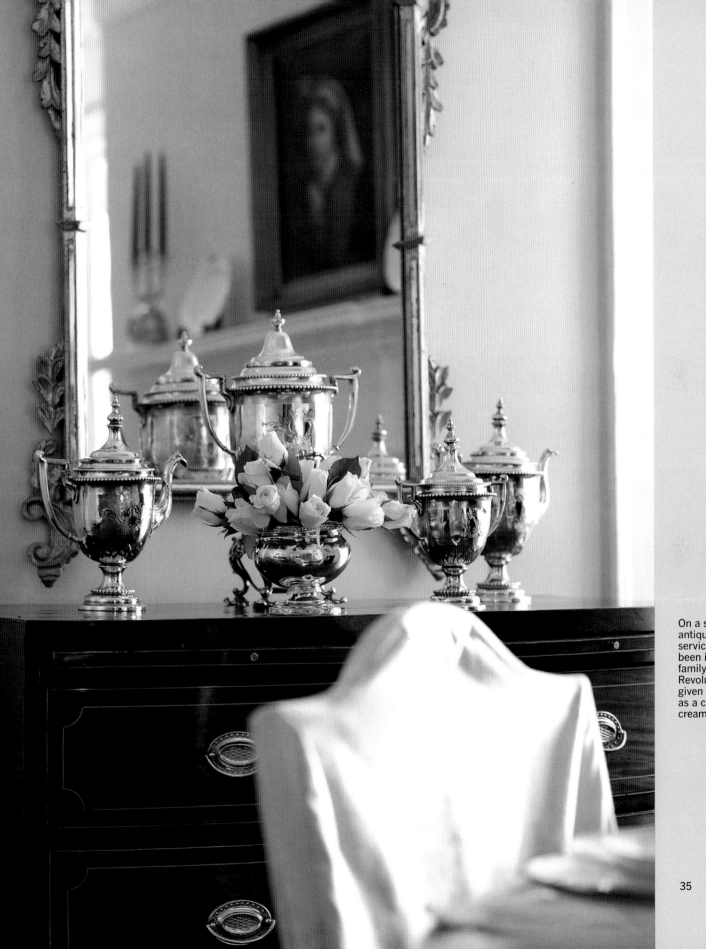

On a sideboard, an antique silver coffee service that has been in the owner's family since the Revolutionary War is given new function as a container for creamy white roses.

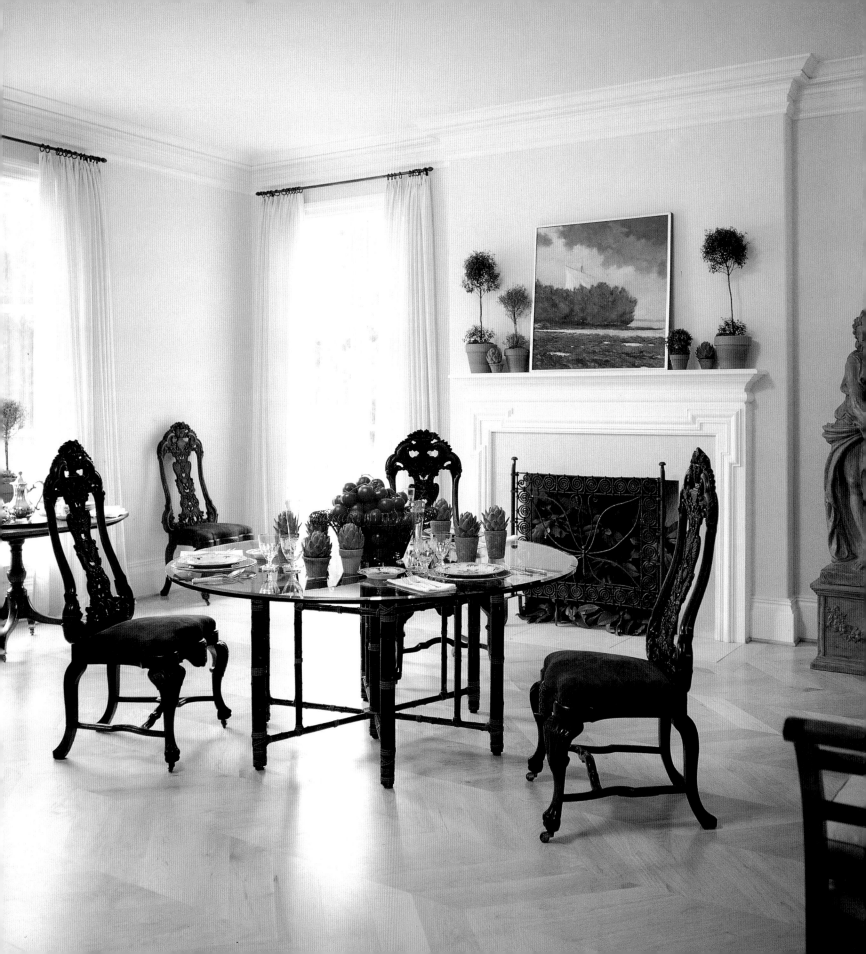

This dining room is swathed in neutrals, providing a seamless flow with the rest of the house. Cushions are placed in chairs to keep guests comfortable. The fronds of greenery in glass vases make a simple but effective centerpiece.

Opposite: A reproduction Ming altar table contrasts with the dark woods of antique chairs. For a summer luncheon, the centerpiece is a wire basket filled to overflowing with ripe red tomatoes. Artichokes in pots are also scattered around the table.

ability for the look of the table, the mood of the party, and the beverages served.

Obviously, centerpieces should not be so tall as to block the view across the table. Guests should be able to converse easily with one another. Though magazines tend to exaggerate centerpiece heights to make interesting photography (we plead guilty to doing that a time or two ourselves), a Brobdingnagian arrangement of flowers in the middle of the table simply isn't practical for real-life situations. Before the first guest arrives, sit down at the table and ensure that the centerpiece falls below or above eye level. Save the larger bouquets for sideboards or hall tables. To keep a centerpiece from looking like a round mass floating in a sea of wood, place smaller arrangements at various spots around the table or at each setting.

Sharing a meal with a guest in your home is a highly personal affair, and the table can be an expression of your interests. Incorporating collections into the decor is a good way to tell company a bit about yourself. If your passion is Staffordshire, use figurines down the center of the table. A Washington, D.C., host who

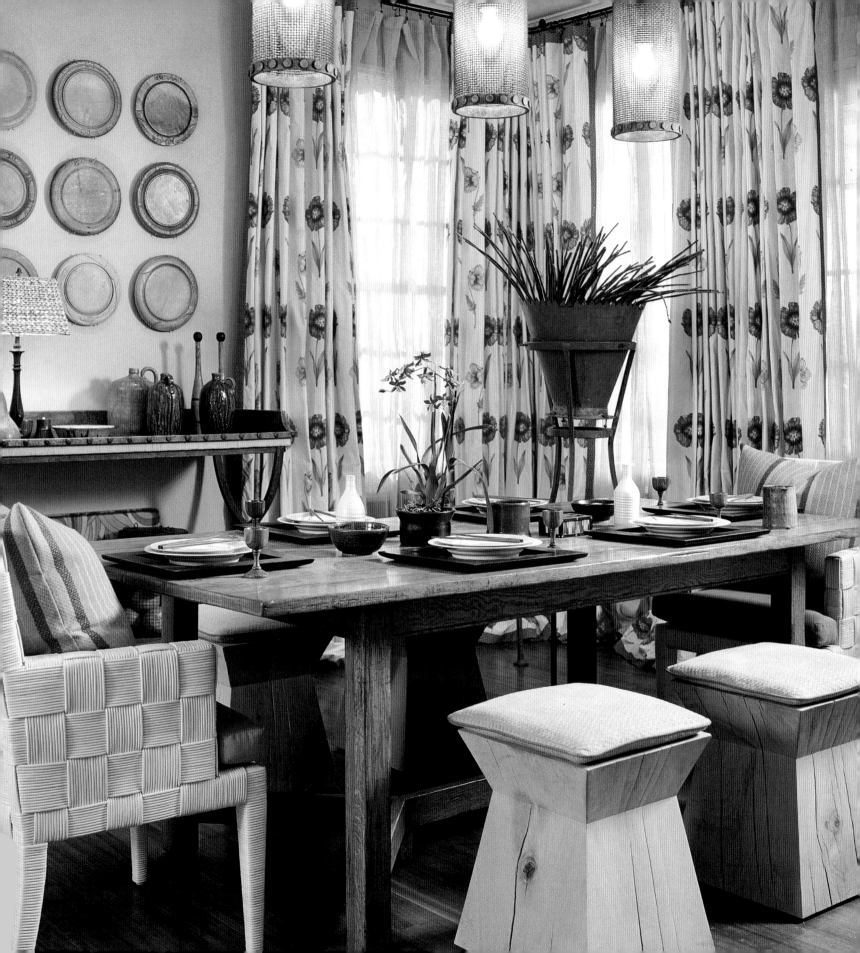

happens to be a jeweler never fails to elicit gasps from his dinner guests when he uses a collection of antique bracelets for napkin rings. (Alas, disappointment follows when guests realize they are not intended to be party favors.) Architectural ornaments such as finials, very popular with collectors today, can add a bit of structural integrity to a table. But employ enough restraint to keep the tabletop from becoming too cluttered — the most important thing is that guests can easily find the forks, knives, and spoons.

# All Around the House

By no means does entertaining have to be relegated to one room. The dining room, after all, is just an architecturally defined space. Any area in the house can become the background for a meal or a party when outfitted with a table, comfortable chairs, a bouquet or two of flowers, and enough space for maneuvering. Porches and patios are ideal for casual parties. Pulling a table up to the fire in the library makes a cozy setting for two or four. The luxury of a wine cellar offers a natural, albeit chilly, place for intimate dinners or wine tastings.

When the guest list is too large to be accommodated in the dining room, other parts of the house must be recruited. Generally, the maximum number of people that can be seated comfortably at a dining-room table is eight or ten. Additional tables can be set up in adjoining rooms, but unless you have at least two such seating arrangements, guests placed outside the realm of the dining room will tend to feel as if they have been relegated to the "children's table" at Thanksgiving dinner.

So if the opportunity to entertain a large number of people presents itself, a cocktail party or buffet supper, rather than a

Opposite: Woven raffia chairs and wenge wood stools give this room an Asian flair. Instead of an expected chandelier, the designer chose a trio of mesh metal lanterns. The grid of antique breadboards hung on the wall provides an appropriate alternative to traditional artwork.

Below: The Asian theme is carried through for a sushi dinner with fish-patterned dinnerware, chopsticks, and black charger plates.

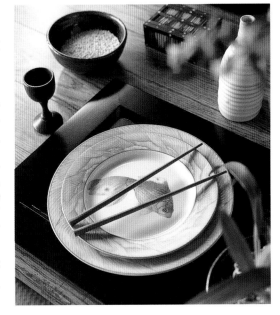

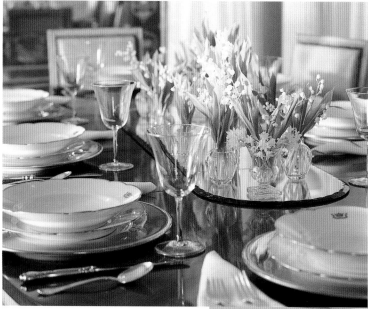

Above: A long oval mirror set atop gleaming polished wood magnifies the impact of small arrangements of lilies of the valley in clear glass vases.

Right: A nineteenth-century country French bench and a twelve-foot-long eighteenth-century walnut table define this Baton Rouge dining space, where windows are dressed with an open-weave cotton muslin.

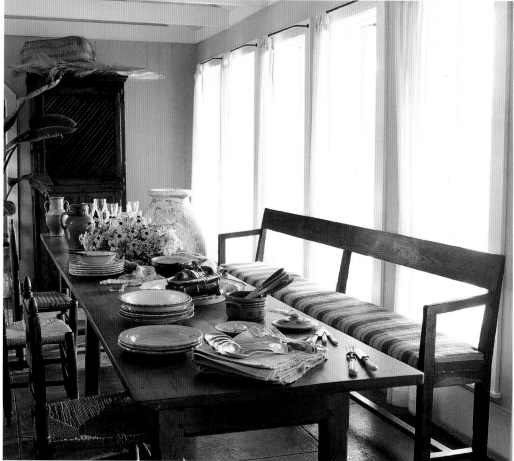

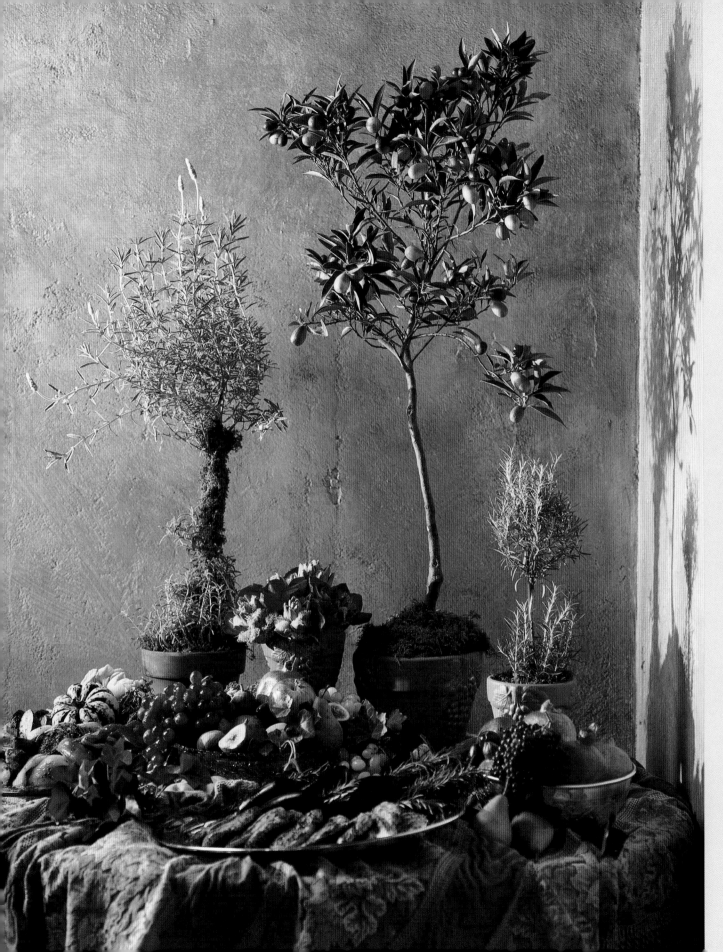

Rosemary topiaries and a kumquat tree anchor an easy-to-eat buffet of broiled chicken breasts, fresh fruits, and vegetables.

41

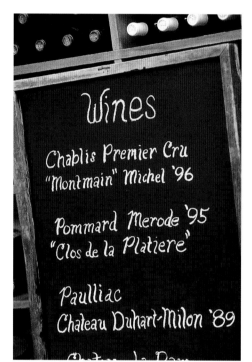

Above and opposite: For a dinner party in a wine cellar, a chalkboard informs guests what wines will be served. Antique bone, pewter, and wooden bottle openers provide an interesting tableau.

sit-down dinner, may be the answer. Cocktails can be casual, perhaps a few close friends over for an after-work martini, or a more formal affair. First, establish where you'll set up the bar. Many people have a built-in wet bar, replete with sink, ice maker, and storage for glasses and liquor. But it's certainly not required in order to have an appealing place to mix drinks. The English idea of a "drinks table" in the living room is genteel, or a rolling bar cart that can be arranged attractively has the added benefit of portability.

Have a variety of wine, liquor, and soft drinks on hand, and if the number of guests is more than twelve, consider hiring a bartender who can concoct drinks to satisfy diverse tastes with ease — it beats having to consult a "bartender's bible" at every turn and will make guests feel pampered. Beautifully cut crystal decanters make for a pretty display, but setting up liquor in the original bottles is perfectly acceptable, and perhaps preferred if you are serving premium labels or several different brands of single-malt scotch. Finally, whether you're having four or forty, it's always necessary to provide a bit of food along with the libations, be it a bowl of nuts or a more elaborate spread of caviar and blinis, imported cheeses, and smoked salmon.

Buffets tend to work well with a more casual style of entertaining. Folding tray tables, coffee tables, and ottomans can be easily converted into surfaces for eating. Keep in mind that setting up for self-service requires as much thought as creating a tablescape for a seated dinner. While food is typically set up on a sideboard or "buffet," the dining-room table also provides ample surface and allows for easy circulation and access to the food, dishes, napkins, and flatware. When hosting a buffet (or any party, for that matter), set out the serving dishes and containers a day or two in advance. Platters can then be matched to food with color and ease of service in mind. In planning the menu, choose foods that can be easily managed

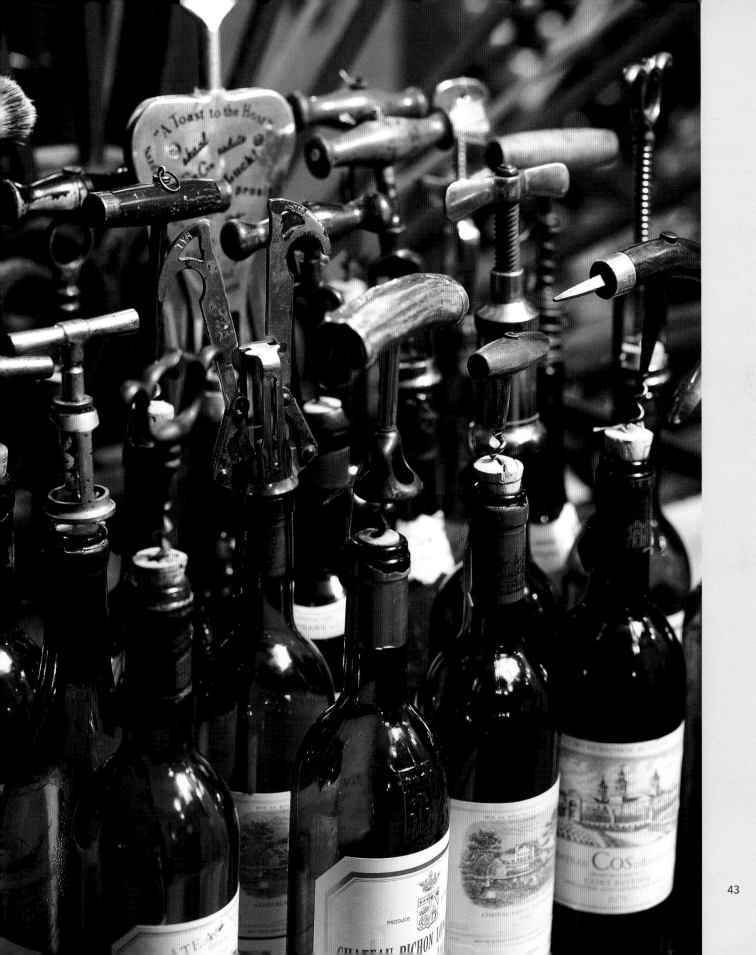

43

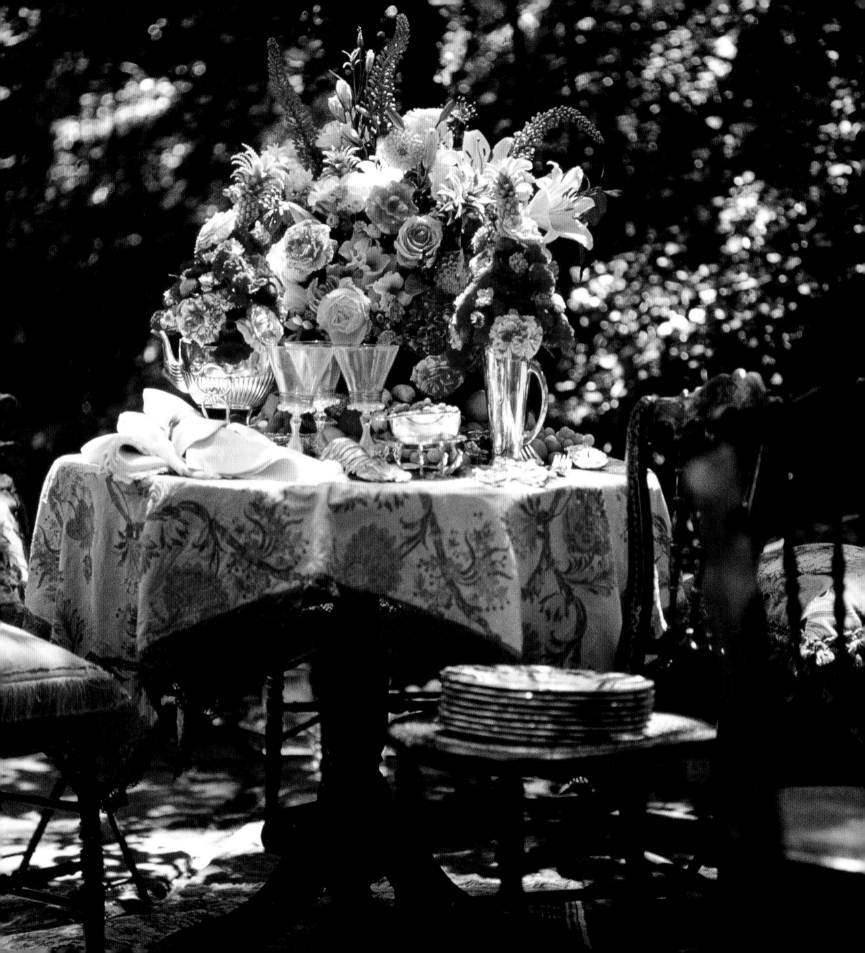

Opposite: A French silk piano cloth, laden with formal tableware and a profusion of flowers, dresses up an antique table that was brought outside for lunch.

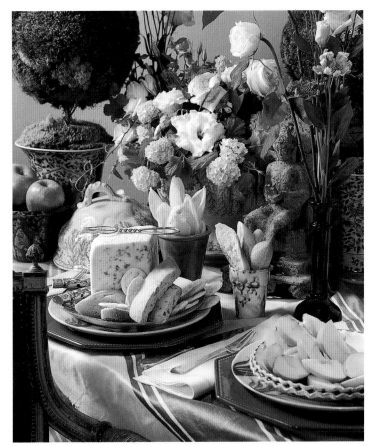

while guests are balancing a plate or tray on their laps. (This is definitely not the time to serve barbecued chicken — save your guests from the embarrassment of an inevitable spill and yourself from cleanup headaches.) Stack plates at the beginning of the line and arrange food platters with the sauces or accompaniments and serving utensils necessary for each close at hand. Flatware can be placed at the end of the line, and drinks served from another station, perhaps in another room, to help prevent traffic jams.

Make the buffet station beautiful as well as appetizing, but it's a good idea to place decorative items out of the way, toward the back if using a sideboard, or in the center if using a dining-room table. Vary the heights of objects for interest with footed trays, candelabras, and cake stands. Dishes can be stacked on trays, boxes, or pedestals that have been draped with swaths of fabric, shawls, or lace. For a less formal look, mix wood, pottery, and handcrafted objects in with the silver serving pieces.

Whether your idea of at-home entertaining means a multicourse dinner for ten, manhattans and martinis for a hundred, or a casual buffet for a few neighbors, remember that decorations make the setting beautiful, but it's the people who make the party. Good food and drink are desirable, but good times and conversation will be remembered long after the lobster and crème brûlée are forgotten.

Blue and white has been a popular tableware choice for centuries, but on this fruit-and-cheese table, it's the infusion of chartreuse in Granny Smith apples, hydrangea, and moss topiaries that updates the color combination. Contemporary patterns mix with eighteenth-century delft, and a swath of striped silk across the table typifies the trend toward combining the casual and the formal with attitude.

# The Well-Stocked Bar

**Liquor**
Blended whiskey
Bourbon
Dark rum
Gin
Light rum
Scotch
Vodka

**Liqueurs**
Amaretto
Benedictine
Cointreau, Grand Marnier, or
    Triple Sec
Crème de menthe
Kahlua

**Wine**
Champagne
Dry vermouth
Red wine
Sherry
Sweet vermouth
White wine

**Beers**
Domestic beer
Imported beer
Light beer

**Mixers**
Club soda
Cranberry juice
Ginger ale

Orange juice
Soft drinks
Sparkling water
Tomato juice
Tonic water

**Garnishes**
Ice
Lemons
Limes
Maraschino cherries
Olives

An old copper butler's cart
is transformed into an
engaging bar with sparkling
silver and bouquets of
belladonna, calla lilies,
roses, and daisies.

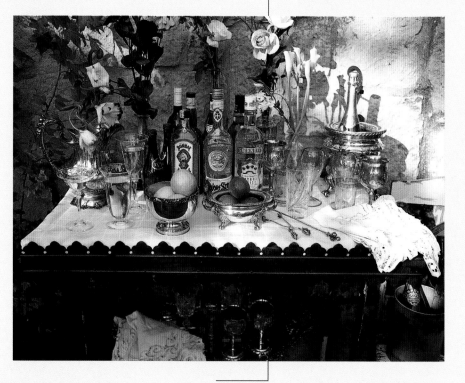

# Laying It on the Table

- Several days before the party, plan what you will use on the dining-room table. Set out china, glassware, and silver and then coordinate flowers and floral containers. If you're hosting a buffet, gather together platters and serving pieces and match them to the dishes you will serve based on size and color.

- Using collections such as porcelain figurines or architectural ornaments on the table is a good way to infuse your personal interests into a setting, but don't overload the table with too many extraneous objects.

- To cover or not to cover? The answer is a personal one. If the wood and grain of your table are pretty, it is fine to forgo the white linen tablecloth, but use place mats to protect the table from heat and moisture.

- Instead of a traditional tablecloth, cover a table with a patterned shawl or quilt. Drape it at an angle to create interest.

- For a casual setting, use greenery such as palm fronds or magnolia leaves as place mats.

- A mirrored plateau in the center of the table doubles the impact of candlelight and crystal reflections. If you don't have one, cut mirrored mats can produce the same effect.

- Bring a floral centerpiece to each place setting with smaller bouquets of flowers in petite vessels such as silver, porcelain, or crystal cups or bottles.

- Fruit piled on a platter or in a bowl makes an easy and colorful centerpiece. For a festive twist, lightly spray-paint apples or pears gold, or dust them with sugar by dipping them in egg white and rolling them in finely granulated sugar. Let the fruit dry before arranging it on a platter or cake stand.

- Pile seashells in a glass bowl for a centerpiece. Shells can also be used as saltcellars.

- Line glass vases or apothecary bottles down the middle of the table and fill them with leaves, ferns, or other greenery.

- Get creative with napkin rings. Tie up linen napkins with organdy ribbons or raffia and tuck in sprigs of rosemary or small flowers such as pansies.

- Float flowers such as lilies or rose petals in finger bowls.

- After everything is set and before the first guest arrives, sit down at the table. Make sure that nothing obstructs your view across the table and that the table settings, as well as any serving accessories on the table, are arranged in a logical and attractive manner.

Chapter 2

# Outdoor Events

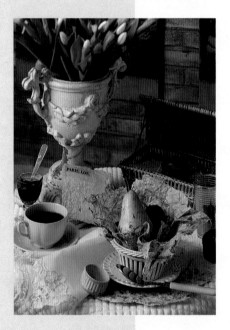

Whether an event is formal or informal, grand or intimate, for the young or old, entertaining outdoors sets a carefree tone that cannot be duplicated at an indoor party. For a spirit of openness and unlimited possibilities and stimuli, a natural setting is ideal.

Of course, the most obvious type of gathering to host

Left: Unexpected things on an alfresco breakfast table will give guests plenty to talk about. Here, a stationery box holds muffins and an aperitif glass is filled with jam. Fiber bowls and mats add textural interest. Right: A beachside party sets a casual tone, underscored by loose floral arrangements, rustic tableware, and young people with an appreciation for the light fare.

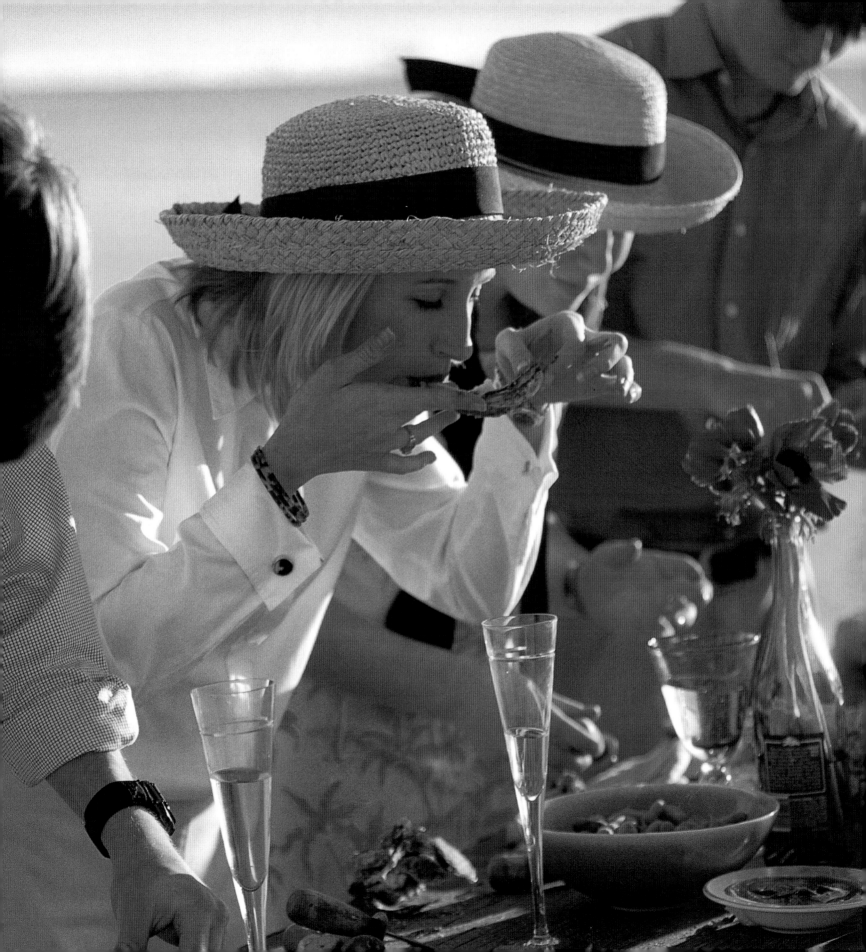

Below: Guests head down the boardwalk for a coastal oyster roast. The menu features two types of oysters: roasted oysters and broiled oysters with smoked tomato sauce or herbed bread crumbs.

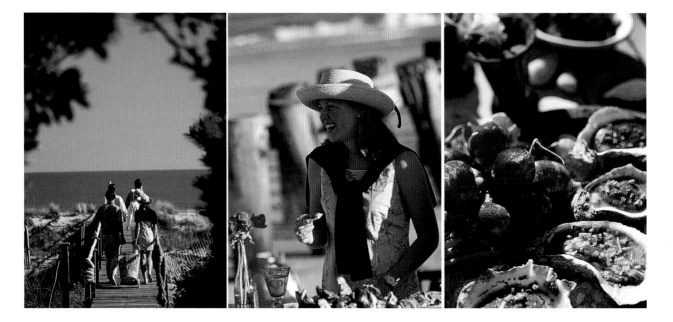

Opposite: A garden party may include any number of guests. In this walled Charleston garden, a lone table invites people to mingle on the lawn and admire the explosion of blooming color.

outside is the more casual sort, where the environment provides the decoration and the justification — a pool party, a barbecue, a game of croquet. But what many of us have discovered, particularly in our interior-obsessed existences going from home to office to mall to home, is that nature provides almost infinite opportunities for spending time with friends and family. Gardens are constantly evolving as we try to get back in touch with the natural — as opposed to the electronic — part of our existence. As a result, alfresco parties need not be decorating dilemmas. Mother Nature provides color that no tabletop arrangement can match. And when flowers are added to the mix, the effect is one of effortless abundance.

Outdoor entertaining lets a host collaborate with the elements to provide the most welcoming and easy setting. But weather is not always accommodating, so it is useful to keep a few basics in mind. First, counting on a sunny, temperate day at any time of year is risky. Prepare an alternative to dining in the wide open, be it a

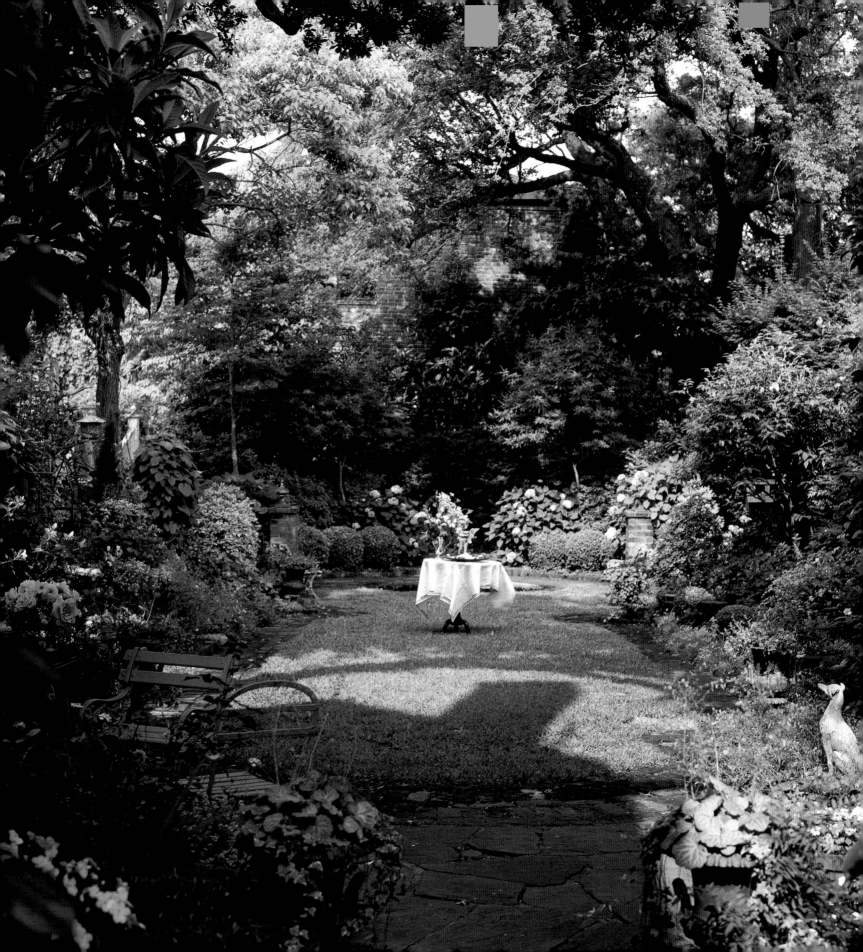

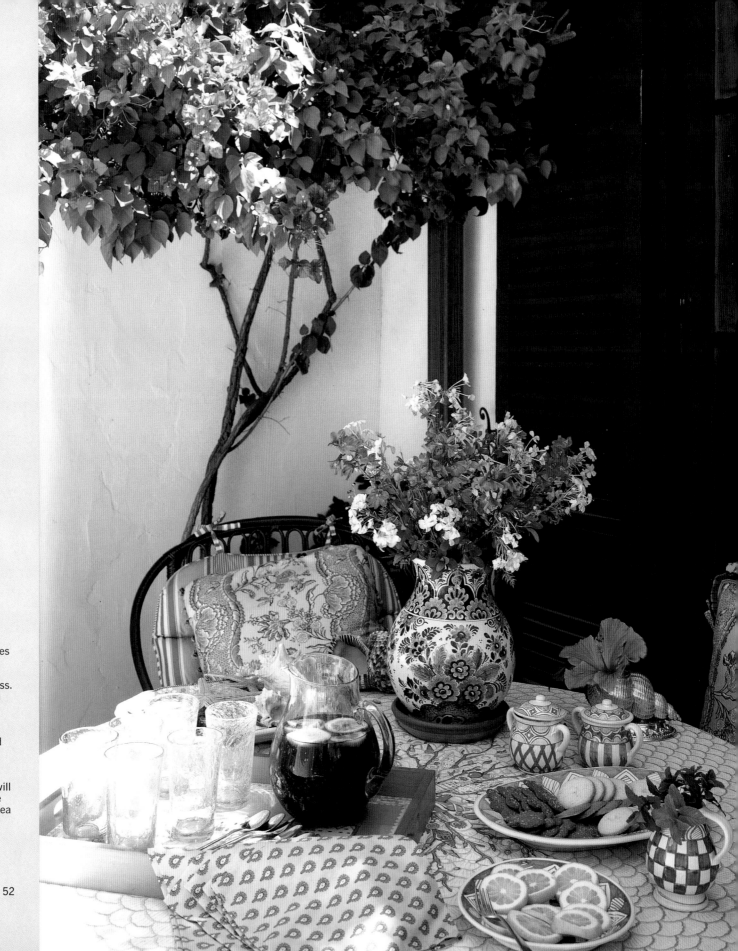

Blue, white, and yellow are perennial favorites because they communicate a sense of freshness. For an afternoon summer get-together, contemporary faience accented by a loose arrangement of blue and purple garden flowers will be as cool to the eye as the iced tea is to the palate.

52

tent or a garden room. And then there is the predicament of the combination of high-heel-wearing guests and a soggy lawn. Always hold more formal parties on solid ground, where stone or brick surfaces make for easier walking, and let your guests know in advance that they will be celebrating outdoors so they can dress appropriately. Everyone loves a verdant backdrop, but the setting for an outdoor party should never be overgrown with grass or, God forbid, poison ivy. Insects and animals may be something of a nuisance, but they are also part of the charm of outdoor entertaining. Have patience: citronella candles and good timing seem to be the only real deterrents.

With such unpredictable elements, it's a wonder anyone dares to entertain outside. But the experience is so rewarding that the benefits outweigh the risks. After all, a garden party offers the opportunity to unveil a garden that has finally grown into its own, an excuse to take advantage of great weather, and a chance to show off wonderful collections of casual tableware. Unless you're hosting a child's birthday party, paper plates and cups have no place at an outdoor gathering. In fact, many tableware patterns, both antique and contemporary, are based on the natural world, their form or decoration finding inspiration in organic shapes. With the availability of colorful acrylic designs

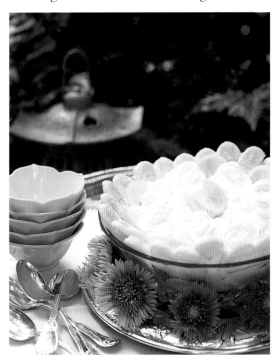

A simple lemon trifle is lovely in its own right, but decorated with fruit and blossoms, it can become a centerpiece.

— perfect at poolside — and tole and enamel plates that mirror the designs and handiwork of more fragile porcelains, the choices are almost endless. There's also no greater surprise for guests than a host who doesn't hesitate to use his or her finery outside. It just takes a little extra effort, a bit of faith, and a relatively relaxed attitude about potential breakage. The result will be a setting that practically guarantees a good time.

With a bit of care, fragile tableware can make the transition to an outside affair. Hand-painted floral plates and heirloom silver lend an air of elegance to a creekside party.

54

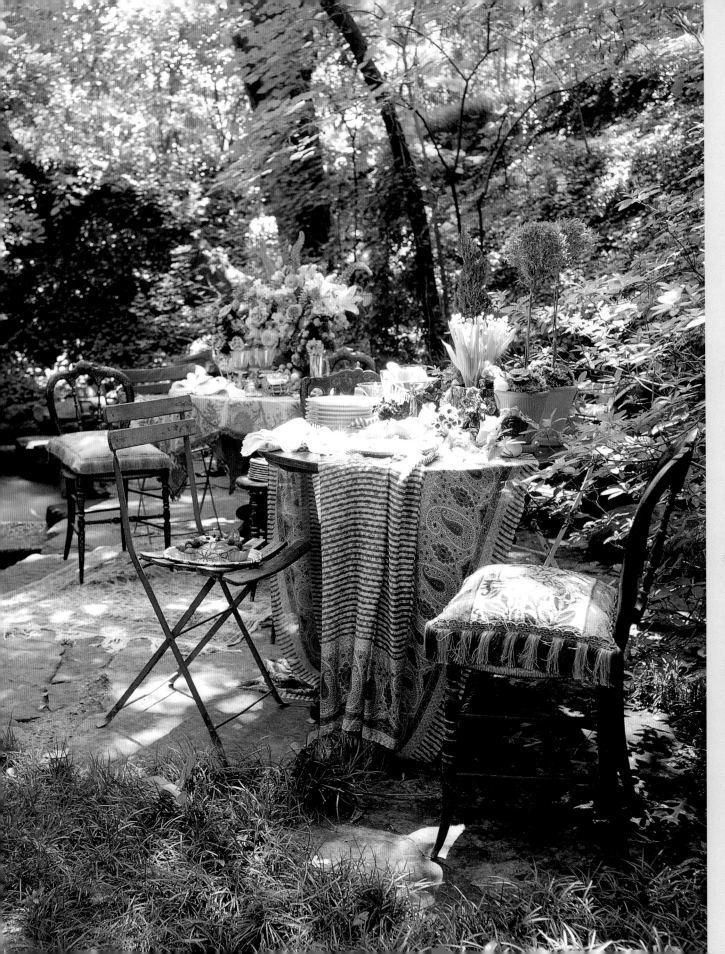

French occasional chairs, silk-covered pillows, and a precious collection of textiles and tableware set the stage for an outdoor summer luncheon, where the temperatures remain cool thanks to shady trees.

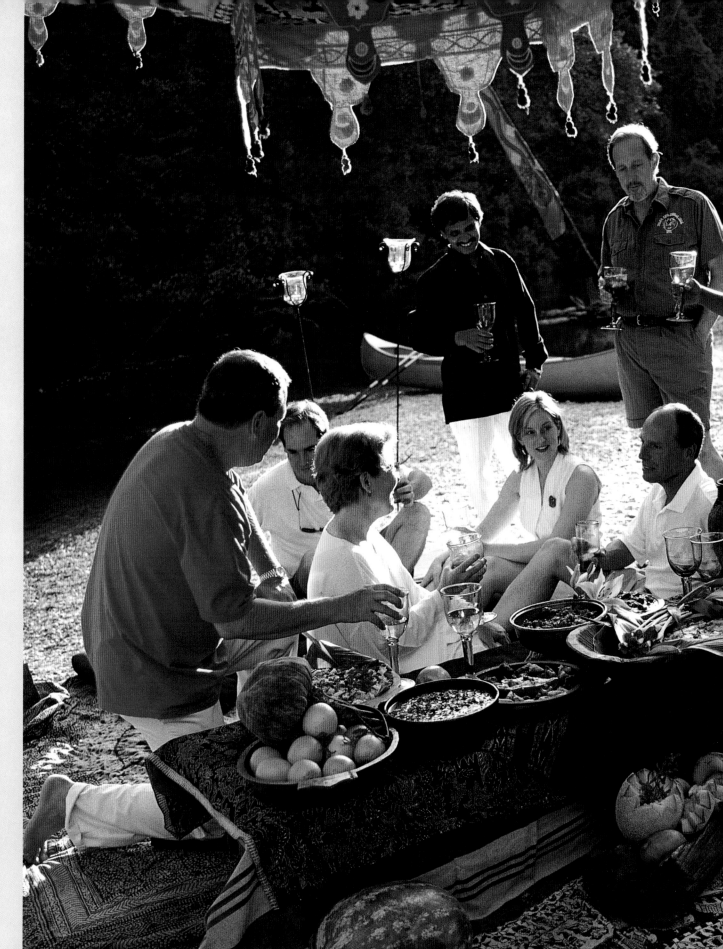

A vibrant tent and rugs of many patterns set the stage for an outdoor party in Mississippi. Rustic wooden serving bowls and embroidered pillows add to the Eastern flavor.

# Picnics

The first step is to determine whether an event lends itself to natural surroundings. Picnics, of course, are designed for a beautiful day. They have been a favorite pastime for centuries, but today's hosts are finding inventive ways to make them fresher and more interesting. Fried chicken and potato salad are still good picnic fare, but less predictable meals are livening up the tradition.

For example, oyster roasts at coastal locations celebrate both the local shellfish and the camaraderie that comes with beach weather. The dress and mood at an oyster roast will be casual because shucking oysters is rather messy. Floral arrangements can take a laid-back attitude, with natural grasses gathered in simple containers, or colorful bundles of anemones massed in bamboo cylinders. Vegetables lend color and form and round out a menu whose main feature is shellfish. Choose robust glassware to go with the setting and serving platters that are as unassuming as a summer day by the ocean. Last but not least, hold the event near where the oysters are harvested, both to set the tone and to let your guests know that their meal is fresh.

An authentic Indian menu, including *dal*, a lentil curry, and *thepla*, spinach flatbread, continues the exotic theme.

A picnic idea of a different sort is an exotic Indian-inspired get-together. The foods, which can be prepared in advance and served at room temperature, need an equally exotic setting. A tent can be assembled fairly easily with poles and a few vibrant textiles. Picnic tables can be made from small, portable side tables, and guests can sit on a rug and a smattering of throw pillows placed on the ground. The saturated colors of India look right at home against a colorful summer backdrop.

Lawn bowling or croquet makes for a different sort of gathering. After all, the games are held on well-tended, manicured lawns, so players will be equally well put together. Ask guests to wear white, and dress the tables with crisp

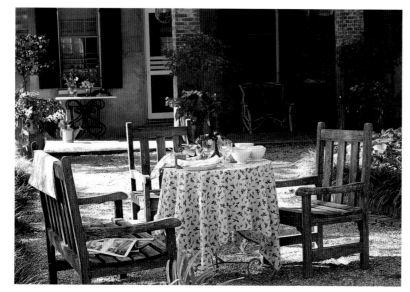

A guest house in a bucolic setting gets a little color when an outdoor table is covered with a Provençal cloth and set for breakfast.

white linen as well. In the same way that green-and-white floral arrangements communicate a sense of clarity and freshness, a lawn bowling or croquet party should be decorated with simplicity. After all, the reason for the event is the game, not the food or drink. But add mint juleps and a plate of delectable finger foods to the mix and the matter of who won the tournament will soon be forgotten.

For all picnics, keep things uncluttered, lighthearted, and original. The trek to the destination and the preparation should never be so time-consuming and labor-intensive that they detract from the celebration. Whatever is carried to the location usually needs to be carted away, and too many elements will spoil the fun. No food should be so delicate that it won't survive the trip or so simple that it can be eaten in the car on the way.

## Breakfast, Lunch, and Dinner

Europeans take many of their meals outdoors as a matter of course. Americans have moved away from that tradition somewhat, but in regions of the country where the climate allows for comfort eight or nine months of the year, it is a nice change of pace to host a brunch or dinner party outside.

Taking breakfast in the garden is a supreme indulgence. The dress is robes and slippers, the entertainment the morning paper, and the cuisine a mix of fresh fruit and pastries. Decoration is simple but attractive enough to start the day off right. A palette of white and green is easy on eyes just awakening, or blue-and-

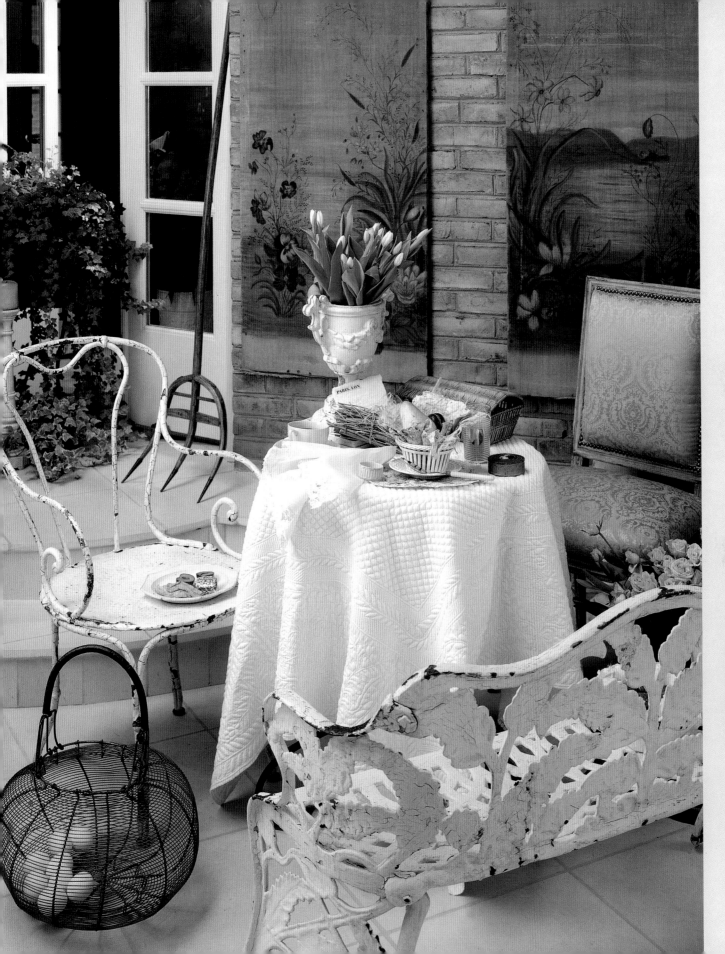

Setting up breakfast on a porch or terrace is an indulgence for houseguests. Unmatched chairs and an English fern bench are pulled up to a bistro table covered with a French quilt.

59

white tableware can provide a cheerful contrast. Sweet daisies in a simple vase can lend a shot of color.

Dinner outdoors on a warm summer night is similarly indulgent, as sunlit evenings provide the light and fresh vegetables and flowers the color. The most formal of dinner parties should probably not take place outside, but outdoor cocktail parties can be refined and formal or spontaneous and easy. Citronella candles keep flying insects at bay, and cool beverages keep the mood festive. As the sun sets, flowers are almost incidental and candles become important. They give the event a soft glow and occasionally a subtle scent, which should be faint enough not to disturb the taste of the hors d'oeuvres.

A casual dinner party, such as a barbecue, can take advantage of standard garden elements for tableware. Gather urns and terra-cotta pots and fill them with ice to chill wine and soft drinks. Small pots might even hold sauces or salads. Rather than prepare the typical buffet barbecue, consider a sit-down meal, so different dishes can

Below: In warm weather, a pool pavilion becomes an ideal spot for a late-afternoon gathering. Teak furniture and a white, gold, and silver palette keep things cool for a light buffet.

Below right: Taking its hue from the sun-bleached deck and trellis, a cocktail table remains neutral with smoky barware, bamboo-handled tools, and taupe- and butter-striped linens.

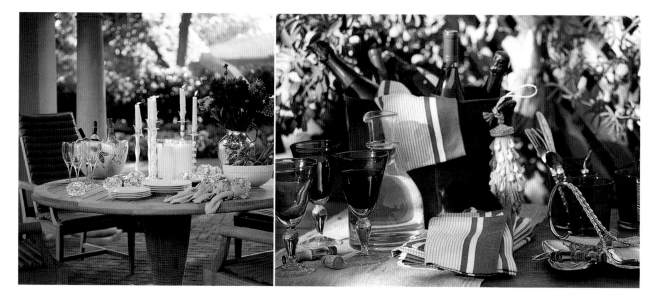

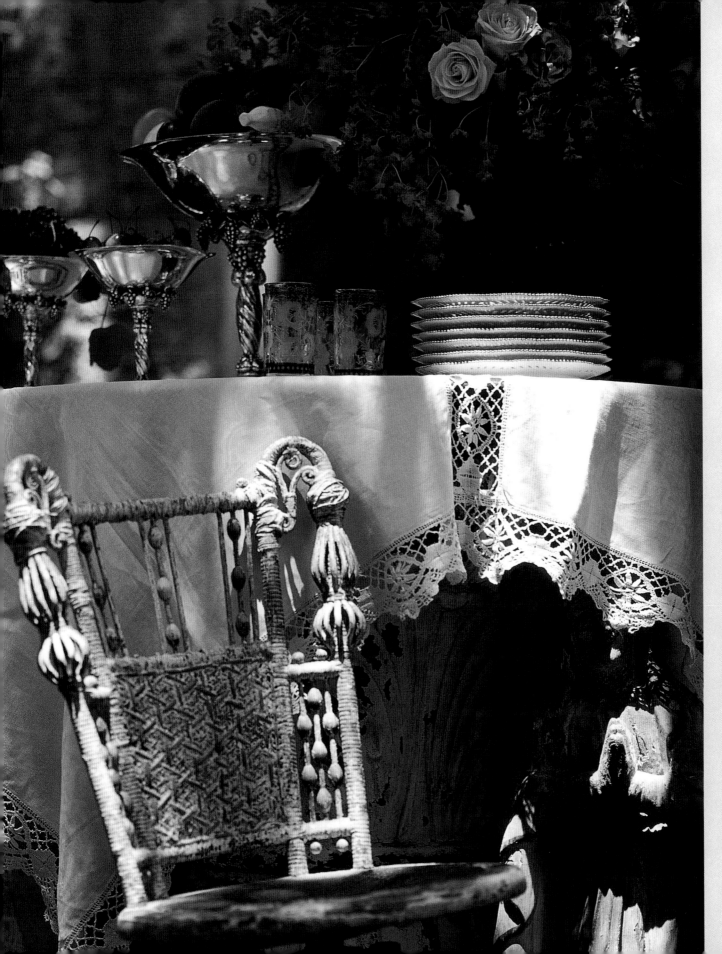

An aged stone terrace in Dallas takes on a European feel with the addition of antique lace, wicker chairs, and silver with a little patina.

61

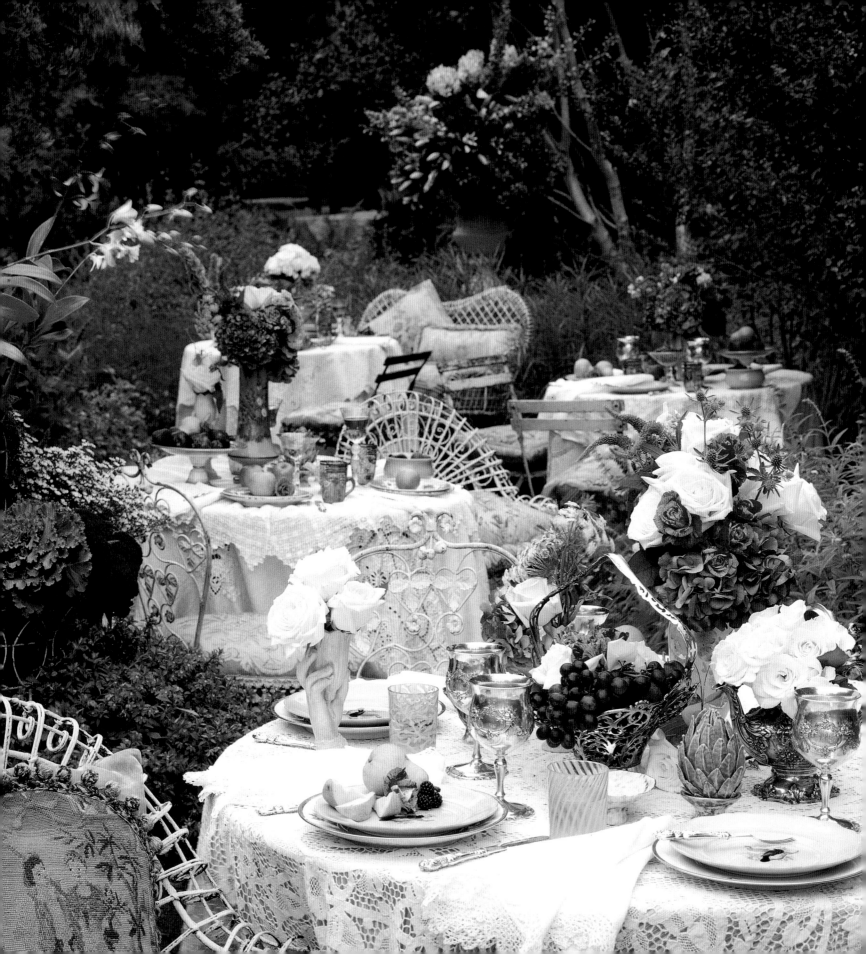

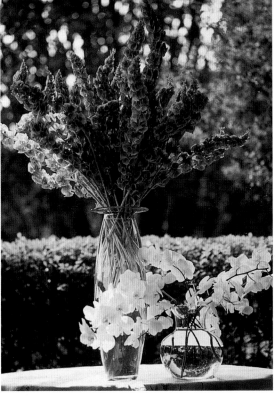

be savored rather than grazed. Tableware need not be fine, but silver, which should be used on a regular basis in order to preserve its polish, can brighten up a table. And if there's an occasion for the red-and-white gingham tablecloth, this is it. But try a complement of red-and-white toile de Jouy napkins to underscore the rustic feel of the occasion and yet add a touch of European sophistication.

Evening entertaining outdoors does pose a lighting challenge, so keep in mind that elements must be seen to be appreciated. Supplement lanterns with background lighting. The food table's surface should be bright enough for guests to see what they are eating. If the party is taking place close to a pool area, rim the area with candles or even float candles in the water to create the feel of a South Pacific getaway — and to make sure that guests won't dive in, unless that is their intention.

More genteel gatherings, such as a ladies' luncheon, call for a little extra effort. For a seated affair, tables and chairs will obviously be necessary. Rented furniture is an obvious choice, but it is often bereft of style and personality. Remember that not everything has to match. Eclecticism is welcome anywhere but seems especially appropriate in a garden setting. Dress up tables with vintage tablecloths and even coverlets from your personal collection, and consider bringing interior chairs outside. After all, furniture, antique or otherwise, is meant to be used, not just admired. But don't hesitate to resort to lawn furniture. Antique Victorian wire furniture is as light and pretty as any well-crafted table, and it's also comfortable. Rustic bistro chairs and teak and painted wood chairs lend themselves to an outdoor repast. Fluff a few pretty pillows and you have created an environment that is as comfortable and stylish as a dining room.

A palette of green and white is especially appropriate for an outdoor party. Bells of Ireland and orchids in plain, clear glass vases await guests at a wedding reception.

63

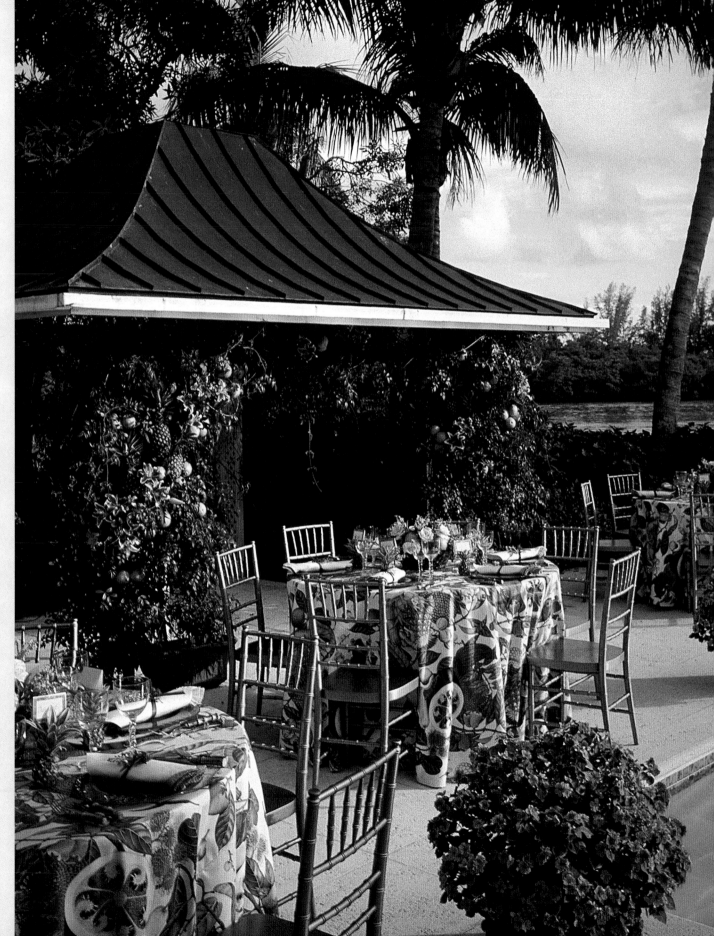

For a luncheon in Florida, round tables covered in tropical-print tablecloths are positioned around the pool. A gazebo garlanded in greenery and citrus fruits provides respite from the afternoon sun.

64

Keep in mind that an outdoor lunch will have guests walking around more than they would if the meal were served indoors. The tables need not be precisely set with a simple centerpiece in the middle and plates placed all around. The tone of the party is lighter by necessity, so the attitude toward the presentation can be more relaxed. Also, when you incorporate special objects and accessories, the food can be simpler, more basic. Most of the attention is directed toward the decorations.

Floral arrangements should take inspiration from the surroundings, with a loosely massed group of flowers in a free-spirited English garden or a tight arrangement of roses in a more manicured French parterre. Colors too may mimic the plantings. Handcrafted pottery might be appropriate in autumn, delicate porcelain in the spring, and even sophisticated acrylic designs in summer.

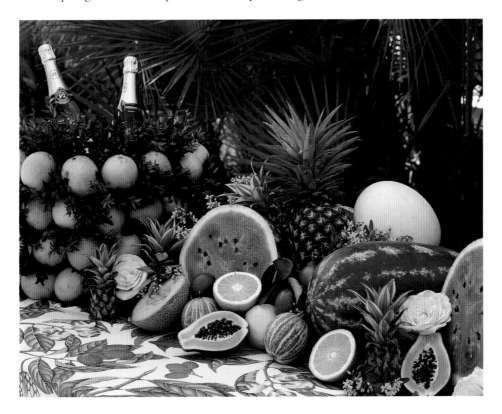

The champagne table is arranged with a veritable orchard of fruit. A bucket used to ice down beverages has been wired with oranges and boxwood sprigs.

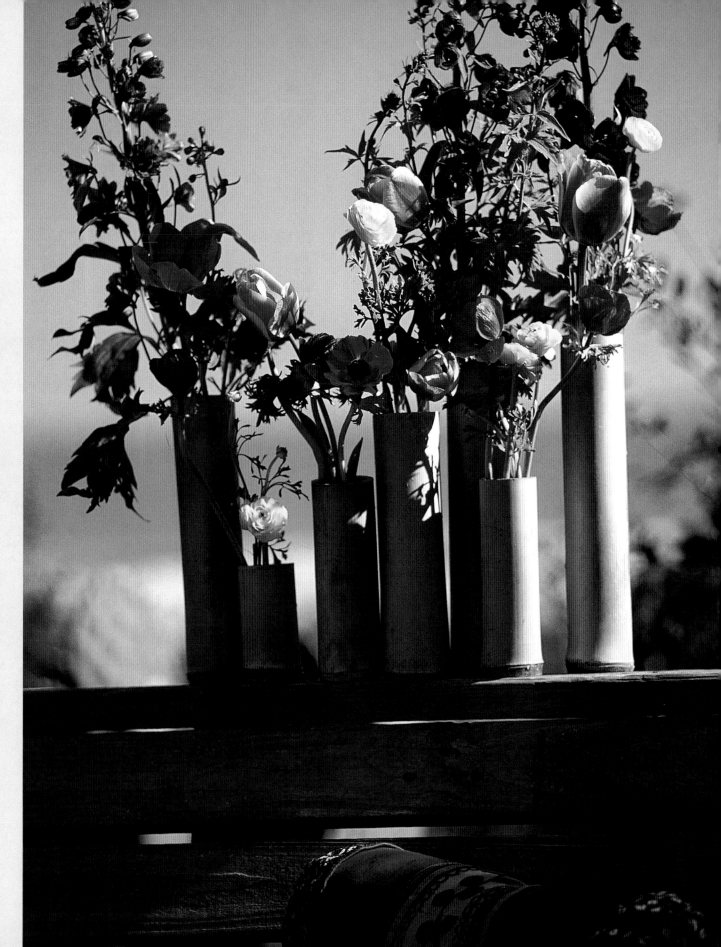

Seasonal flowers massed in bamboo cylinders are an appropriate decoration for an outdoor party.

66

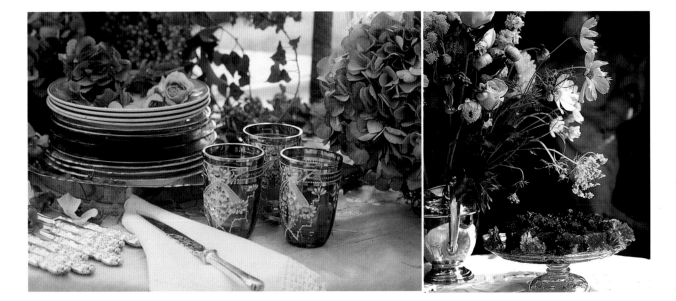

Above left: Plates in a variety of patterns provide a charming alternative to rental china while adhering to the garden theme.

Above: Food adds a dash of edible color to an outdoor table. The raspberry wine cake is as lush and rich as the garden that surrounds it.

Ideal locations for luncheons include a back porch, a flowering meadow, a creekside terrace, or even poolside. At the latter, the palette may mirror the turquoise blue of the pool. Instead of using mossy greens and earthy browns, work with almost fantastic tropical colors like fuschia and coral to provide the accents.

An outdoor event challenges us to be a little more resourceful in creating the presentation. Avoid relying on tables alone for interest and look to nature for inspiration. Use stones and stumps for serving tables, line platters with large leaves, gather moss for a centerpiece. A shallow spot in a cool creek may be just the right temperature to chill a bottle of wine. We're limited only by our imaginations.

When hosting an outdoor meal, especially one with formal elements, provide plenty of shade if the season is a warm one, and easy access to your home so guests don't feel isolated. Exercise restraint in decorating so no one will be overwhelmed by too many things. A table that is overflowing with flowers and accessories can be more claustrophobic than welcoming.

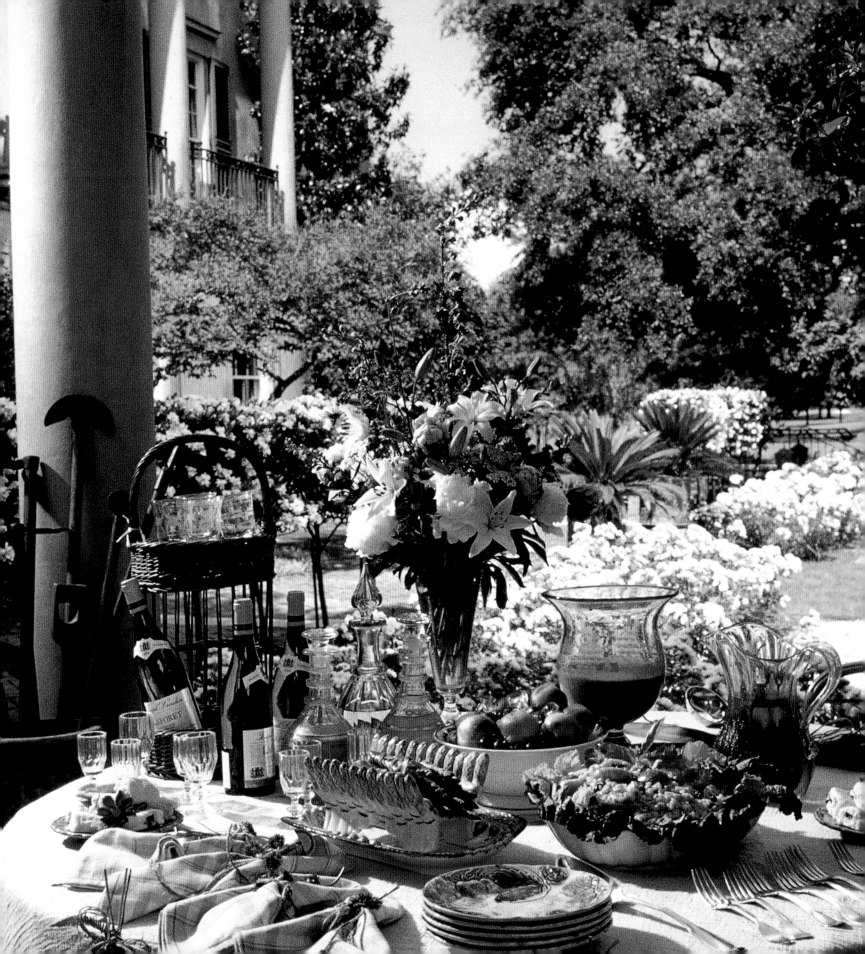

# Theme Parties

Some events just lend themselves to outdoor entertaining. A gathering planned around a sporting event, such as a tailgate party preceding a football game, breakfast before Wimbledon, or a cocktail party after a day at the Masters golf tournament, will almost always be held outside. Garden club meetings are another example, but any group may get together outdoors to celebrate when the purpose is sheer enjoyment of the setting.

One occasion that is particularly suited to the outdoors is a plant-sharing luncheon. Terrific for garden enthusiasts and novices alike, it is an event that promotes the sharing of horticultural knowledge as well as the tangible exchange of plants. For this lunch, the textures might be as rough as the earth that sustains the plants — brown burlap, white cheesecloth, and even moss for the table coverings. Party favors can be miniature pots filled with young plantings or small garden tools; napkins might be tied with something as rustic as twine or grasses. Use organically inspired tableware such as old European majolica pottery, which in many cases resembles vegetables such as cabbage leaves, asparagus stalks, and cauliflower heads, to brighten the tabletop in a way that is especially appropriate for a garden party.

Such affairs are fun to hold in a backyard garden, but they can also be organized in a public garden that rents different areas for events. These locations work for entertaining on a grand scale, and fund-raising is often the motive. Entertaining is a gracious way to raise money for a worthy cause, and planning an outdoor party to benefit a historic

A beehive of icing weaves around a cake outlined with white yarrow flowers.

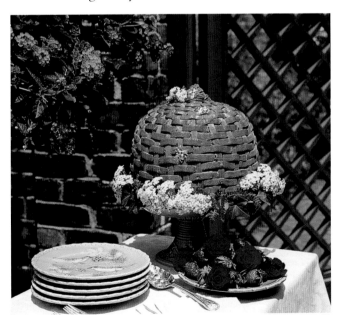

69

Right: Sprays of lavender perk up linen napkins spiked with miniature garden tools that double as party favors.

Opposite: Potted poppy pods as well as handwritten place cards and menus punctuate tables dressed with slabs of moss. A luncheon of shrimp and orzo salad and asparagus is appropriate for a late-spring afternoon.

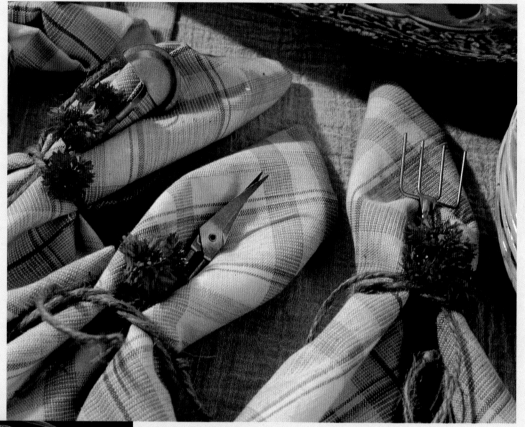

A makeshift burlap desk provides a surface for penning invitations and planting narcissus bulbs, another option for party favors.

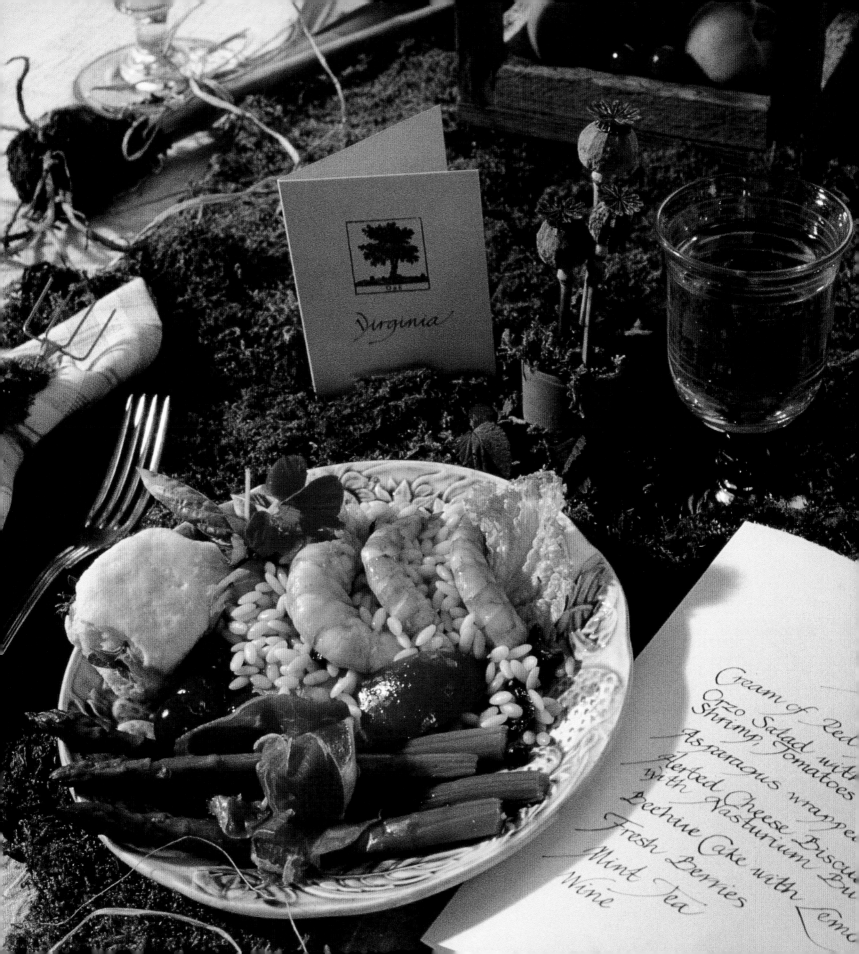

Virginia

Cream of Red ...
Orzo Salad with
Shrimp, Tomatoes
Asparagus wrapped
Herbed Cheese Biscuit
with Nasturtium Bu...
Beehive Cake with Lem...
Fresh Berries
Mint Tea
Wine

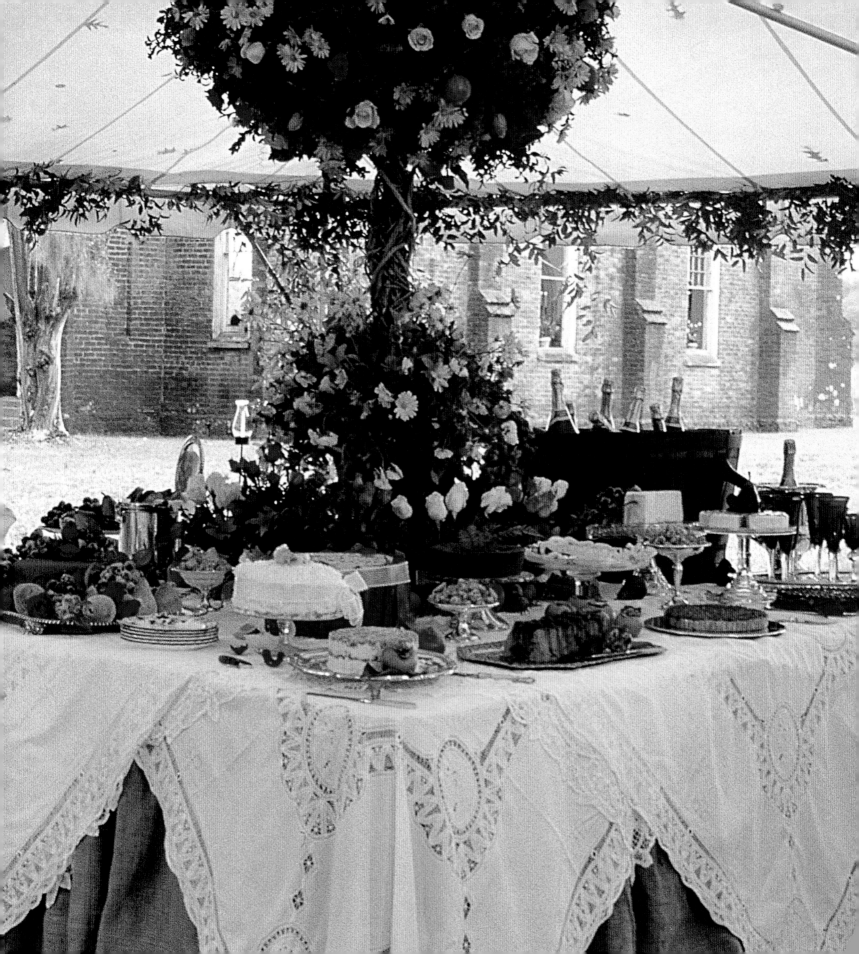

site or botanical garden seems especially appropriate, particularly if the site can serve as the setting for the fete.

Historic preservation has become such a serious matter that groups throughout the country are always searching for ways to preserve threatened sites. In St. Francisville, Louisiana, concerned citizens rallied to protect a historic church that had fallen into disrepair. A concert in the stabilized structure, which had neither windowpanes nor electricity, provided the excuse to summon potential donors to a dessert party on the church grounds afterward. A light rain spurred organizers to assemble a tent at the last minute. To prevent the canopy from emphasizing the fact that the weather was less than perfect, organizers rimmed its roof with fresh greenery. The dessert table, laden with sweet confections, was also decorated with garden flowers. As the real decoration was the church itself, nothing too elaborate was needed.

Many such sites no longer function as they once did, but they can still have a place in the community. They make ideal settings for gatherings, be they weddings, cocktail parties, or fund-raising events. The challenge is in imagining the potential of the site while acknowledging its possible fragility and its previous role. An old church will not host a New Year's Eve bash, in the same way that an old steel plant will not be the setting for a wedding.

Whatever the event, look around your environment to find an ideal outdoor setting for a party. Entertaining alfresco removes barriers and apprehensions and puts guests instantly at ease. It can be unpredictable, but that's a large part of its charm. So relax, go with the flow, and get set for the great outdoors.

In keeping with the rustic sophistication of the party, a clay pot holding an arrangement of roses and greenery sits atop a weathered windowsill.

Opposite: On the grounds of an Episcopal church in St. Francisville, Louisiana, a tent ringed with greenery invites concertgoers to a table with a soaring rose-and-daisy topiary and delectable desserts. The event was organized to raise funds to preserve the church, which had fallen into disrepair.

- Have an alternative plan for inclement weather. Move the party to a covered porch, or erect a canopy or tent to keep the rain from ruining the fun.

- With a little extra care, indoor furnishings and tableware can make the transition to outdoors. Choose china with a floral motif, plump tapestry pillows in chairs, dress up a stone terrace with a kilim rug.

- Spread blankets or quilts on the grass and let guests pick up individual baskets (such as the kind fruit comes in at the farmers' market) lined with a toile napkin and packed with picnic fare, colorful plates, and a split of wine.

- For breakfast, line creamware baskets with handmade fibrous papers and serve a selection of fruit. Pile muffins in a rattan box and serve jams in aperitif glasses.

- Use a Chinese blue-and-white urn for a wine cooler; if the event is more casual, chill drinks in a garden urn or large galvanized metal bucket.

- Tailor the decorations to a woodsy setting. Line platters with foliage or tie woodland bouquets on the backs of chairs. Write names on leaves to serve as place cards.

- Plant herbs in small terra-cotta pots and put at each place setting for garden party favors.

- For a barbecue, roll up eating utensils in fingertip towels and tie with raffia to make for an easy pickup.

- As an alternative to tiki torches, edge a pool in votive candles or use floating candles in the water.

Scheduling an outdoor party can be a challenge because of practical concerns like weather, but planning an event to coincide with the full bloom of colorful flowers such as hydrangeas and roses will allow for effortless decoration.

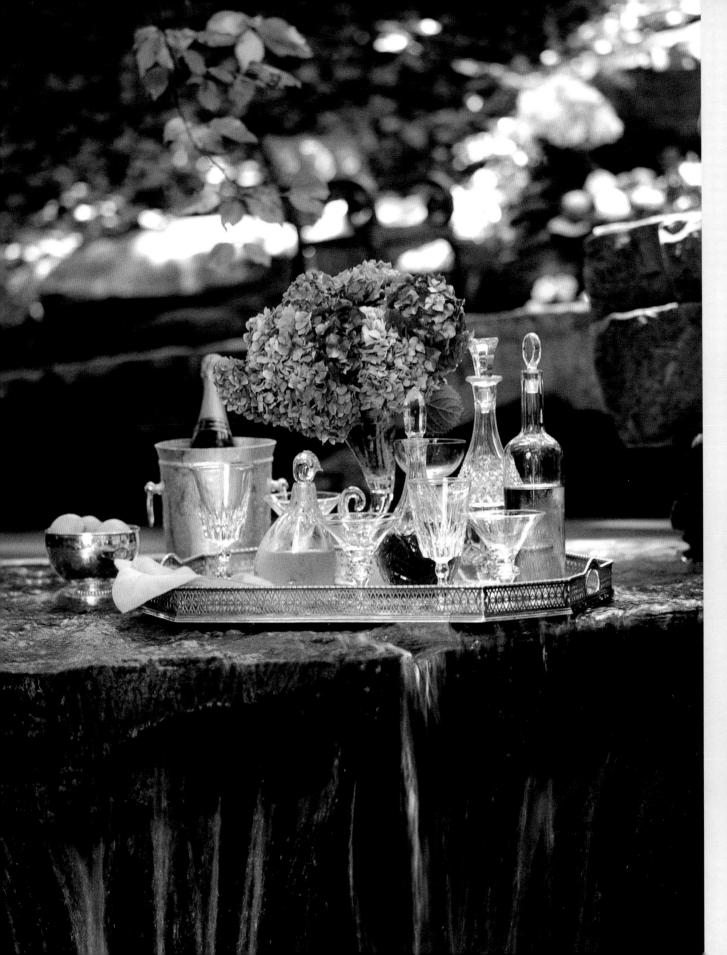

Such necessities as coolers can present an aesthetic challenge at an outdoor party. Here, a dripstone in the creek provides natural refrigeration for a silver tray holding wine and spirits.

# Special
# Occasions

A lively gathering of close friends and family can make any party special, but there are certain occasions when we really want to pull out all the stops to create a magical setting. Many of us remember high school proms that took place in large, cavernous spaces (usually the school gym) disguised temporarily by balloons, streamers, and

Left and right: Entertaining for charitable causes is increasing in popularity. Almost a thousand people attend the Swan Ball in Nashville, which benefits the Cheekwood Museum. Guests sit down to tables decorated in a manner that celebrates the theme of the occasion.

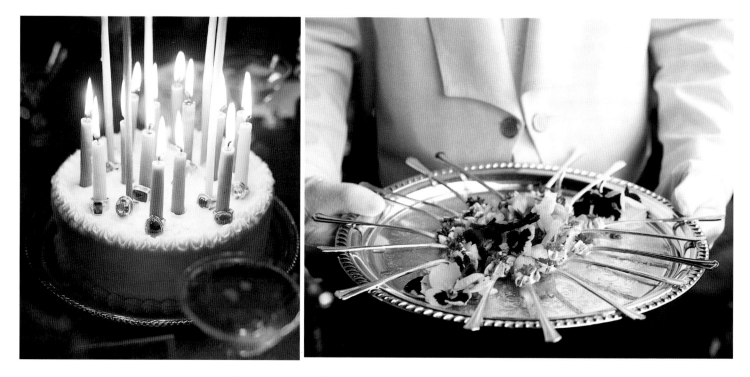

Above: Inspired by the tradition of dropping rings over candles for good luck, jewelry designer Elizabeth Locke decorates a cake with her own creations.

Above right: Lobster-and-cream-cheese appetizers are thoughtfully speared on forks to be easily enjoyed by standing guests. Pansies give the silver tray a stroke of color.

whatever theme the prom committee could dream up. While the effect seemed ethereal in our youth, this is the kind of affair that most of us willingly leave behind after our teen years, thankfully never to be re-created. Our birthday parties, however, must grow up along with us. Not surprisingly, paper hats are not nearly as becoming on adults as they are on five-year-olds, and the anticipation of being another year older just doesn't hold the same allure. However, any time we come together to celebrate a personal milestone, the honoree should be made to feel just as special as he or she did decades earlier. Successful party planners know how to do just that.

These days when a reason for grand-scale entertaining presents itself, most caterers and ball committees strive to create an atmosphere that melds sophistication with the realities of bringing a few hundred guests together in one location. Whether the event is a birthday bash or a ball, an intimate wedding shower or an anniversary party, the more personal the better, the more distinctive the more memorable.

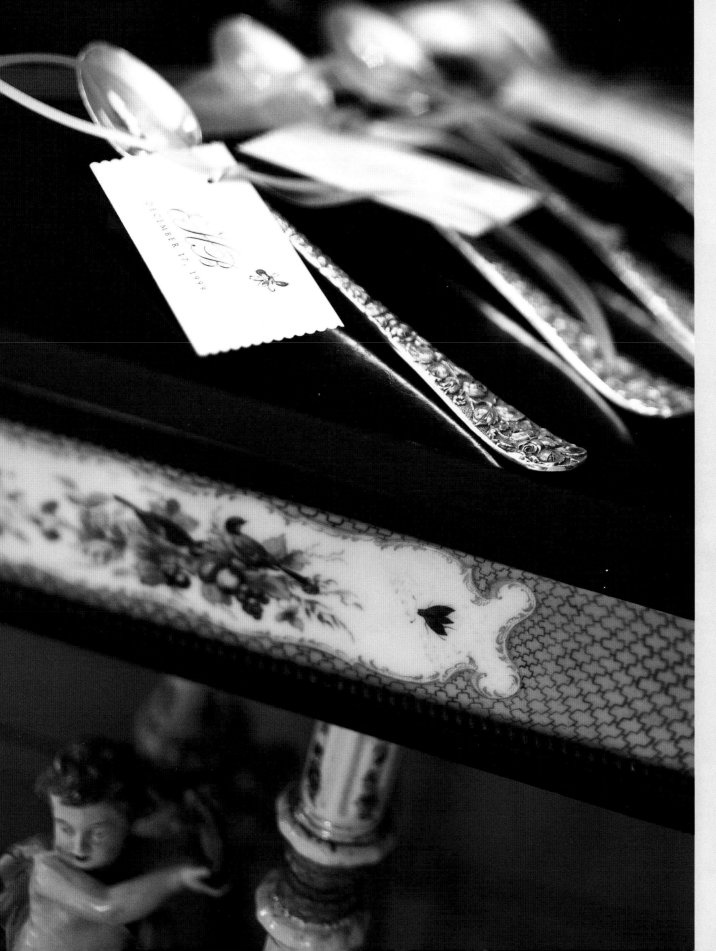

At a bridal-shower luncheon, iced-tea spoons in the bride's pattern make ideal party favors.

Right: At a Kentucky wedding reception, Italian lights strung around bare branches hung throughout a tent make for a fairy-tale atmosphere.

Below and bottom: Outlined in lights and filled with candles, flowers, and fabric, a conservatory welcomes guests to a Houston party.

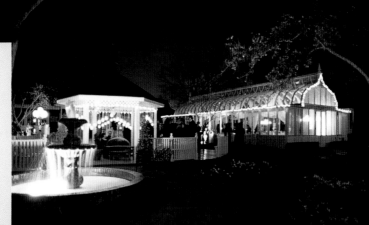

# Grand-Scale Entertaining

Most at-home entertaining is of a simpler sort, but once-in-a-lifetime events seem to bring out our theatrical sides. Whether the purpose is to fete a friend or to indulge yourself as you celebrate a fiftieth birthday, a decision to go all out requires a real commitment. Similarly, nonprofit institutions such as children's hospitals, art museums, and botanical gardens are all becoming more creative when it comes to raising funds. An event that makes patrons want to write hefty checks must be fabulous enough that the guests have no other choice.

Grand entertaining has become so popular that there are people who devote careers to creating fantastical settings for orchestrated events that go off without a single dropped plate or toppled centerpiece. But even if you are working with a professional who will choreograph the party as agilely as a pas de deux from *Swan Lake*, it helps to bring a few ideas of your own to the table, so that no matter the size of the event, it will seem as personal as a dinner party for four.

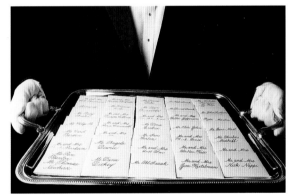

Exquisitely penned seating assignments on a silver tray are offered by a white-gloved attendant.

Unless you live in a Versailles-sized estate (or have access to one), most large-scale gatherings will involve a tent. The harsh reality is that tents cannot be totally disguised — accept their practicality and prepare accordingly. They can, however, be dressed up and personalized in a manner that will transform them into makeshift dining rooms and ballrooms where guests will be happy to while away a few hours.

When entertaining throngs, as with a charity gala or large wedding dinner, rental linens, china, and glassware are also unavoidable necessities. A sea of round tables covered in white cloths and set with undistinguished china and glassware does not exactly make for a festive atmosphere, so a little extra effort is needed to create interest inside the tent. Consider covering all the tables with the same white, burlap, or muslin undercloths and then draping them with squares of

complementary textiles. It's an easy way to inject color into an area that can become stark with too much white. For a wedding reception in Charlotte, the mother of the bride, who is also an interior designer, chose purple toile de Juoy to create the feeling of pastoral France, though in this case the field in the distance was a country-club golf course.

The tent itself often poses an aesthetic challenge because, in essence, it is all poles and canvas. But if you drape yards of voile or muslin from the ceiling and around the poles, hard edges can be softened. Columns placed throughout the tent will break up the visual area, making manageable rooms out of the vast space. Or tie branches and other sculptural elements to the supporting poles and cover them with small lights, creating a luminescent ambience. Additional lighting can come from candelabra or chandeliers that hang from the tent ceiling.

The Virginia Museum of Fine Arts becomes a theatrical stage evoking the opulence of imperial Russia. The event marks the high point of Richmond's social season.

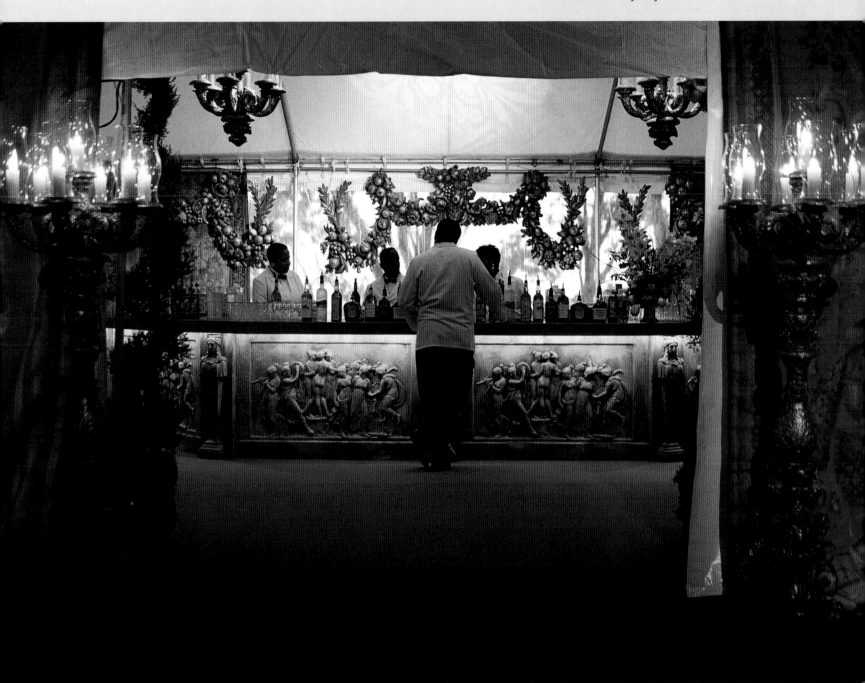

At the Swan Ball in Nashville, tapestries hand painted for the event, statues, and gilt torchères transport guests back to sixteenth-century Italy.

Special touches give guests the feeling that they are dining in a friend's home. Paintings and mirrors hang from the tent walls. Candelabra and free-flowing floral arrangements, accented by ivy, make up the simple centerpieces.

84

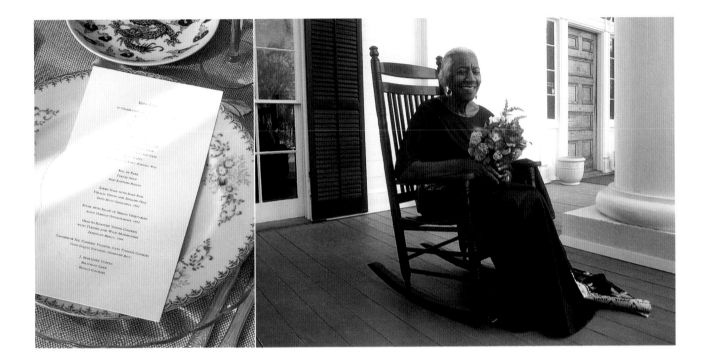

Sculpture, particularly antique garden statuary, will add a little patina and character to the space as well. And rugs placed atop wood floors go a long way toward creating the feel of an indoor dining room. Serving tables, whether fine wood buffets or linen-covered folding tables, placed at strategic points around the perimeter are practical for a catering service and also provide decorative surfaces for floral arrangements and accessories.

Even when the guest list isn't in the thousands, tents can still be a practical necessity. Weather snafus are the most likely calamity to befall any outdoor affair. A wood floor that will stay sturdy atop soggy grass, a covered walkway to guide guests to the party site, umbrellas, and a leak-free tent will provide a pleasant experience in all but hurricane conditions.

One of the most memorable parties *Southern Accents* ever photographed was an eightieth birthday party organized for Edna Lewis, a woman known for her extraordinary contributions to Southern cuisine as a cookbook author and chef. She

Above: The eightieth birthday party of celebrated chef Edna Lewis heralds all the good things about the South: friends, family, delicious food, and a naturally beautiful setting.

Above left: The menu of turtle soup, baked shad, roasted chicken, buttermilk biscuits, and organically grown vegetables reflects both Edna Lewis's and host-chef Scott Peacock's interest in Southern cuisine.

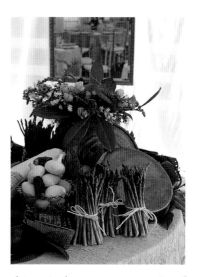

Above right: Bowls of vegetables, copper trays, bunches of asparagus, and a kitchen utensil or two are used for sideboard decorations, underscoring Miss Lewis's career as one of the country's top chefs.

Below: A silhouette of Miss Lewis hangs on the wall of the tent, presiding over the champagne table.

Below right: The fact that the party is in her honor doesn't prevent Miss Lewis from consulting on event details.

has commanded the stove at chic eateries from New York to Charleston, but when it came time for this special occasion, friend and chef Scott Peacock chose to host the fete at Bulloch Hall, a historic home just outside of Atlanta. A hundred or so guests were invited — luminaries from the world of food, as well as friends and family — and the sizable crowd was accommodated in a tent set up on the lawn. However, Peacock and other party planners didn't go the rental-china route. Instead, they borrowed everything from pottery and porcelain to flatware and platters from a generous group of friends. The result was a graceful hodgepodge of color and pattern on the tables. The group scattered rugs on the floor and brought out sideboards decorated with compositions of everything from fresh asparagus to cooking utensils to salt-cured hams. And art — still-life paint-ings (with food as the theme, of course) and silhouettes depicting the guest of

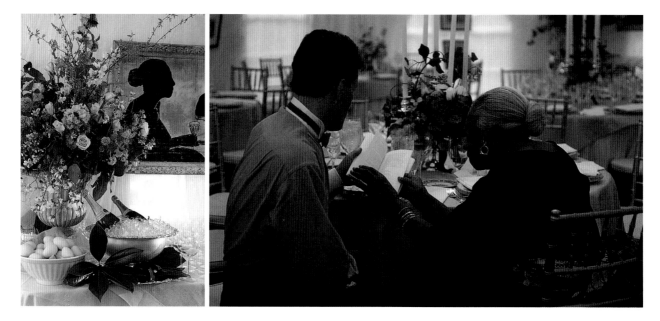

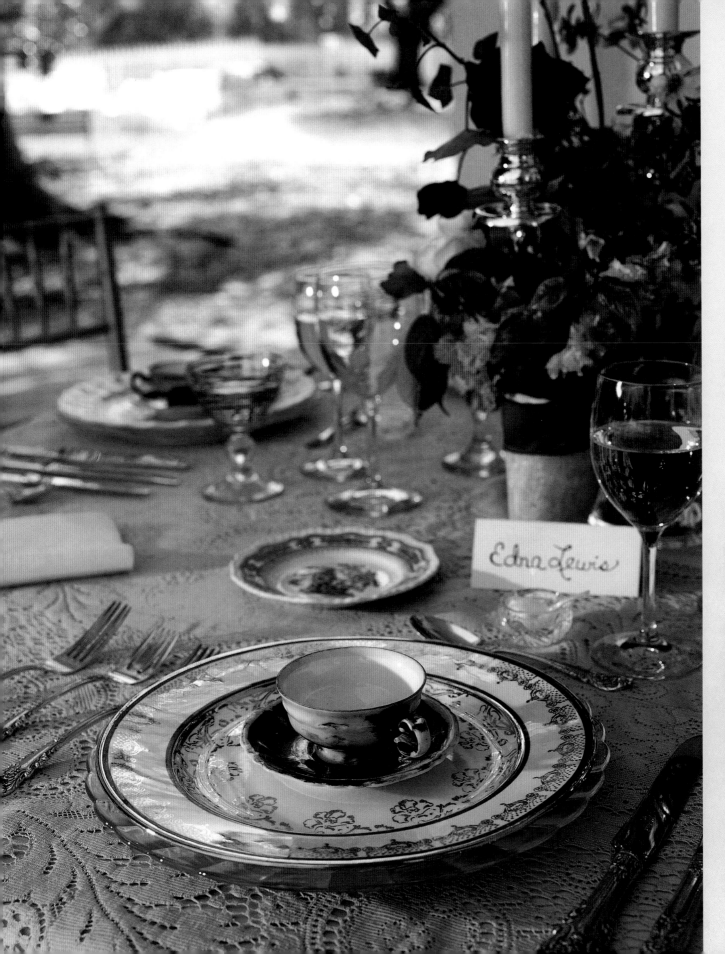

A hodgepodge of tableware that has been borrowed from friends and antiques shops makes up the party decor.

*Edna Lewis*

honor — hung on the tent walls. Guests obviously had high expectations for the meal, and they were exceeded with the help of some of Miss Lewis's favorite recipes. The setting was equally spectacular in an elegant yet unassuming way that seemed perfectly suited to the honoree.

## Intimate Occasions

Birthday parties, anniversary dinners, and bridal and baby showers are rarely opportunities to invite a list of thousands. It's more gratifying to host a close group of friends who can appreciate and celebrate a landmark occasion. And the better you know your guests — your old college roommate, who prefers steak to chicken, or your favorite neighbor, who takes his martinis shaken, not stirred — the more you can customize the party to suit their tastes and yours. You might decide to hold the party at a restaurant or other favorite spot. If you're hosting the party at home, using a room other than the dining room might be a way to take a little predictability out of the party.

Opposite: A beautiful arrangement of garden roses decorates the gift table for a bridal shower.

Below: To welcome guests to a party, petite bouquets of herbs and garden flowers are massed in unassuming jelly jars lining a porch.

Because the group is smaller, the challenges that characterize large events are mostly absent. Guests can move indoors or out, from room to room. Further, the decoration or backdrop for the party can be homelike and cozy or as over-the-top as your entertaining style and budget allow. The flowers might be profuse, with arrangements at every place setting, or one simple, beautiful example for understatement. But the decoration should reflect the occasion in an appropriate manner. For an anniversary party, there might be a photograph

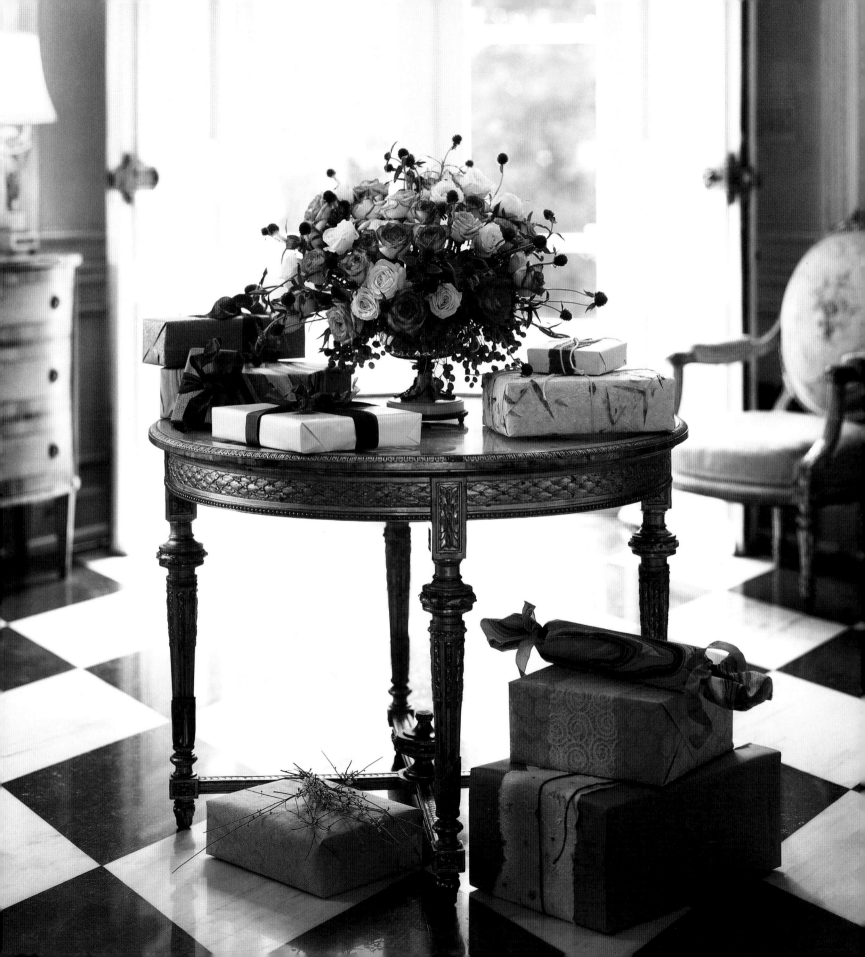

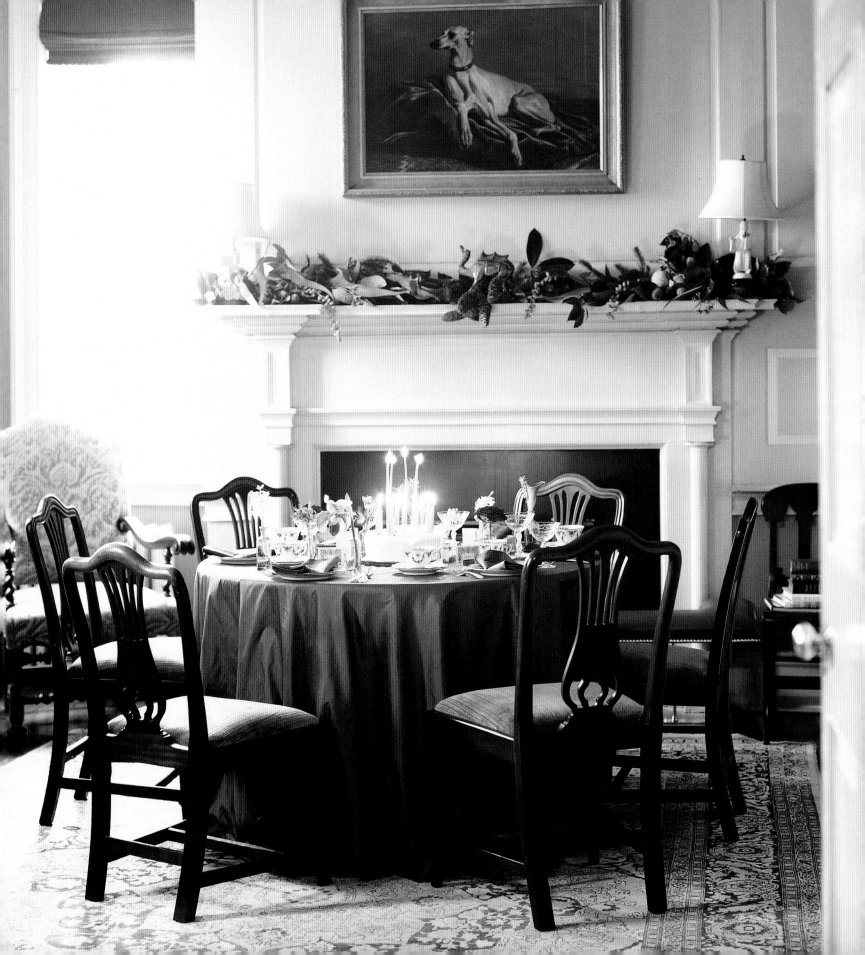

on the buffet table of the couple on their wedding day. If the anniversary is a silver one, bring out all the sterling, from platters and a coffee service for food and drink to a variety of pitchers and vases to hold bouquets of white flowers. At an engagement party, framed photographs of family weddings from past generations will provide a nostalgic touch.

Knowing that black balloons and "over-the-hill" banners were just not her style, a Houston hostess who was marking her fiftieth birthday elected to plan her own celebration. As she is an accomplished travel writer and globe-trotter, she invited friends from all around the world and devised a setting that was well worth the trip. A local conservatory, available for rent, served as the party location. Guests wandered down candlelit paths to find the glass structure sparkling with white lights, with additional illumination coming from chandeliers accented with greenery and white flowers. To continue the green-and-white theme, white cloths were draped around tables. Baby artichokes nestled in terra-cotta pots had place cards tucked within their spiky leaves. The icing on the cake, literally, was the centerpieces — frosty white birthday cakes placed on silver pedestals at each table.

Just as birthdays are inevitable, many of us will have an opportunity at some point to host a bridal or baby shower for a friend or relative. These kinds of parties generally revolve around a theme, such as bed-and-bath, tool-and-gadget, kitchen, or "stock the bar" showers for brides (and today, often grooms). With baby showers, the theme will be obvious, but if the sex of the child is known, it's tempting to take a pink or blue palette to the hilt. However, a string of crepe paper booties, matching punch, and the like are a little predictable. And fortunately, traditions of silly pad-and-pencil games have given way to more sophisticated parties (guessing the circum-

For a bridal shower, a collection of heirloom silver pitchers filled with white flowers, vintage black-and-white wedding photographs, and antique lace decorate the gift table.

Right: At a fiftieth birthday party, frosted birthday cakes atop crystal stands serve as centerpieces at each table.

Below: Because the well-traveled birthday honoree has a fascination with the Far East, the menu features Asian-inspired food presented with an artful flair, such as the vegetable-filled spring rolls.

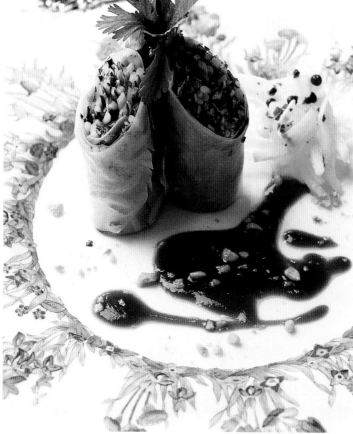

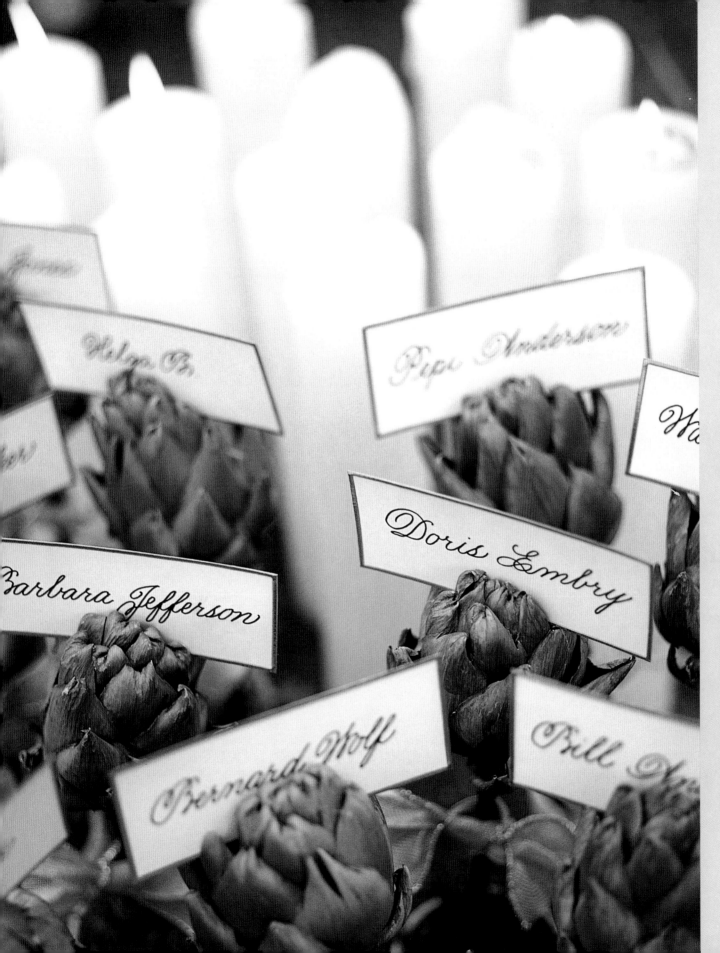

Place cards tucked into artichokes allow guests to find their seats for dinner.

93

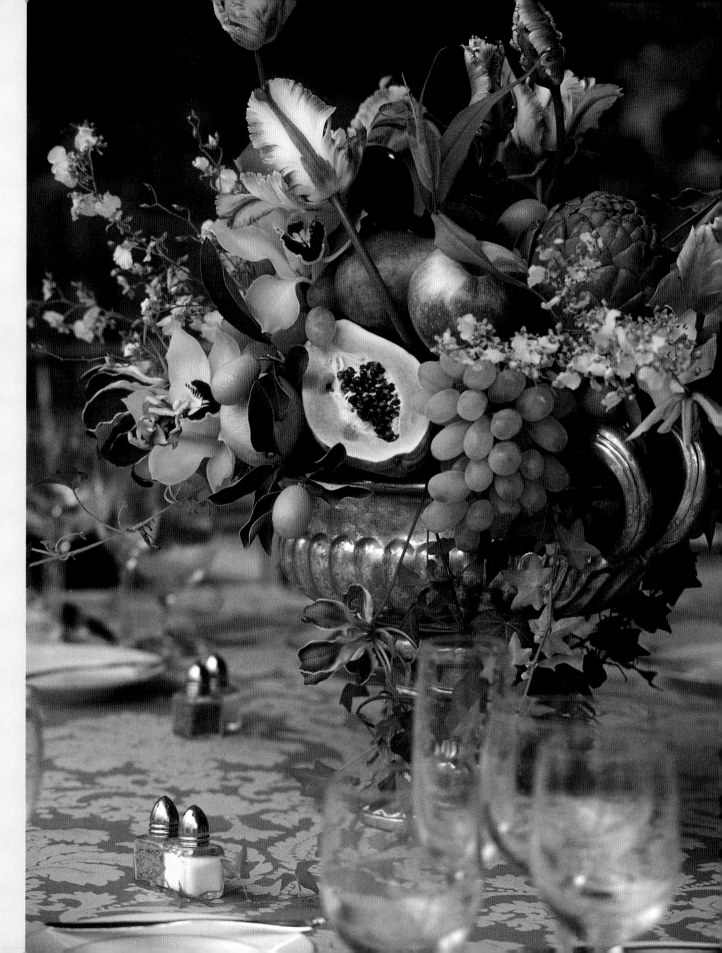

The centerpieces
evoke European
still life paintings
in keeping with the
Renaissance theme
of the Swan Ball.

94

ference of an expectant mother's waist was never all that endearing anyway).

A Birmingham hostess planned a bridal luncheon theme to revolve around her honoree's china pattern, which depicted colorful fruits and flowers. Everything from the custom-designed invitations and menu cards to a showstopping fondant-covered cake was inspired by the colors and ornate decoration of the china. In Dallas, a creative hostess also had china on her mind when organizing a party for a friend who had recently had a baby girl. Each guest received a teacup-shaped invitation (with a tea bag attached) asking her to drop over for tea to meet the new arrival. The hostess requested that everyone bring a teacup, either antique or new, to start a collection for the child that will be enjoyed long after diapers and stuffed animals have been outgrown.

Another smart party planner took special care of children — and their parents — at her wedding reception. A long table covered in white craft paper held plenty of treats to keep little hands occupied, from chocolate kisses to small toys and even crayons with which to create their own tablecloth designs. The children were entertained, and the grown-ups could enjoy a glass of champagne and uninterrupted conversation. It is that sort of creative thinking — and caring for the comforts of every guest — that makes special occasions, or everyday entertaining for that matter, a joy, whether you're the guest or the host. The beauty is truly in the details, and it is always worth the effort.

At the annual ball at the Virginia Museum of Fine Arts, which coincided with the opening of a Fabergé exhibition, well-known British set designer Michael Howells created massive topiary eggs of roses and moss to greet guests at the museum's entrance.

Chapter 4

# Home for the Holidays

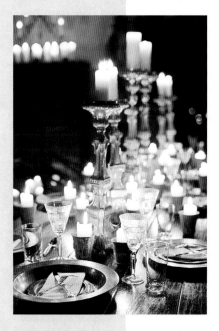

No other time of the year brings out our desire to gather more than that month or so between Thanksgiving and New Year's. In a frenetic season that has increasingly been given over to the commercialism of hawking salespeople, flashing lights, and dogs barking "Jingle Bells," it's important to step

Left and right: Whether they are massed on a dining-room table or console, candles create a glow that seems magical during the holiday season.

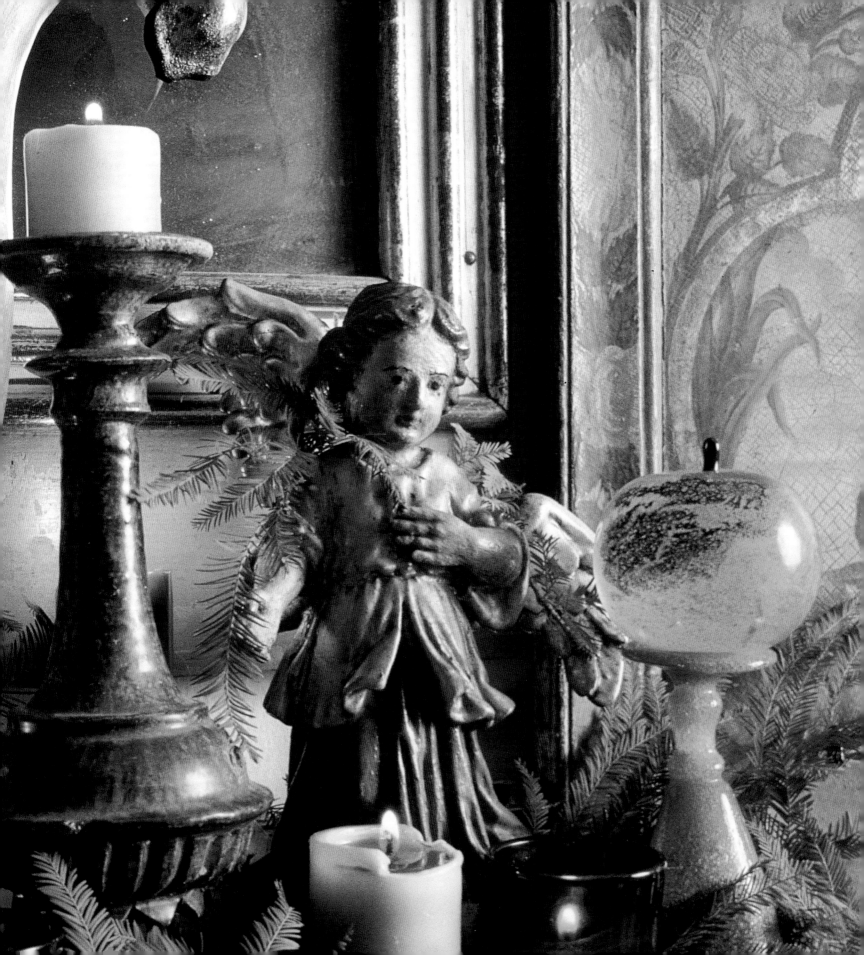

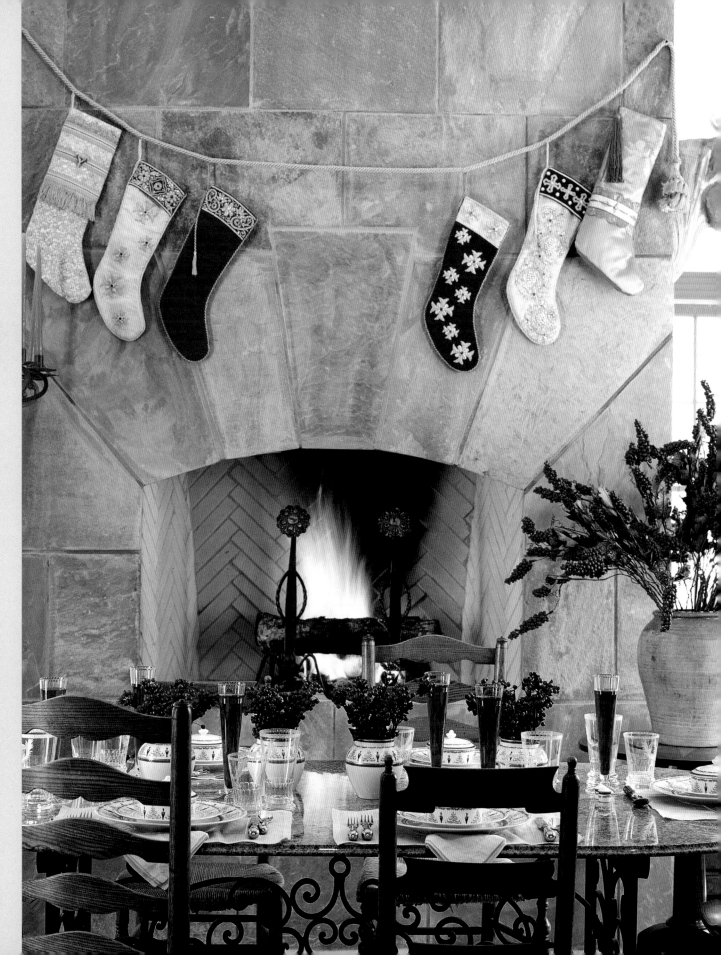

Dining by the fire imparts a particular coziness, perhaps no time more than when stockings are hung by the chimney with care. A classic holiday china pattern and champagne flutes filled with kir royale cocktails add unmistakable festivity to the setting.

98

back, reflect, and take stock of the people and rituals that enrich our lives.

The holidays are a time to celebrate and perpetuate the traditions that give life continuity, though by no means do these traditions have to be conventional. Memories may be about setting the sideboard with your grandmother's silver tea service, which was always in place for family dinners past, or perhaps they're about ordering Chinese takeout while putting together the children's toys on Christmas Eve. Whether your rituals include baking gingerbread men from an old family recipe, arranging a crèche that has been handed down through generations, organizing a caroling party for the neighborhood, or putting together a puzzle with your children, these are the things that make the holidays meaningful. And traditions become even more enriching when we share them with others through our hospitality.

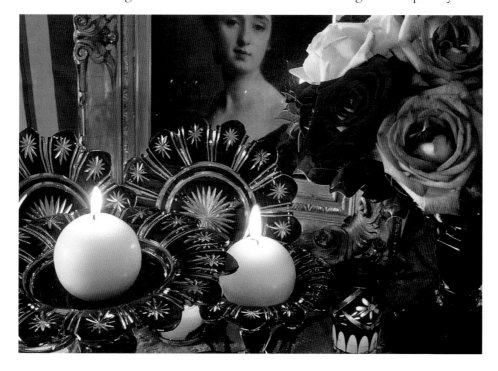

The holiday season offers an ideal opportunity to bring out inherited objects that don't receive much use during the rest of the year, such as the cranberry cut glass used to hold spherical candles.

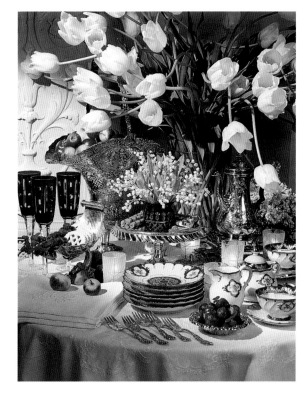

Integrate collections and sentimental heirlooms into holiday decorating. A glass cylinder filled with white tulips and a small bouquet of lilies of the valley in cranberry glass balance ornate antique porcelain and silver.

Two distinct groups tend to emerge during the holidays. The first approaches the season with a Martha Stewart–like zeal. Their gifts have been purchased since Halloween; they've addressed and stamped greeting cards that are ready to be mailed the day after Thanksgiving; they're throwing a party for five hundred of their nearest and dearest friends and perhaps even planning to do all the cooking themselves. The second group tends to let the holidays sneak up on them. They become best friends with the Federal Express delivery man the week before Christmas; you'll find them frantically scouring the mall on December 24; perhaps their season's greetings will be sent by e-mail this year.

The majority of us tend to fall somewhere in the middle. We want all the trappings of the season, but we're also busy at the office, taking care of our families, or both. In the hustle and bustle, the true message of the season can appear to be lost. However, everyone can agree that this is a time to spend with the people we most care about. When all is said and done, the most appreciated gifts we can give to others (and the ones they can't return but will want to return to over and over) are a bit of food and drink, laughter, and most important, our time. Sharing hospitality, no matter the method, and creating a beautiful environment for maximum enjoyment are paramount.

After an afternoon spent shopping, invite friends to relax and compare purchases over tea and wine. A tray of pretty china and crystal and simple bouquets of flowers arranged in champagne flutes are an easy way to make the party jolly.

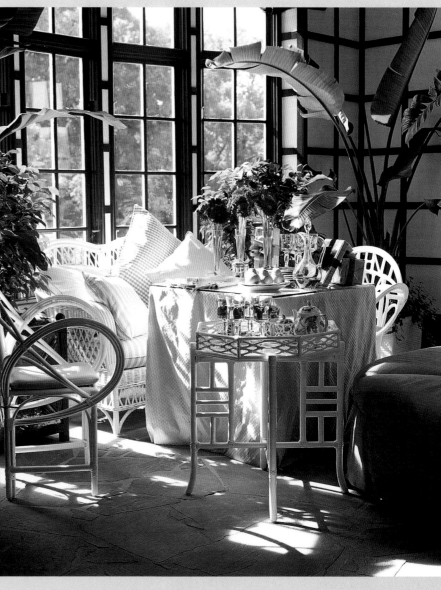

101

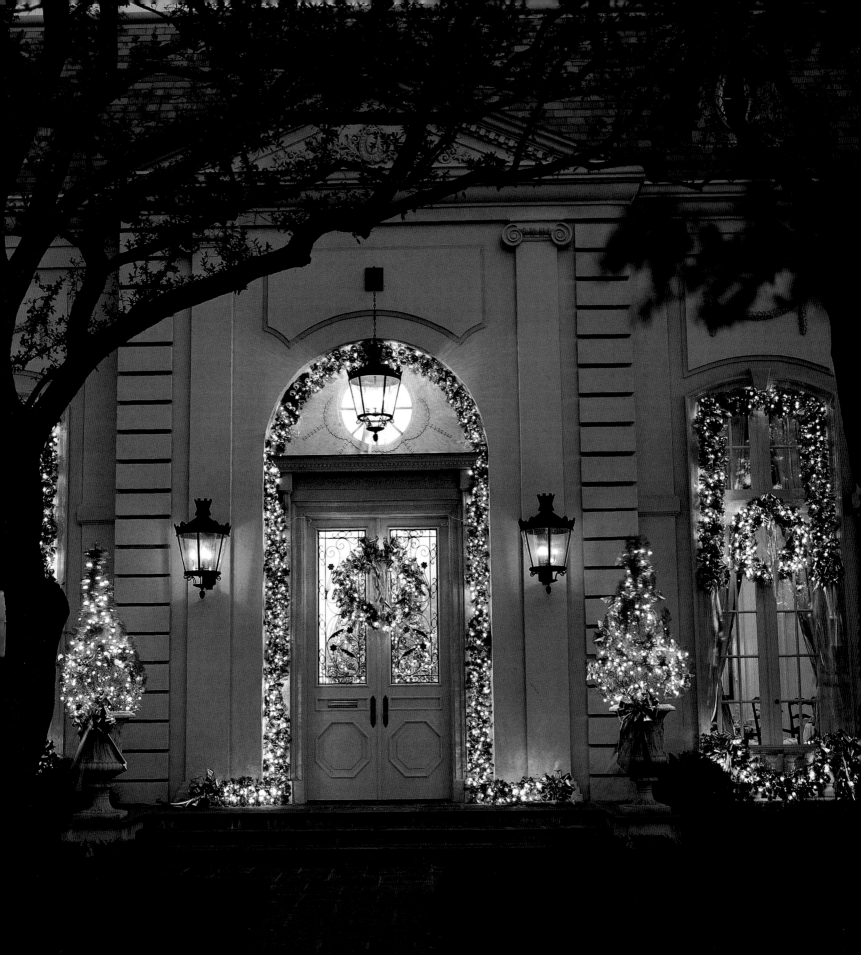

# Decking the Halls

Just as people do, houses make first impressions. When guests arrive for a party or drop by unexpectedly, the first thing they see is your front door. Make it welcoming, whether it's with an elaborate swag of fruit, twinkle lights, and greenery, or with the simplicity of a bay leaf wreath entwined with red ribbon. Paperwhites have become a holiday standard, so a designer in Texas uses the bulbs rather than the flowers, nestling them into manmade birds' nests constructed with grapevines. A rough-hewn wreath of crab apples and twigs can offer a cheery welcome at a lakeside or mountain cabin. Fruit is an enduring symbol of hospitality and especially appropriate for the wreaths and garlands that drape doorways during this time of year.

The holiday palette need not be limited to red and green. In this Dallas breakfast room, blue and white have full play, even during the month of December. English and Dutch delftware mixes with French and Italian faience and toile de Juoy. With Old World grandeur in mind, the homeowner and floral designer fashioned a topiary of gold-painted pears, hyacinths, and euphorbia swathed in ribbon.

Inside, pull a round table into the entryway for special occasions if there isn't one there at other times of the year. Cover it in a luxurious fabric, such as rich red velvet or beaded purple silk. Arrange a centerpiece of magnolia leaves or cinnamon-scented pinecones, display Christmas cards, or perhaps set out a tray of champagne to greet guests as they arrive for an open house.

All around the house strive to incorporate your own interests, personality, and collections into holiday decor. Choose the degree of ornamentation that feels appropriate for the space — and for your

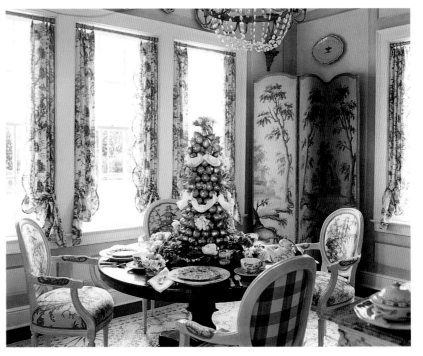

Right: Paperwhites have become a holiday standard. Here the bulbs, rather than the flowers, enhance a wreath.

Far right: A Fraser fir garland and a wreath spiked with sumac berries grace this doorway, while fur of the canine variety also gets into the holiday spirit with a red collar.

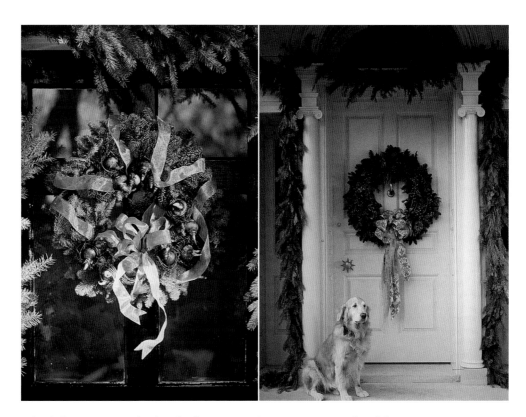

schedule. Are you the kind of person who wants a touch of festivity in every corner of the house? Or would you prefer the ease and understatement of concentrating on just a few main focal points? Many of us make the mistake of sweeping away the things we live with eleven months of the year and bringing boxes of decorations down from the attic to scatter furiously about during the month of December. Instead, focus. There is no need for our homes to become places that even our own families won't recognize. Just integrate everyday art and collections into the plan. Drape a favorite painting with a garland of fresh cedar. If you have a passion for the blue-and-white porcelains on your mantel, keep them out

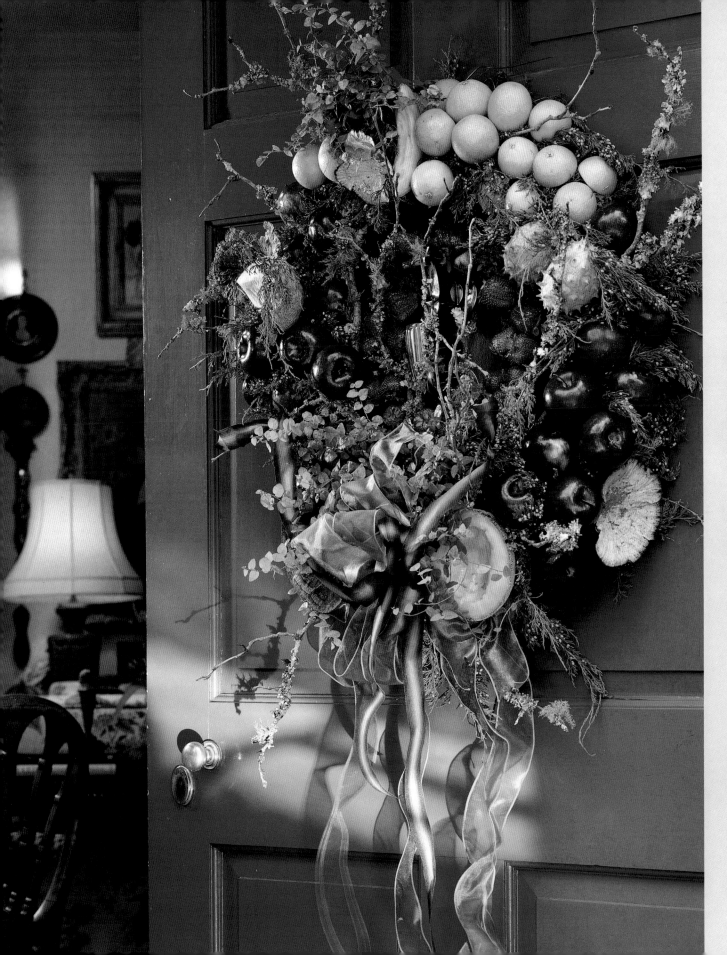

A traditional symbol of hospitality, fruit is especially welcoming when it garnishes a wreath at the front door. For a party, cut cantaloupe is added for a hint of melon orange, though it is obviously not intended to last throughout the season.

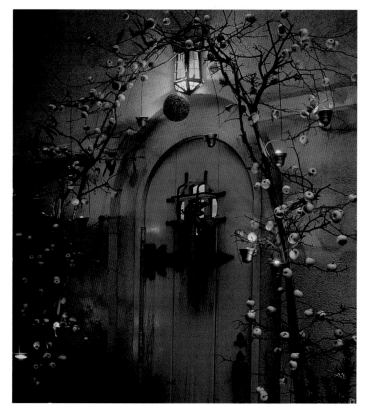

Trained crab apple tree branches laced with Lady apples and votive candles arch over a kitchen door that once belonged to an old fire station.

and fill the ginger jars with fresh bouquets of red tulips or amaryllis.

The day-to-day interior color scheme in your home should also come into play. Although red and green may be the combination we usually associate with the season, it is certainly not the only one that will communicate a merry atmosphere. Neutral interiors can take on any palette. Weave a pine-and-cranberry garland along the mantel and you have a green-and-red room. Use urns of lemons intermingled with sprigs of greenery, a bowl of oranges, and hurricane globes filled with kumquats, and you'll have a sunny room filled with citrusy hues.

Other perennially popular holiday tones are gold and silver. Both instantly create feelings of opulence and glamour. They also complement almost any color scheme. Play with the sparkle of sterling silver against rich, chocolatey browns or the glimmer of gold against spicy shades of orange or persimmon.

Sometimes the simplest ideas have the biggest impact. Decorations don't have to shout. Boxwood topiaries, magnolia garlands, and other embellishments that appear to be made with things that have been freshly plucked during a walk in the woods — or from your own backyard — can make an imaginative statement. Nature has the most incredible sense of color. Take advantage of it and choose organic materials. It's a great way to get "back to the basics" during a season that can sometimes seem dominated by the kind of artifice that is off-putting to our family and guests.

During this time of year, we're apt to have more houseguests than usual, with

Right: For a holiday open house, a wreath of lemons, lemon leaves, roses, and sheer gold ribbon accents this stately doorway.

Below: This intricately carved Mediterranean-style doorway needs little decorative competition. A fragrant wreath of bay leaves and red ribbon is all that is required to make the entrance merry.

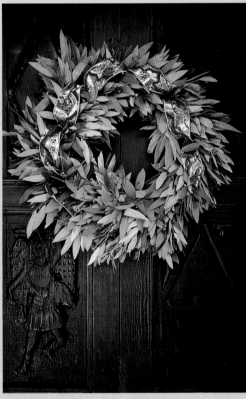

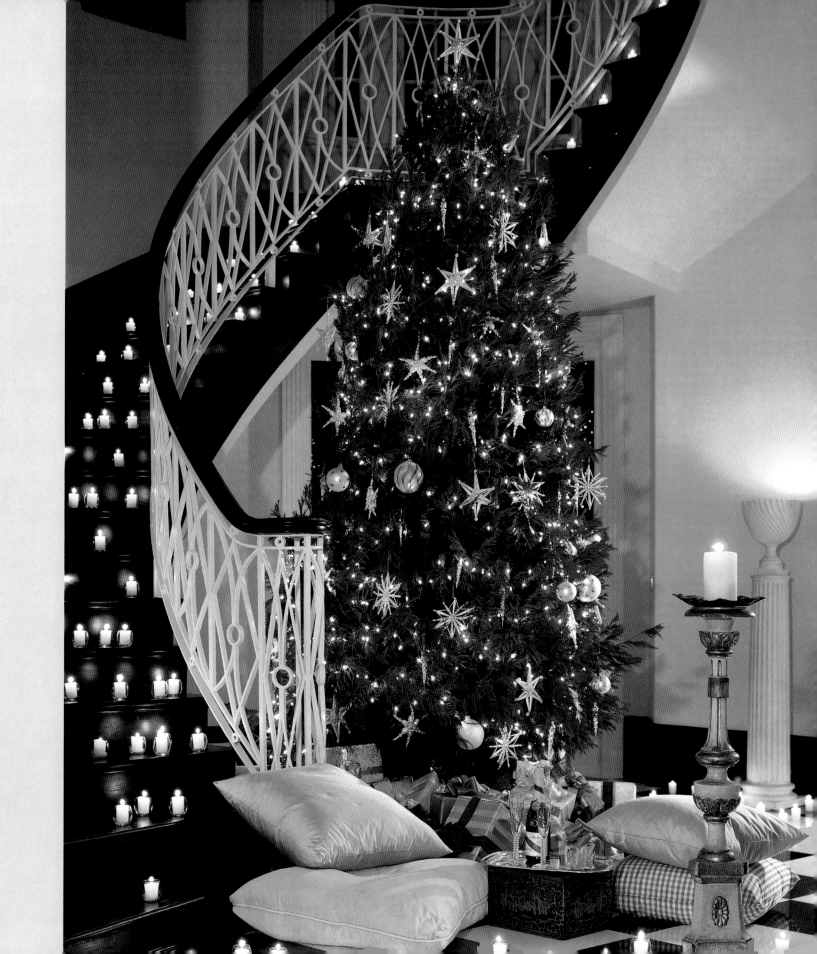

far-flung friends and extended family coming in for a day or two to participate in the holiday revelry. Make them feel welcome and at home. They'll appreciate the little luxuries you can provide in a guestroom, such as fresh flowers, a silver pitcher of water at bedside, or special soaps and candles. Don't leave their rooms out of the merriment. Consider placing a wreath in a window or over the mantel and decorating a fresh tabletop tree, perhaps hung with old family photographs or vintage ornaments. Although the best guests know not to overstay their welcome, with touches like these, at least they will regret leaving.

# Trimming the Tree

No holiday symbol has become more loved and enduring than the Christmas tree. It instantly becomes the major focal point in a room, and it will be the place where family gathers during the season to exchange gifts, sing carols, or simply ponder the magic of twinkling lights. Whether the tradition is to tromp through the woods to cut down the perfect pine or to visit the local nursery to select an ideally formed Fraser fir, the tree will undoubtedly take center stage during the season.

Creating themed trees has become increasingly popular over the years, from the flocked versions of decades past to today's decorator-perfect renditions trimmed with organdy or French wire ribbons and brightly hued balls that tie together interior color schemes. But trees are a highly personal matter, and some of the most delightful ones display specific interests. Perhaps globe-trotters will want to make a habit of picking up a trinket or two from their travels to let the tree serve as a pleasant reminder of a junket through a Moroccan flea market or a seaside stay in a Nantucket cottage. A Birmingham designer who happens to have a large extended family asks relatives to bring their silver baby cups to her family Christmas celebrations. Each cup is tied to the tree with raffia, and the overall effect is of gleaming sterling set off by white lights. It not only looks festive, but it is also a

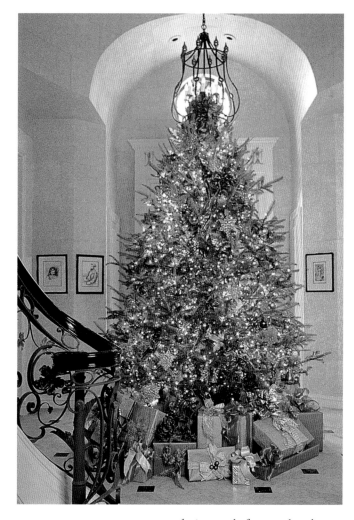

An eighteen-foot Douglas fir decorated in gold and copper ornaments and ribbons lights up this foyer.

distinctive way to incorporate grandparents, aunts, uncles, nieces, and nephews into her holiday decorating. Needless to say, upon birth, each new member of the family is presented with a beautiful cup destined to adorn future trees.

Some of the most enchanting trees harbor a hodgepodge of ornaments that have been collected over time. What could be a nicer tradition than giving an ornament to a loved one each year? If the practice is started with children, by the time they're old enough to celebrate holidays on their own, they'll have an assortment of beautiful baubles that will also evoke memories of Christmases past.

A tree festooned with handmade decorations is also particularly charming and a wonderful way to share the season with little ones. Making ornaments and garlands together not only fosters closeness, it also serves as a useful distraction from the seemingly endless anticipation that children experience during this time of year. Almost every adult can remember classroom projects linking chains made from red and green construction paper and etching angels and snowmen on tinfoil. Pass along the fun and by all means encourage a young person's creativity. If a Charlie Brown–style tree dripping with silver icicles and ornaments crammed on low branches doesn't quite fit into your decorating vision, consider having two trees: a formal one in the living room and a more homespun version in the family room or child's bedroom.

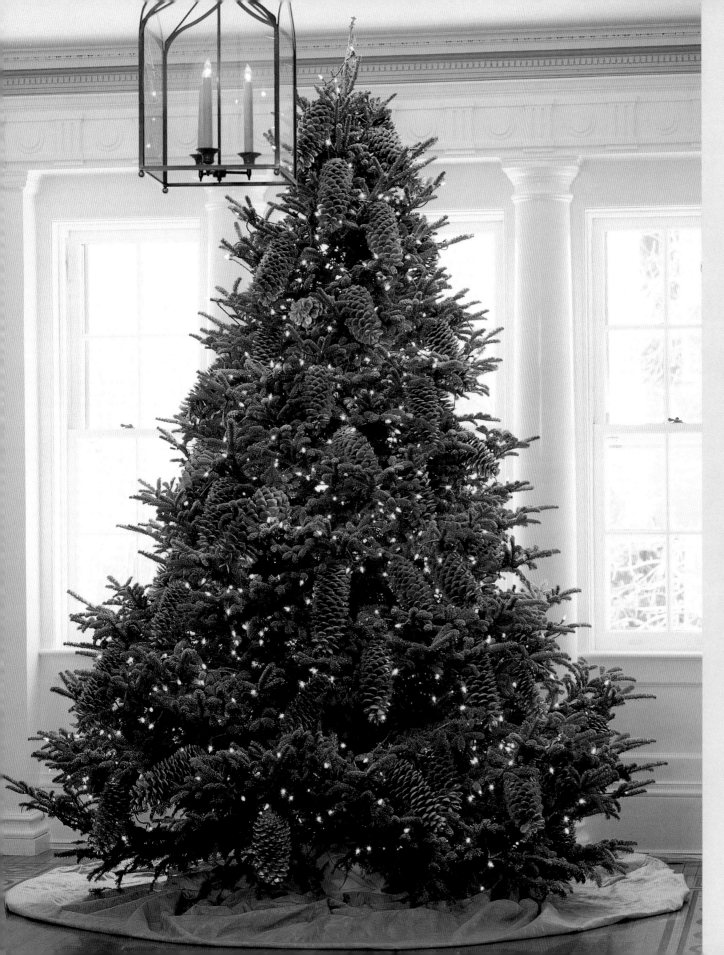

A large tree
trimmed with
oversized pinecones
and white lights
is a natural
for neutral
interiors.

111

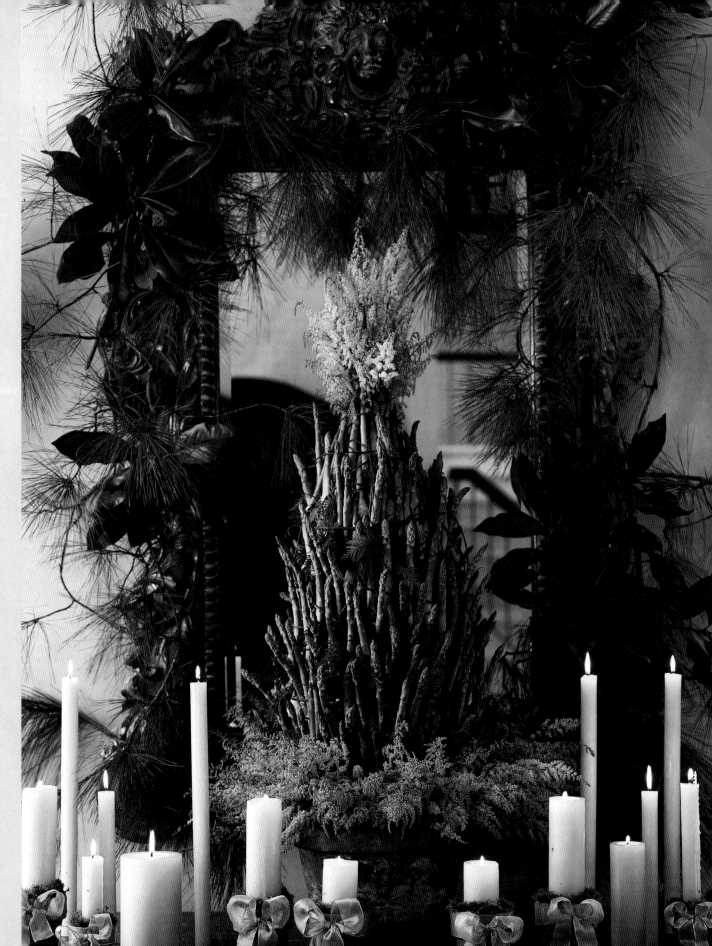

An entry table offers a bounty of fresh asparagus formed in the shape of a Christmas tree. White candles of various heights and widths are arranged on the table, some planted in terra-cotta pots embedded with moss and tied with gold bows.

112

Small candles make a large impact when grouped by color and staggered in varying heights.

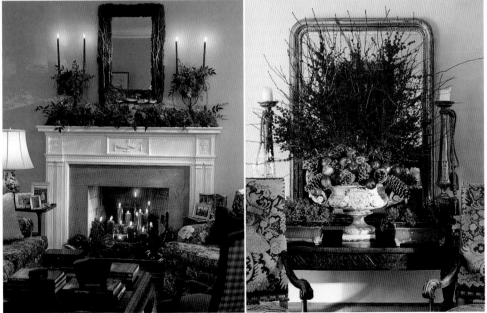

Left: An urn of berried branches, pomegranates, and pinecones stands guard.

Far left: Instead of a yuletide fire, red candles of varying sizes are arranged on logs nestled in a bed of magnolia leaves cut from the yard. The mantel gets a healthy dose of nature as well, with a moss-and-mushroom-covered mirror and swags of nandina berries, moss, and twigs.

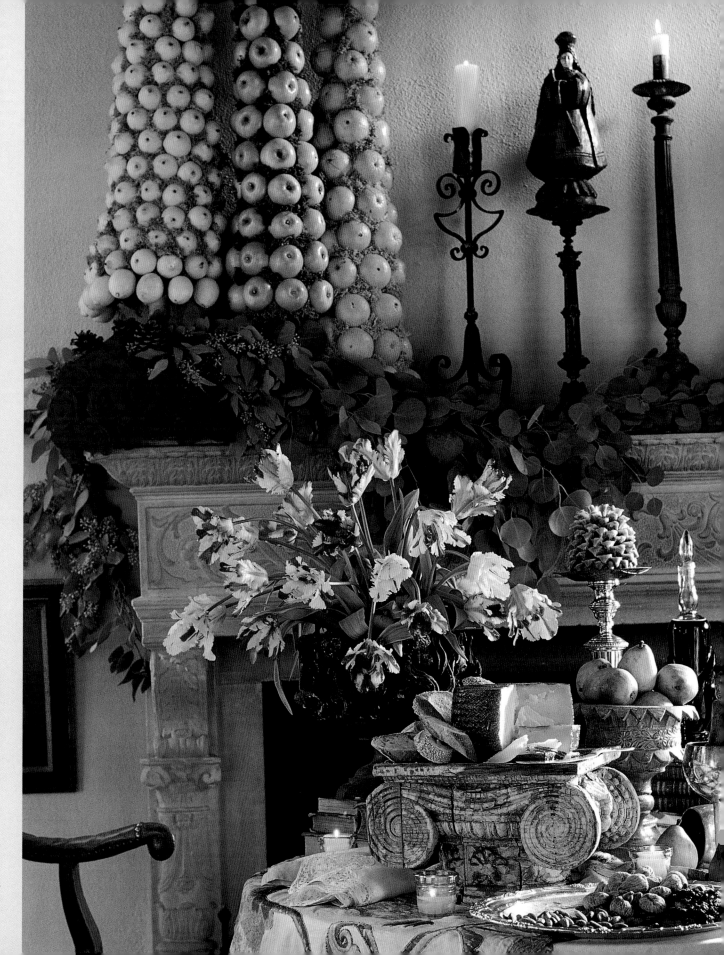

If the hustle and bustle of the season do not allow time for a dinner party, a wine-and-cheese party is much more easily put together. Towering topiaries of lemons, apples, and oranges decorate the mantel, and a table draped in an embroidered cloth is pulled up to the fireplace and set with fruit and cheese. An old column capital is used as a cheese board.

114

# In the Mood for a Party

Lighting establishes a frame of mind and can instantly make or break an occasion. Too much light creates a severe environment; too little light makes it difficult to see through the front door, let alone find your way to the dining-room table. Just the right touch of a golden glow flatters, creates intimacy, and welcomes guests coming in from the cold. The glimmer of lights on a Christmas tree, the roar of a blazing fire, and the flicker of candles placed on mantels, side tables, and dining-room sideboards all create a magical mood.

Scent is also important, as it's the key that unlocks so many of our memories. Just a whiff of apple cider brewing or the smell of a peppermint candy cane can transport many a visitor back to childhood. Pine, fresh herbs like rosemary, simmering spices, and fragrant flowers such as lilies add a welcome aroma. Candles

In Florida, warm weather allows for alfresco entertaining even during the holiday season. Underneath a covered loggia, outdoor furniture is set up for a dessert buffet. A trio of tabletop containers holds pyracantha branches, tulips, and fruits and vegetables, but the real showstopper is a chocolate cake cascading with berries and sugared crab apples.

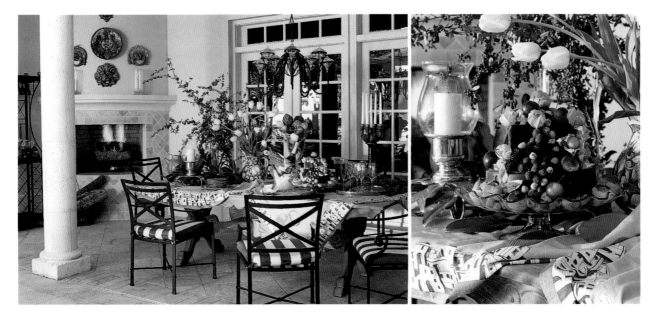

have replaced the ubiquitous potpourri and are an easy way to perfume a living area or powder room. Of course, avoid any overpowering fragrances, especially in the dining room, where they might interfere with the enjoyment of a meal. After all, what could be a more satisfying smell than a turkey roasting or freshly baked sugar cookies emerging from the oven?

## Setting the Holiday Table

When it comes to choosing tableware, there are any number of good-looking holiday china patterns on the market — Tiffany, Spode, and Bernardaud manufacture just a few of the classics. But even a simple white porcelain plate can create a little stir of its own when placed atop a gold charger or upon a bed of magnolia leaves used as a place mat. Bring out the silver — nothing adds more instantaneous glamour — and if there isn't time to polish it down to a perfect shine, remember that patina is in. Just think of it as a way to add character to the table.

Opposite: A twelfth-century Norman hall, transplanted from England to Alabama, provides an especially grand setting. With such spectacular architecture and furnishings, little additional adornment is needed. Simple garlands of greenery drape arches, and a mass of candles on the refectory table creates an ethereal atmosphere.

Right: White and gold are the traditional colors of Twelfth Night. In New Orleans, crowns, swan-shaped cream puffs, and silver and gold almonds revive the custom. The Empire-period Vieux Paris wine cooler decorated with bacchanalian handles, and a towering croquembouche are ideal accompaniments for the masked fun.

Far right: Gold tableware works with almost every dining-room color scheme. This table evokes a conservatory with miniature watering cans, gold-washed terra-cotta pots filled with roses and candles, and a spray-painted birdcage holding a container of lilies of the valley.

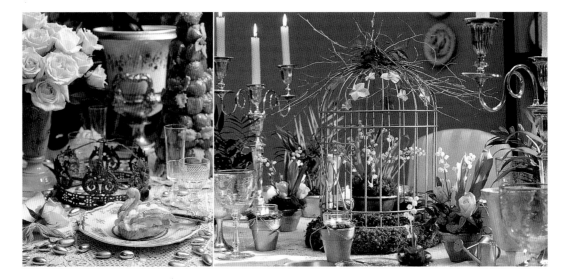

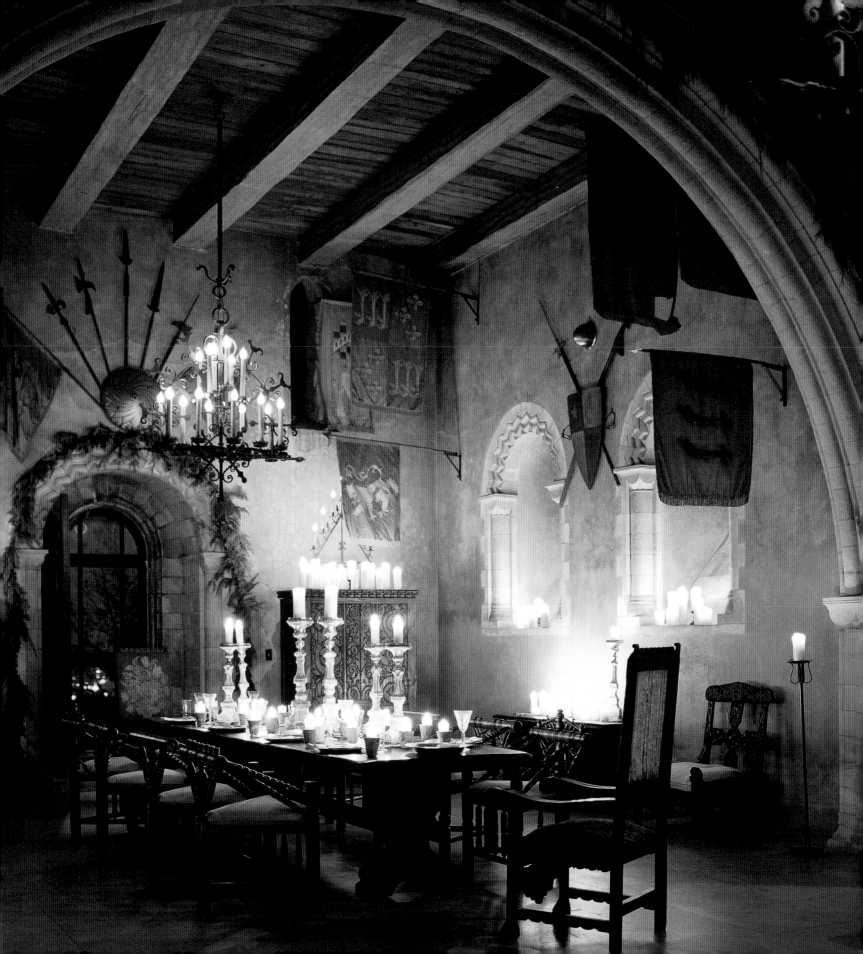

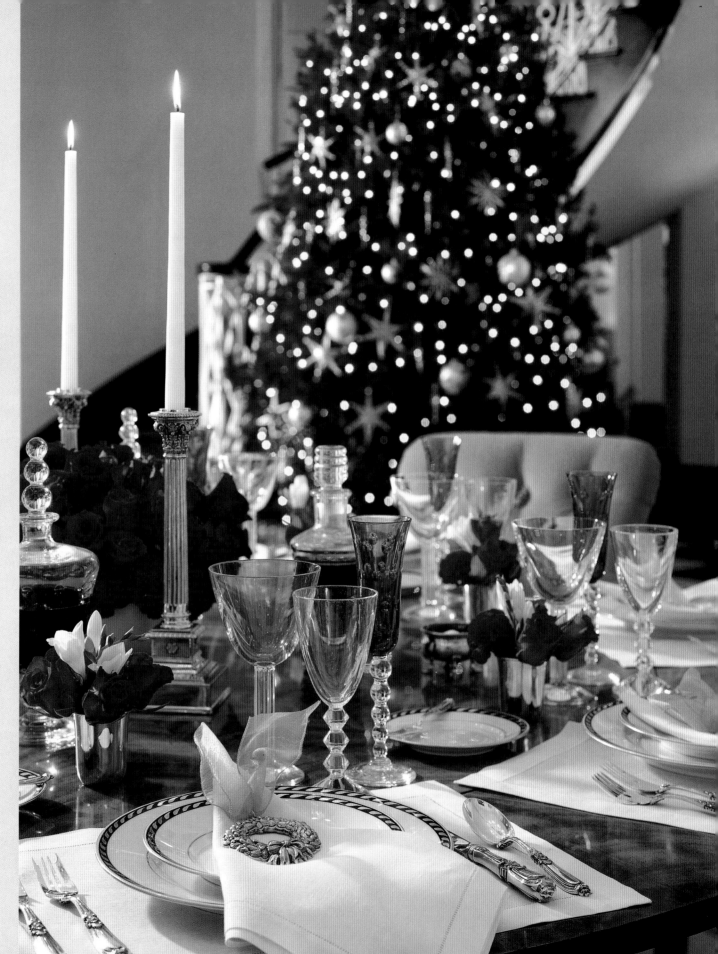

Red and green
dominate many a
holiday gathering.
Here arrangements
of red roses and
cockscomb and
green champagne
flutes contribute
the traditional
color combination.
For a dinner with
friends, providing
small favors, such
as an ornament at
each place setting,
is a generous
tradition.

Holiday entertaining is also a terrific opportunity to use china and glassware that you have purchased from antiques shops and flea markets, and most important, things you have inherited. It seems especially appropriate at family gatherings to carry on using the bone china, sterling silver candlesticks, and etched crystal wine-glasses that have been lovingly used and carefully preserved by previous genera-tions. Often these pieces may be a bit too ornate to use on a regular basis and hence spend a great deal of time tucked away in the back of the closet. But they will look festive on the holiday table. No matter that they are not beribboned with holly and ivy; guests will appreciate the special effort taken to set a table that is both pretty and meaningful.

Nevertheless, for some hosts, the forks, plates, and water glasses will take a backseat to centerpieces and other tabletop decorations. There is a fine line between elegant and over-the-top, but if there is a time for ex-travagance, Christmas is certainly it. If fruit decorations are your passion, no one will look askance at a table bedecked with topiaries of apples, pears, and cranberry garlands, or scooped-out oranges that serve as votives.

Dangle ornaments with satin ribbons from the chandelier, or pile heaps of gold balls in silver bowls that parade down the center of the table. Fill simple glass vases to the brim with cranberries, or string cran-berries around the branches of candelabra to create a festive twist on bobeches. And, if you really love candles, gather a couple dozen, dim the lights, and just let the room glow.

If the dining room's everyday design exhibits a flair for the dramatic, take it to the next level. Contrast

For a dessert party, a *bûche de Noël*, or yule log, studded with meringue mushrooms tempts guests to indulge their sweet tooths.

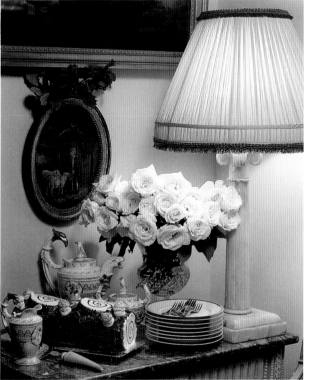

Chinese red or lemon yellow walls with a dash of springtime green by growing ryegrass in small containers, such as terra-cotta pots or silver cups. Sow a few seeds, sprinkle daily with water, and in a week or so there will be a veritable tabletop lawn. We don't expect to find fresh growth this time of year, and guests will love the surprise. Mercury glass gazing balls nestled atop moss heaped in garden pots can add another touch of the outdoors to the table.

When interiors call for a look that is somewhat more serene, elegant touches of gold are especially appropriate. For an interesting way to gild the lily, spray paint an old birdcage gold and insert a terra-cotta container that holds a bouquet of lilies of the valley. Scatter smaller gold-washed pots around the table and use

Opposite: Touches of red in an Oushak rug and Moorish-style screen make this dining room festive 365 days of the year. But for a holiday party, slipcovers dress up the chairs and a long, low centerpiece of wild fruits and berries runs the length of a table set with antique silver, creamware, and gold goblets.

Right: Incorporate favorite objects (and those that you live with every day of the year) into holiday decorating. Blue-and-white Chinese urns are dressed for the season with bouquets of yellow and peach amaryllis, peach tulips, and yellow ilex berries. The springlike palette, a visual surprise in December, is inspired by the room's wallpaper.

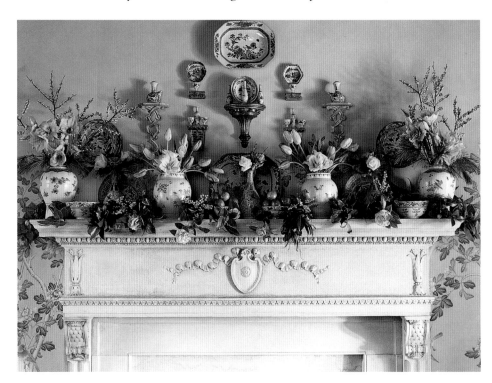

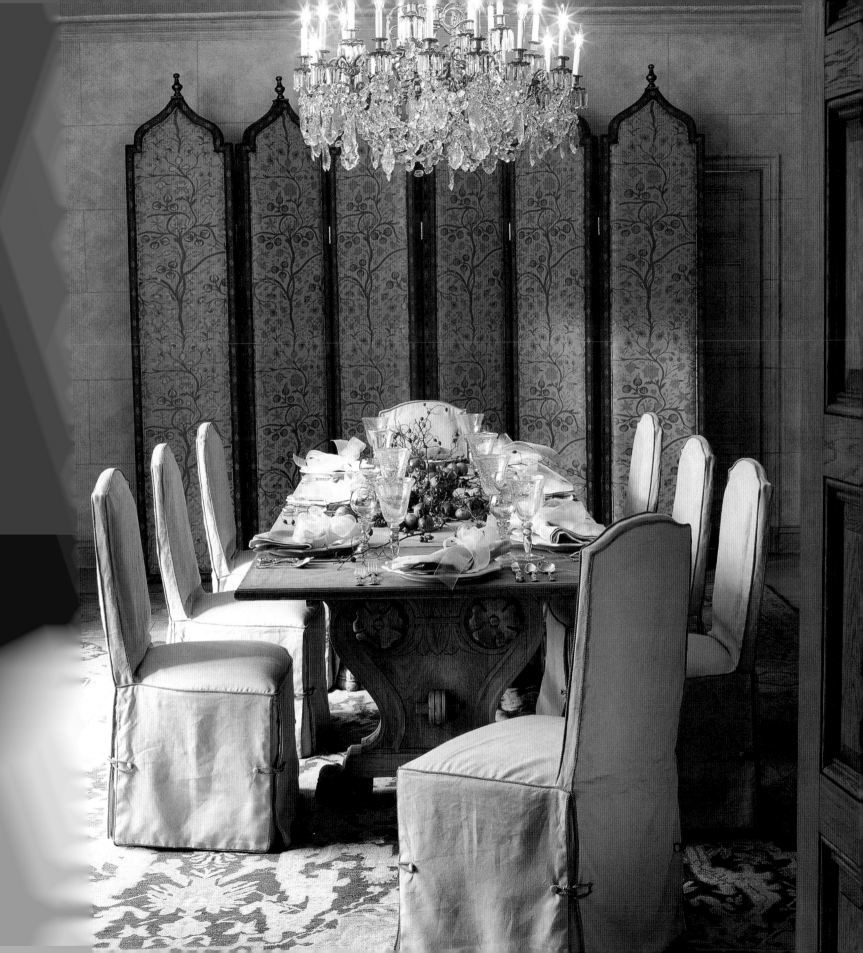

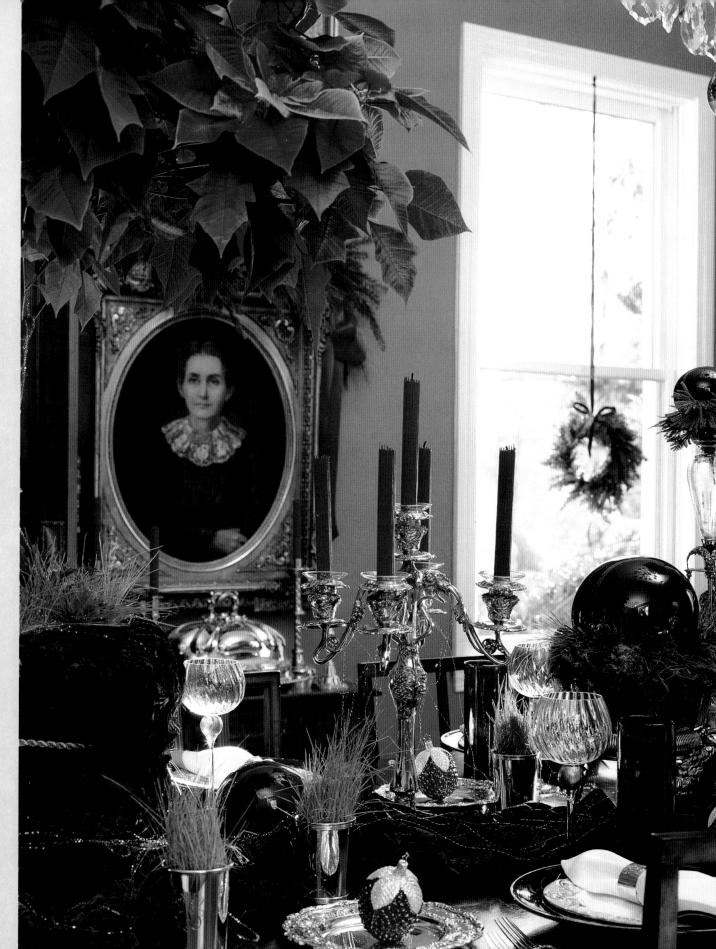

This table includes an unexpected growth of ryegrass sprouting from mint julep cups planted a couple of weeks before the party. The host also plays on the idea of Christmas ornaments by using mercury glass gazing balls on the epergne as a centerpiece, and by placing ornaments on each plate for party favors.

them to hold candles or bouquets of freesia, roses, and tulips at each place setting.

The tradition of giving a gift to each dinner guest is a delightful one. Nothing elaborate is necessary — make it a token that will be a happy reminder of the occasion. It can be as simple as a red ball that serves as a place card when painted with each guest's name in silver. You might take Polaroids when everyone arrives for the party and put them in small frames at each place at the table, or tape the pho-

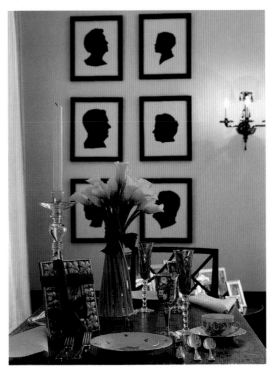

For an intimate Christmas-morning breakfast, calla lilies are tied together with a red bow and placed atop a silver saucer filled with water to keep the arrangement fresh.

tos onto holiday-bordered cards and attach them to the backs of guests' chairs. For napkin rings, tie silver snowflake ornaments with pretty green ribbons around linens and invite guests to take them home to hang on their trees. Or bundle up a small toy or an assortment of candy in a velvet napkin, add a sprig of greenery and a gift tag, and place a package at each table setting.

But if the thought of ornate decorations, orchestrated cocktail parties for a cast of many, or a five-course dinner for twenty makes your blood pressure rise, forgo them. It's often the intimate gatherings and the impromptu parties that are the most memorable. Plan a wine-and-cheese party for colleagues, prepare a pot of chili for a tree-trimming party, or pick up a bottle of champagne and a dessert from the local bakery and have everyone over after a local performance of *The Nutcracker*. Think of your own creative way of extending hospitality and goodwill toward men. And whatever your entertaining comfort level is, just do it.

123

# Holiday Hints

- Bring out the silver and fine china. If there is any time of year to indulge in a little opulence, this is it.

- Don't become so enchanted with the holidays that your home resembles a North Pole workshop. Integrate seasonal decorations into your existing decor.

- Remember your houseguests as well as your dinner guests. Give your guest bedrooms a little holiday cheer with a simple wreath or a small tree.

- Christmas trees should reflect you and your family, so hang heirloom ornaments that you've picked up during your travels, and handmade baubles crafted by your children.

- Plant narcissus bulbs and ryegrass in a white ceramic container. Natural arrangements pulled together from the garden or the nursery will be the most compelling.

- With all of the colors of the season in abundance at the farmers' market or grocery store, a bowl of apples or oranges in a special container may be all you need for an attractive centerpiece — especially if it's accented with a little seasonal greenery.

- Scoop out oranges and fill them with votive candles.

- String cranberries around the candle bases on a candelabra to catch wax and to transform the piece.

- Mass candles on a mantel or sideboard and unify them by color or candleholder material. Use white candles of varying heights to impart a sense of serenity; mix round candles with a collection of cranberry compotes; place tapers in a group of unmatched silver candlesticks for a shimmering tableau.

- Fill bowls around the house with silver and gold Christmas ornaments.

- Create individual floral arrangements in gold spray-painted terra-cotta pots planted with petite flowers, or fill silver pitchers or cups with greenery.

- Christmas balls can also function as place cards when guests' names are written on them with paint pen.

- Make napkin rings with ornaments meant for guests to take home.

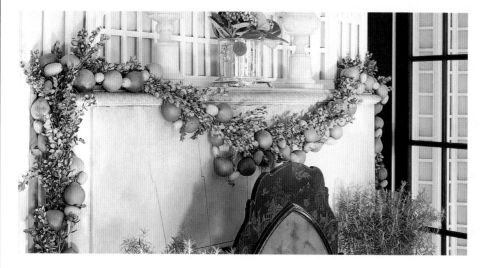

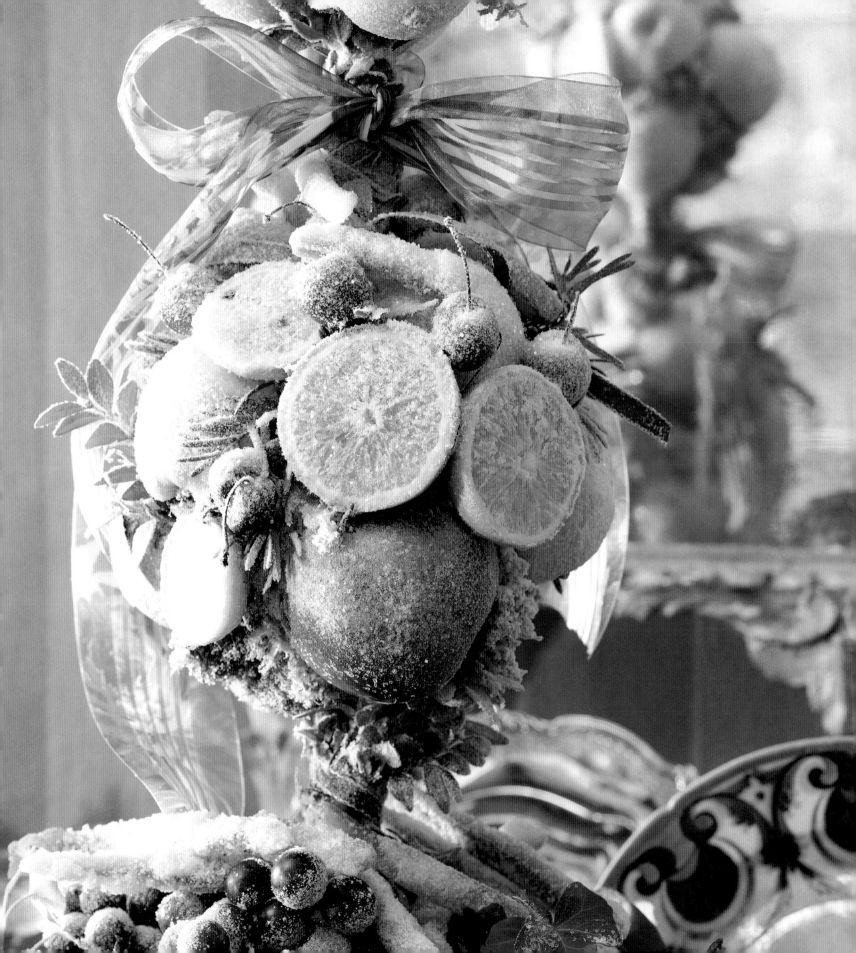

## Chapter 5

# Elements of the Table

Fundamental to the idea of entertaining is a successful presentation that invites guests to admire as well as to partake of a meal. The food to come may be of Michelin-star quality, but it's the decoration of the table that will make the first impression and set the tone of the party. Plates, platters, and glasses need not

Left: First produced in the seventeenth century, opaline glass was meant to mimic the look of expensive porcelain. Today it has its own allure, as collectors seek out pieces like this circa-1840 French candelabra. Right: Though white on white is the most traditional combination for monogrammed linens, royalty often chose red embroidery. Nineteenth-century commoners then embraced the custom, using red for everything from dish towels to damask napkins.

Opposite: These nineteenth-century chrysoprase green vases retain little of their gilt decoration, but that has not diminished their desirability among collectors, who value the intense color and semi-transparent glow.

Below: Antique transfer ware combined with a similarly colored toile de Jouy cloth turns a riot of pattern into a fairly subtle backdrop for intensely colored chartreuse salad plates and greenery.

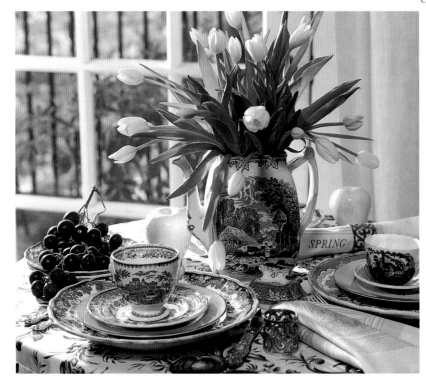

be the finest porcelain or the most delicate crystal, but they should be assembled with care and displayed with pride.

Bridal registries have virtually ensured that most households have at least one complete set of china, flatware, and glasses. But many of us also have bits and pieces, a plate or two of miscellaneous patterns that we have inherited. And pottery and glassware have become so accessible that both new and old plates are likely to fill our cupboards, if not decorate our walls. The idea of combining collections is an old one, and the skill required to do it effectively is constantly being honed by today's hosts.

Table elements aren't limited to dishes, glasses, forks, knives, and spoons. We have changed the age-old idea of setting the table. Now we give place settings individuality and character by using personal collections to distinguish a tabletop display.

For those just beginning to assemble the elements of their tables or looking to expand their collections, it is useful to take stock of what you already have. You'll find that the things you take for granted or overlook on a day-to-day basis can take on new life when added to a table setting — mismatched colored glasses, pottery acquired over the years, aged silver vases, even candles that might make a beautiful centerpiece.

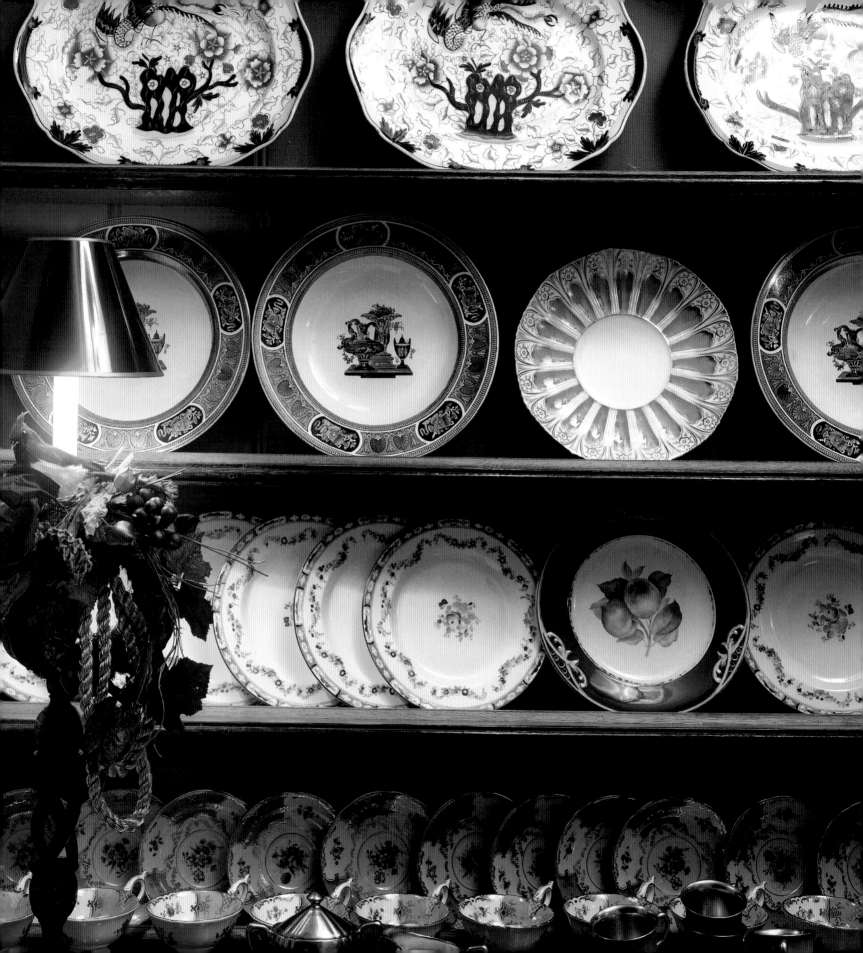

# Plates

Ceramic tableware will set the degree of formality in a table setting. It may be highly decorated porcelain, collectible transfer ware, rustic old slipware, or more contemporary, such as the bone china found in department stores. If you look at the process of setting the table as an opportunity to share your tastes and not as a chore that will be scrutinized, you gain a sense of freedom that results in a creative, personal table.

Combining patterns and colors is a matter of creative preference, but mixing ceramic mediums can be a bit tricky. Porcelain looks terrific with bone china, but rustic pottery dinner plates will never go with a refined Meissen dessert plate. Essentially, setting a table requires a keen appreciation for varying textures and tones. Antique

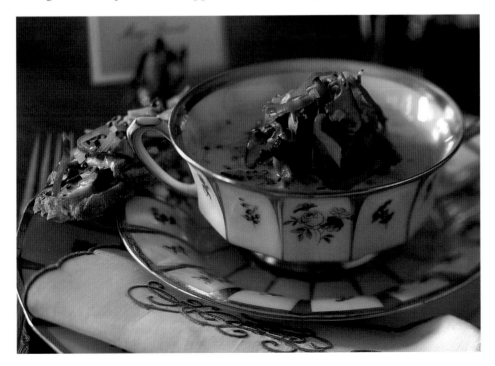

Left: In an era when the trend leans toward paring down, it is a special treat to return to the customs of the past, when gilt-edged, floral-decorated china promised an elegant evening. In fact, current china manufacturers recognize that although simplicity is the buzzword of the day, there is always a place for a little ornamentation.

Opposite: Displaying ceramics invites creative combinations of color and form. From Japanese Imari platters on the top shelf to a Coalport tea set at the base of the Welsh dresser, the plates are always at the ready and also function as one large work of art.

Above: Blue-and-white tableware is as popular today as it was in fourteenth-century China. A dessert plate made in Germany features one of the most popular designs to emerge from the venerable Meissen factory — the blue onion pattern.

Right: A Spode cup and saucer are decorated with transfer printing, a process developed in eighteenth-century England that revolutionized the ceramics industry. Seen on the pieces is the ubiquitous blue willow pattern.

Dutch delft is an early earthenware with a tin-glazed white surface meant to resemble Chinese porcelain. Rustic in texture and saturated with cobalt, these wares work best with other examples of pottery, especially similar glazed earthenware examples from Portugal or Italy.

A single brandy decanter and glass may seem too small to be noticed, but they let guests know that quality libations are not too good to be enjoyed by the host on a quiet night alone.

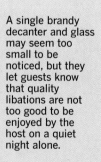

134

pottery, while it often achieved a look that approximates fine porcelain, still has a rustic quality. In fact, it is probably the most versatile of any ceramic because it can be dressed up or down. White ironstone, Italian majolica, and English salt-glazed stoneware are equally at home with brightly polished silver or old pewter vessels.

# Glasses

Ever since the great civilizations — ancient Egypt and Rome — dominated culture, glass has been manufactured and used to make vessels as well as purely aesthetic objects. Since that time, Western civilizations have created different formulas and mastered their own glassware techniques. Murano, in Italy, is known for fantastic, highly decorative wares that were popular as collectibles all over Europe from the sixteenth through the eighteenth centuries and are still prized today. Bohemia, in what is now the Czech Republic, created beautiful colored glasses that captured the fancy of the European and then American upper classes in the seventeenth through the nineteenth centuries. The United Kingdom gained attention for its cut glass and engraved wares during the Georgian period, 1714–1830. And today, companies like Saint-Louis, Baccarat, Waterford, William Yeoward, and Moser manufacture finely crafted wares that will add modern sparkle to a tabletop.

Colored glassware has always been popular, but it will never eclipse clear stemware. Shaded by red and white wines and shaped by smooth lines, crystal wineglasses evoke elegant understatement.

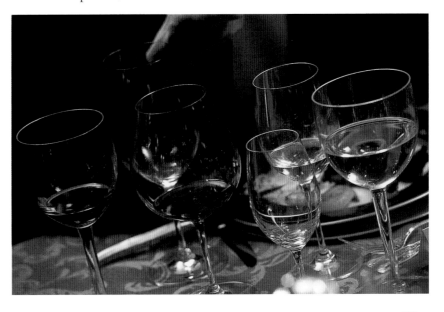

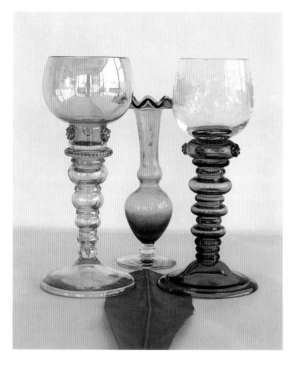

Above: Antique Bohemian and Venetian glass are hotly collected tabletop commodities. Because they are so delicate, it is rare to find an entire matching set. But similar colors can be assembled.

Opposite: Contemporary wine stems, vases, and bowls are tinted with every shade of the spectrum: rose, amber, cobalt, green, and violet, making for a highly imaginative tabletop.

Combining glass and crystal in a table setting has always been fairly commonplace. (The only real difference between the two is that crystal contains lead, which makes it less brittle than glass but also easier to scratch.) Not all the glasses need to match, nor must they be the same color or medium. If you have a set of antique champagne flutes, it is interesting to mix them in a place setting with different patterned wine and water glasses.

Over the centuries, in an effort to distinguish their works and because they often had a hard time achieving the clarity we see in glass today, artisans created colored wares in a variety of shades. Ranging from blue and turquoise to red, pink, yellow, and green, the pieces were as beautiful as they were delicate. Rarely do whole sets survive, but miscellaneous pieces can be found relatively easily at antiques shops.

In more formal table settings, heavy engraved and etched glasses seem most appropriate, but they are not de rigueur. In spring and summer, simplicity reigns supreme, so glassware whose form is light and fluid appears most often. Choose glass and crystal vases that are heavier in weight and appearance during cold months. Consider lining up glass vases along the length of the table and filling them with petite flowers whose height won't obscure guests' views across the table. If vases aren't available, try a collection of drinking glasses.

Vases are not the only glass accessories to show up in the dining room. Chandeliers, whose crystals drip from the ceiling, are another classic element. They add flattering light to a room that should never be illuminated by harsh overhead hundred-watt bulbs (nor should any room, for that matter). To alter the rather predictable, albeit beautiful, look of clear glass baubles dangling from a chandelier, consider colored glass pieces — amber and amethyst are the most popular.

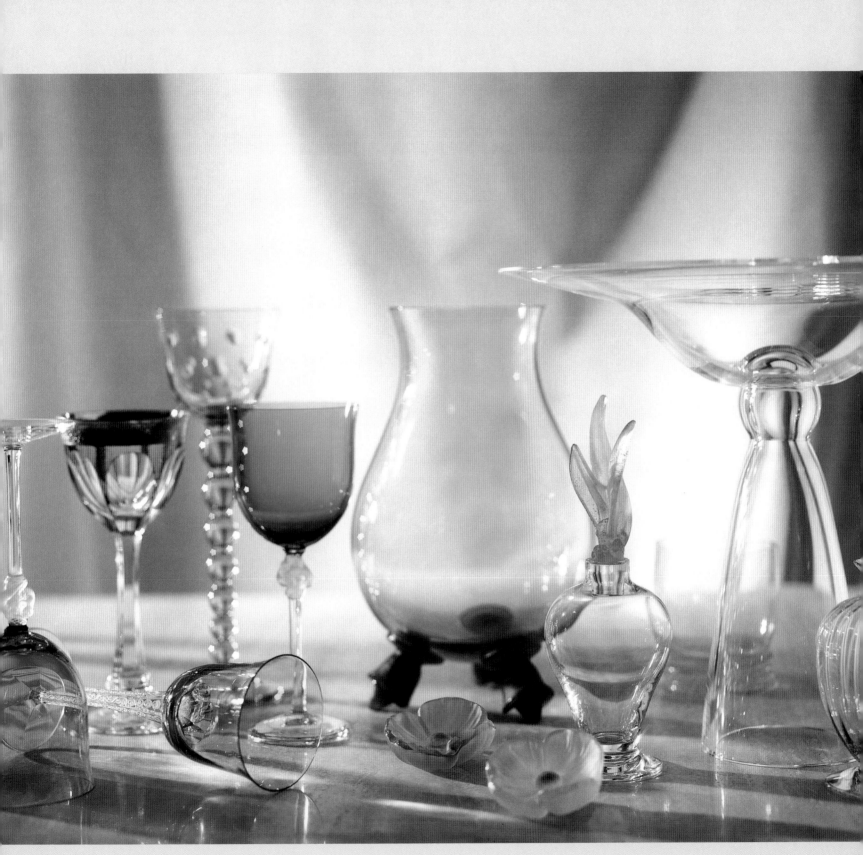

# Linens

The question of whether or not to cover a table is one that hosts have been dealing with for most of this century. If your dining table is beautiful, the prevailing wisdom asks, why cover it? But if your linens are beautiful, why not? Their function is both practical and aesthetic. Tablecloths and napkins protect wood from hot dishes and sweating glasses and provide a backdrop for tableware.

For centuries and in almost every culture, women have been executing detailed designs on woven linen textiles. Made to cover beds, pillows, tables, and people, heirloom linens can often be the first step in assembling elements to decorate a table. Monogrammed or not, damask or batiste, the heirloom varieties are as individual as their makers. Contemporary linens are also attractive, with white examples serving as a background for freshly polished silver and gleaming porcelain. Colored linens seem especially appropriate for more casual situations: Provençal patterned cotton cloths enliven a spring breakfast room, toile de Jouy patterns hearken back to old France, gingham checks complement an unpretentious repast.

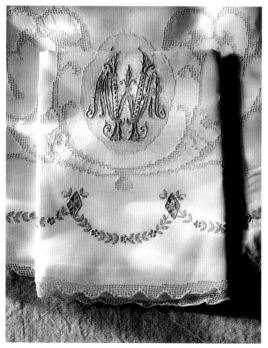

Linens like this batiste napkin and place mat were typically part of a woman's trousseau and thus marked with her maiden initial. Such ornate textiles seem particularly suited to a holiday celebration or an afternoon ladies' luncheon.

Of course, actual linen need not be the only textile that covers a tabletop. Today's hosts are looking through their attics, pulling out old beaded silks, grandmother's quilts, and even colorful kilim rugs to add a little color and dimension to the table. Certain practical concerns do come into play — the fabrics should not be so textured that plates end up sitting atilt.

Textiles serve another function as well. They can turn surfaces other than those used for dining into makeshift serving tables. By covering a gaming table or side table, a desk or a coffee table with a special cloth, you can expand the space allotted for entertaining.

Most embroidered napkins are marked in a corner so the monogram can be seen when folded. Contemporary collectors seek out nineteenth-century textiles more for the quality than the initials, so it is common to see many different monograms atop a table.

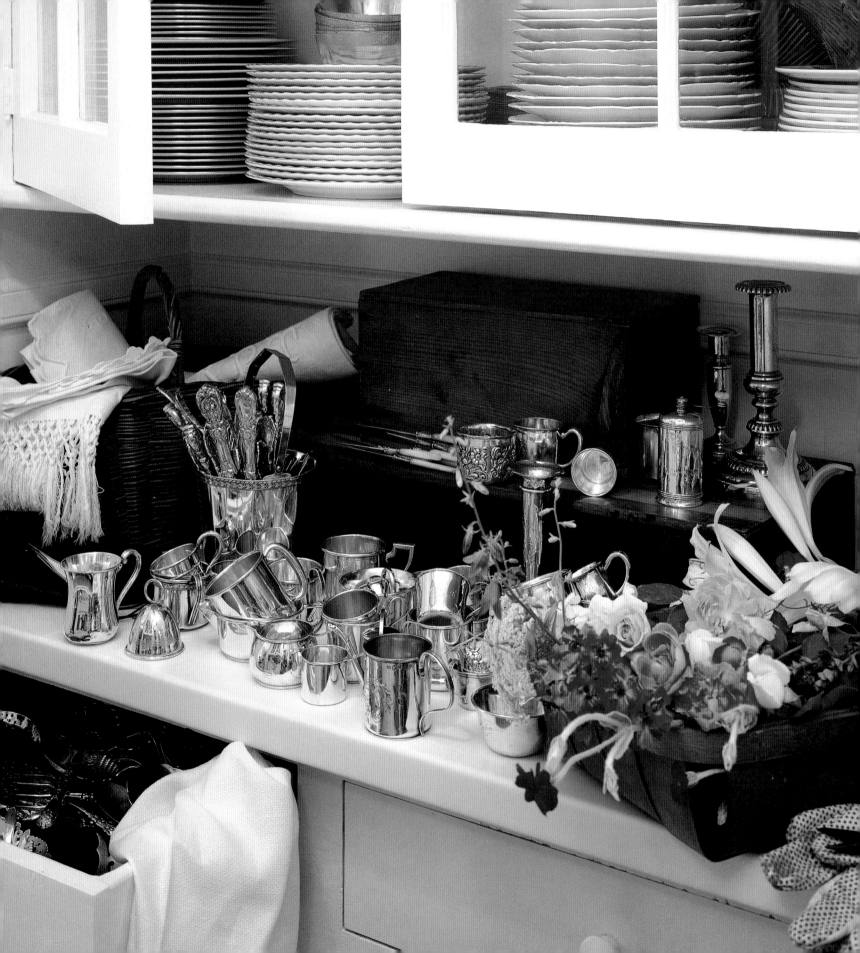

Cloth napkins add individuality to a table setting. In Europe, the tendency is to have ownership of one napkin that is washed weekly. By necessity, all of the napkins are in different, complementary colors so that family members will know whose napkin is whose. The idea can be adapted for a party (with a fresh washing, of course) when table decor is made up of several different shades. But it's best to avoid creating napkin contortions — birds, towers, hieroglyphics, and the like. A simple folded napkin or one loosely gathered in a ring set atop a plate is all that is necessary. Besides, there are so many interesting ways to create napkin rings if you have none of the silver or ceramic variety that it seems a waste of energy to fold a napkin to the degree that it shifts the focus away from the table arrangement as a whole.

## Serving Pieces

Serving pieces have been favorite and necessary table elements for centuries. Past modelers of ceramics made tureens that evoked the soup they were intended to hold—for example, a tureen for boar's-head soup with the steam escaping through the nostrils of a ceramic boar. Silver tureens often sported elaborate family crests, and their lids were topped with finely crafted details. Then as now, platters either matched the plates atop the table or complemented them.

Laden with food, serving pieces have their own obvious allure as centerpieces. But when a traditional container is transformed by a floral or fruit arrangement, the look is entirely different. Instead of using vases, fill a tureen with fall flowers or a platter with a spring arrangement. The pieces themselves will be interesting enough so that only the simplest floral composition is necessary.

Today's table settings feature all sorts of metals sharing space, but it is important to keep a few things in mind. Silver, by its brilliant nature, seems most appropriate among other fine pieces, such as porcelain, but it can also work in a modest setting. In fact, it is the form of the silver that most determines the formality of the table. Ornately engraved and chased serving pieces are almost too heavy to grace

Opposite: A collection of silver can serve a multitude of functions, from decorating the Christmas tree to adorning a table. But one thing is certain: en masse, the effect is unforgettable.

simple tables. Cleanly molded pieces are more versatile and will be as at home on a farm table as on a well-dressed sideboard.

Because silver is such a long-standing tabletop accessory, it can easily become predictable. To avoid that pitfall, you might consider using your silver in innovative ways. Put a bouquet of flowers in a tea- or coffeepot. Use silver cups or chalices at each place setting to hold individual floral arrangements rather than letting one central arrangement provide all the color. A silver Revere bowl can hold floating candles or a simple mound of pears.

Displayed on a sideboard, bowls, samovars, and tureens can function on their own as works of sculpture. A platter hung on a wall with a collection of plates can take the place of a painting and underscores the fact that you are in the dining room.

## Utensils

Called flatware to distinguish them from hollowware pieces, utensils will always be metal, and most often silver. Today, people are collecting a variety of patterns, so setting a table is less regimented and therefore more interesting. Metals other than pure sterling are being collected and displayed in a way that makes them both easy to use and attractive. Pewter spoons may be arranged on the shelf of a hutch; hotel silver may be massed in cylindrical glass vases; coin silver spoons may be set next to knives with stainless-steel blades.

However, stainless-steel flatware rarely works next to silverware because of the striking difference in their patina and craftsmanship. But table settings that combine

Nineteenth-century ironstone pieces, such as these sauce and soup tureens with smooth finishes, graceful lines, and pure forms, are especially suited to the current taste for neutrals.

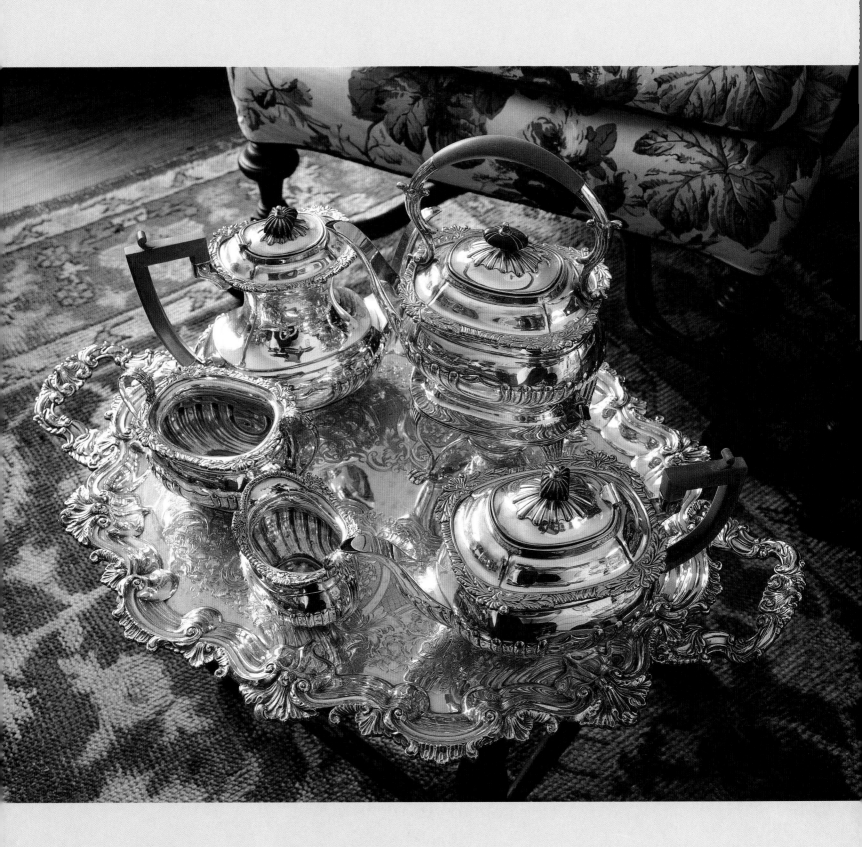

your finest china with stainless steel, or your everyday pottery with antique silver will create a look that celebrates unlikely pairings. The inconvenience of polishing silver on a regular basis often banishes it from the table for all but the very best occasions. That is unfortunate, for silver used on a regular basis will keep its shine better than that used only rarely.

## Condiments

Salt and pepper, sugar and cream, mustard and nutmeg not only add flavor to food, they also come with interesting accoutrements. A table should be outfitted with condiments suited to the meal that will be served. Traditionally, salt is dispensed from a shaker or a cellar, and both can be as pretty as they are useful. No guest will want to constantly reach for the salt, let alone indicate to the host that not enough salt was added to a particular dish. So invest in a few sets of salt and pepper dispensers. Individual salt cellars, particularly the types that have cobalt glass bowls, are very collectible.

Spices such as cinnamon, nutmeg, and the like all have their own special containers. Cinnamon casters, nutmeg graters, and mustard pots let guests sprinkle or spread their own toppings on a cup of cappuccino, a serving of sweet potato pie, or a slice of country ham. Each container's purpose is specialized, but many are versatile and can hold other condiments if the need arises. Be wary, though, of too many unique containers for flavorings that will only clutter the table and confuse your guests.

## Menus and Place Cards

For a special occasion, when the meal promises to be as rich as it is complicated, menus are decorative and also helpful. Displayed in menu or place-card holders or laid atop plates, they invite your guests to take part in a meal and anticipate the courses to come. Antique holders for menus are hard to come by, but

Opposite: This antique English tea service is part of a silver collection that was assembled after many antiquing trips. Placed atop a tea table, an ottoman, or a sideboard, the service adds elegance matched by few other tabletop accessories.

Below: An invitation may be simple, or decorated with the same motifs and colors that will be used at the party. It should be special enough to be used as extra ornamentation on a side table or gift table.

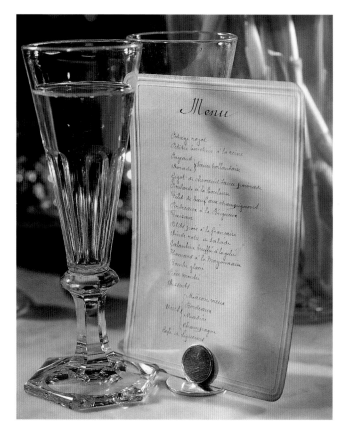

Menu cards have an obvious function, but they can also be attractive tabletop accessories.

they add a touch of history that may be particularly appropriate on an antique-laden table. Menu cards do not have to be stationed at every place setting. For a meal in a wine cellar, you might prop up a blackboard on which the food course is noted next to the wine to be served. Or one menu may sit in the center of the table or atop a sideboard or buffet. There is no need to have menus professionally printed. Handwriting is a classic touch that lets your guests know how personally involved you were in every aspect of the party preparation.

Similarly, place cards make an often difficult political situation easier. Decide in advance who will sit where. Guests will be grateful (or, if not, the long-practiced game of switching the place cards will keep them occupied). In order to indicate assigned places, purchase place-card holders or place cards that are folded so they can stand on their own. You can also attach place cards to party favors or tie them to napkins or around flatware atop each plate. Generally there is no real reason to provide place cards for a gathering of fewer than twelve people.

## Candles and Candelabra

Candles are often taken for granted because they have traditionally been white paraffin tapers used in silver candlestick holders — a pretty look, but a predictable one. Increasingly, candle manufacturers are introducing new shapes, sizes, and colors. Selecting candles is mostly a matter of preference, but there are a few things to keep in mind when it comes to showcasing them.

A French compote shows off the softer side of opaline glass, with delicate pink beads embedded within and dangling from gilt vines. The crimped rim is characteristic of opaline glass that was manufactured in the 1860s.

With so many accessories to put atop a table, it's often refreshing to opt instead for simplicity. Here, a minimalistic look is achieved with brushed-metal bowls filled with water and floating candles.

148

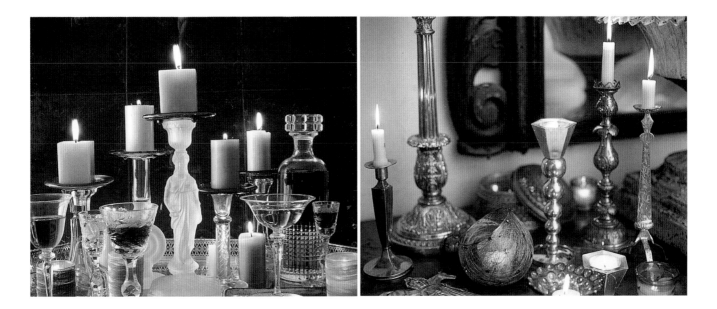

Although tall floral arrangements are verboten, tall, slender candlesticks are not, as they will not block your guests' views across the table. Mass shorter, stocky candles that can stand on their own for a powerful centerpiece. Choose colors that will complement one another or use all one color. Consider different shapes and heights as well.

Never use candles on the table before 5:00 P.M. (their purpose is to cast a flattering glow across the room — an effect that can't be achieved in broad daylight). Before the party, blacken the wicks. And be aware of fragrance during meals. A vanilla-scented candle and roasted lamb do not make an appetizing combination. In fact, try to avoid scented candles in the dining room altogether.

Above: Silver — whether a votive, candlestick, or wire-mesh ball — is a classic complement to candles because it reflects light so radiantly.

Above left: Neither candles nor candlesticks have to match to create an intoxicating balance when displayed on a silver tray with liqueurs.

# Ceramics

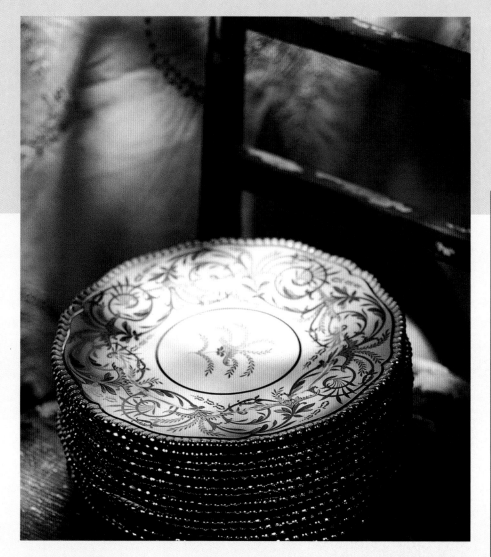

The term *ceramics* describes pottery and porcelain, of which there are many subgroups. Only serious collectors concern themselves with the specifics. For decorating a table, aesthetic distinctions are the most important.

**Pottery** encompasses most ceramics made since the beginning of civilization. Made of different clays and fired at a relatively low temperature, pottery looks rougher than porcelain and china.

**Porcelain** was first produced in China and is most often associated with blue-and-white wares that were exported to Europe from the seventeenth century onward. In the eighteenth century, a factory at Meissen, Germany, discovered the formula for hard-paste porcelain and became the undisputed leader in European porcelain production.

Other European factories, such as Sèvres, in France, and Spode and Worcester, in England, developed soft-paste porcelain wares that approximated the look of the hard-paste pieces made in China and Germany but lacked the same clarity and translucence. Still, both types of porcelain are very popular among die-hard collectors and those with an appreciation for craftsmanship and beauty.

**Bone china** is created out of bone ash to approximate the look of porcelain but much less expensively. Today, most contemporary ceramic tableware is known simply as china. (The term is often incorrectly used to describe porcelain and pottery.)

Scalloped and gilded Spode plates from the 1920s sit on a chair, offering an alternative to the stack usually placed at the end of a buffet table.

150

# Silver

**Sterling silver** is widely considered the finest silver alloy because of its high percentage of silver, 92.5 percent. While higher percentages do exist, sterling is the most available and the most thoroughly regulated, with a system of identification and hallmarks that makes faking new or antique pieces virtually impossible. The system was set up in England, and most antique sterling made before the nineteenth century comes from that country.

**Sheffield plate** is the best known and most highly regarded silver plate. First made in England in the eighteenth century, it is exceedingly expensive today, and prized because of its rarity and patina. It is made of a silver layer over copper, and most pieces have a slight coppery hue, as the silver has worn thin, revealing the copper underneath.

**Coin silver** refers to most antique silver that is not 92.5 percent silver to copper alloy. It was made in the United States in the mid-nineteenth and early twentieth centuries. Similar in appearance to sterling, it is often recognized by its pattern of decoration (sheaves of wheat, baskets of flowers, etc.), markings (that identify maker and retailer), and monograms (usually indicating the initials of first owners).

**Silvered glass**, often called mercury glass, is actually hollow glassware filled with silver nitrate. Popular among the burgeoning middle classes in Europe and the United States in the eighteenth and nineteenth centuries, it is still being manufactured today. Although the value of the pieces cannot compare to that of silver metal wares, it is still collected because of its brilliance and easy maintenance. No polishing is required, since the silver is encased within the glass.

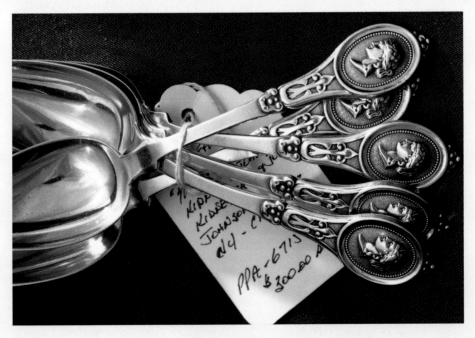

American coin silver from the nineteenth century is prized by collectors today. These spoons feature medallions on their handles, a particularly sought after type of decoration.

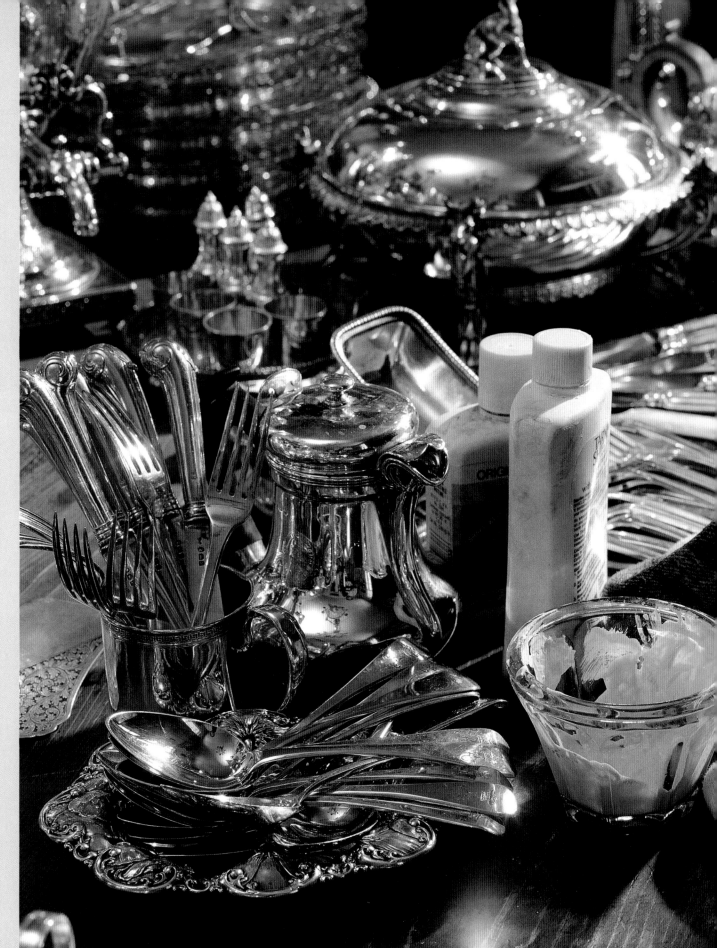

Although silver doesn't require weekly polishing, it occasionally needs special treatment. A quality cream polish should be used rather than a clear dip, which can wear the silver.

# Caring for Tableware

- Frequent use of silver actually means that it has to be polished less frequently. Don't save the sterling for one or two meals a year; pull it out and use it often.

- Rinse silver implements that have been used in mayonnaise, salad dressings, and other salty or egg-based foods immediately to avoid the tarnish and corrosion caused by salt and sulfur.

- Sterling is best washed by hand, but if you must use a dishwasher, do not mix silver with stainless steel, as the interaction between the two metals will cause unremovable black spots.

- The luster and fine lines that come with frequent use of sterling are desirable, but to avoid major scratches, dry pieces with a soft cloth. When you begin to notice tarnish, use a mild soap, like Ivory, to clean the piece. This will restore the shine. If you must polish, use a cream substance rather than a clear liquid dip. Polishing is hard on silver, but the dip is harsher. Every time you polish, you are removing a layer of silver.

- Silver should be stored in a "pacific cloth" specially designed for silver care. Silver should be kept out of the air for optimal preservation.

- Rinse china immediately after you have used it. Much of it can be washed in the dishwasher unless it has a metallic band, but it is always best to err on the side of caution. Dry china with a soft cloth.

- Ceramic plates and other wares should be packaged individually for storage. Alternatively, stack them with felt liners between each piece. Cups should be hung from hooks and not stacked atop one another.

- Never put a piece of china with a metal rim in the microwave.

- Avoid abrasive sponges on ceramics or glass. Use water that is warm, rather than hot, on crystal.

- When hand washing especially fragile glassware, line the sink with towels or rubber mats to avoid breakage.

- Soak glasses with stains in white vinegar and water for one to ten days, or rub them with a halved lemon.

- Store glass and crystal in a space that is well ventilated and has no temperature extremes, with enough space between pieces to ensure that they will not knock against one another.

- When washing cotton table linens, avoid using hot water or a hot dryer, which might shrink them.

- Iron damp linens dry (back side first) on a medium setting, or store damp linens in a plastic bag in the refrigerator or freezer until you have time to iron them.

- Armoires, sideboards, and blanket chests make good storage solutions for linens. Put cloths in a place where you can get to them easily. Fragile heirloom linens should be stored in acid-free tissue paper.

- Fold linens loosely so they won't crack along the crease lines, and refold them differently every time to prevent permanent creases.

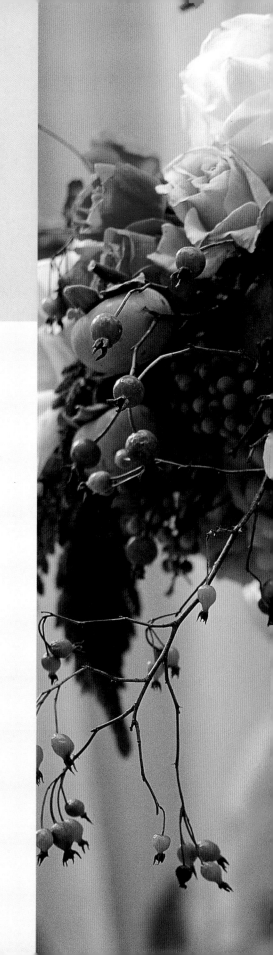

Chapter 6

# Flowers

Is there anyone among us who doesn't love flowers? Since the beginning of time, flowers have provided poets and painters, artisans and gardeners, and other people of all ages with an endless supply of inspiration. Children make wishes and blow the wisps off dandelions — much to the dismay of their weed-weary parents. Teenagers faithfully

Left: A cobalt water goblet spills over with parsley, oregano, and white bee balm. Right: A special dinner party often calls for an over-the-top arrangement, such as this alabaster epergne filled with roses, pomegranates, and amaranthus. Though abundant, the centerpiece is above eye level, allowing guests to converse easily.

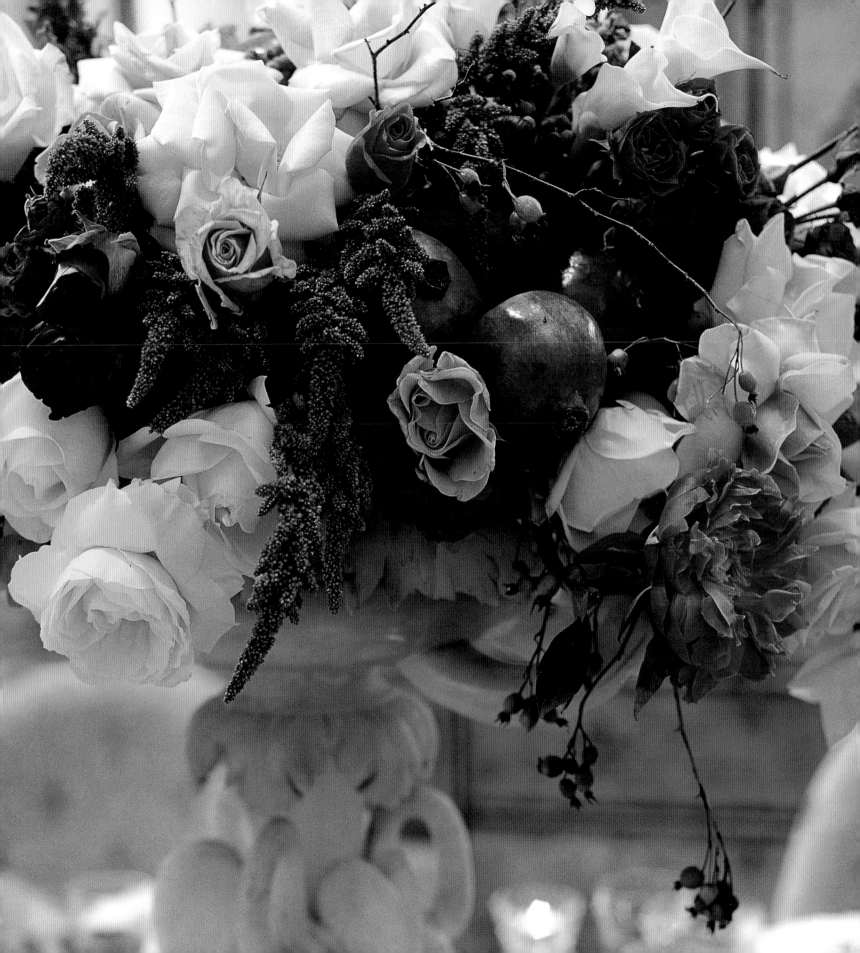

pluck the petals off daisies in a hopeful game of "Loves me, loves me not" and squeal with delight at the arrival of their first prom corsages. Adults know a bouquet of fresh flowers will provide cheer to a hospital patient, send a message of romance to a prospective love interest, and signal a festive party in the making.

Within the last decade or so, getting our hands dirty — in the soil, that is — has become all the rage. Perhaps it's our desire to reconnect with the earth in the era of the information superhighway. Glossy garden books and magazines devote pages to planting herbaceous borders and propagating heirloom roses. In practically every city, stylish shops have sprung up as an alternative to nurseries and proffer wares that range from utilitarian tools and hardy waterproof clogs to ivy topiaries and iron lanterns. Hence, you can now find everyone from Wall Street barons to soccer moms tending rooftop terraces, cutting gardens, and backyard vegetable plots.

Our desire to bring flowers inside, not only for special occasions but also for day-

A parade of diminutive herb arrangements livens up a kitchen windowsill. Rosemary, tarragon, and parsley not only look charming, they're also within easy reach of the cook.

to-day living, is a natural outgrowth of our passion for gardening. A touch of spring green foliage or a vase of snapdragons will always be welcome in our homes. In fact, for many people, flowers are not a luxury but a necessity, perhaps ranking just a bit below food, water, and shelter! Granted, the majority of us will not have full-blown Flemish-style arrangements as a matter of course. Life, after all, isn't always a bed of roses. But a loose handful of hydrangeas or a branch or two of dogwood may be all it takes to satiate our desire for an indoor communion with nature. Flowering potted plants can also do the trick. A Phalaenopsis orchid, whose price tag might seem a little dear at first glance, will last a month or so and provide boundless pleasure with its striking blossoms.

Below: The swirling colors and pattern of a rustic pottery vase cue a palette of purple and white.

Above: Pineapple mint sprigs in an old tin cup add a touch of welcome at a front door.

Left: Casual flowers and elegant containers provide an interesting juxtaposition. On a sideboard, an heirloom silver compote dresses up an arrangement of greenery freshly gathered from the garden.

157

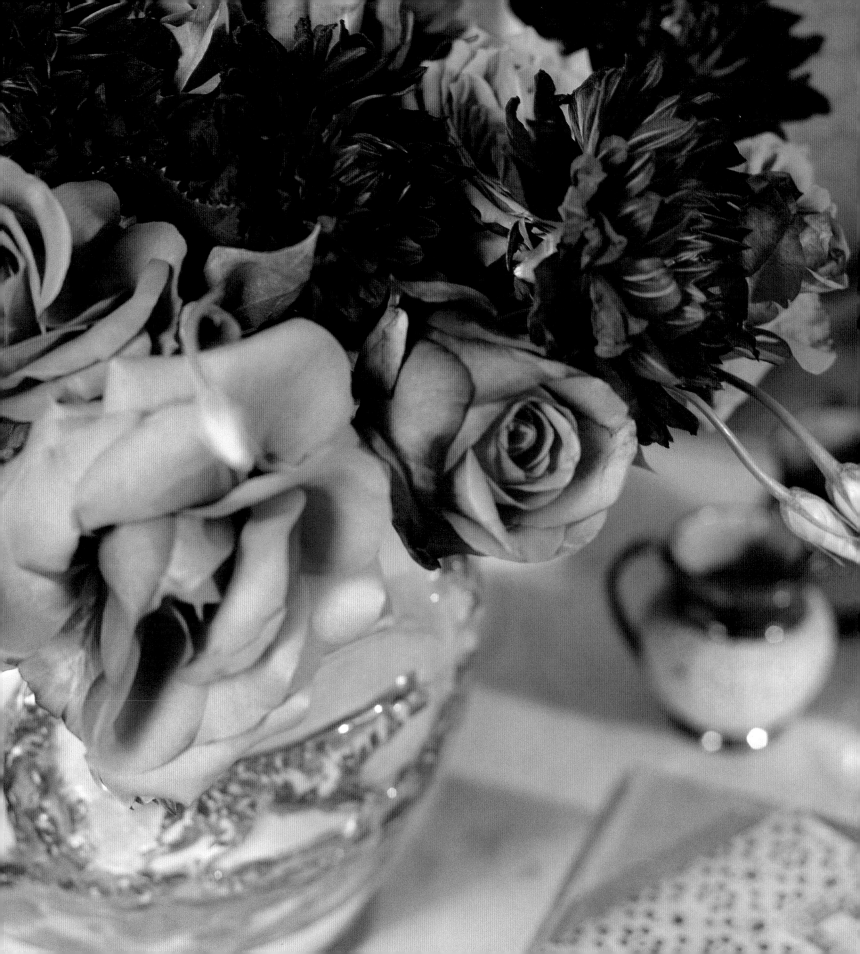

The variety of flowers to choose from is seemingly endless, limited only by seasonal availability — and even that can be overcome by working with a floral designer who has access to a worldwide network of growers. Some flowers have been degraded by commercial tricks (think of the horror of carnations dyed green for Saint Patrick's Day) or overexposure (mums, gladioli, and baby's breath come to mind as being currently out of vogue). But when it comes to flowers, as in most things, individual taste rather than fashion should be your guide. Roses, tulips, and hydrangeas are beloved by almost everyone; however, any flower can be appealing when viewed in its natural environment or arranged in an unaffected way. Fresh, seasonal blooms add a look that is always appropriate, and there is no more instantaneous way to dress up a room.

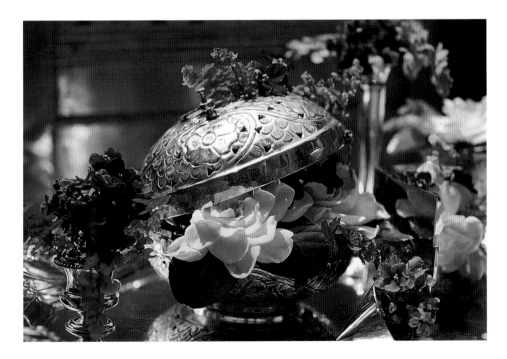

Above: A few stems of cut orchids, placed in a pretty container such as this silver-overlaid vase, add a simple but extravagant element to a party.

Left: Unexpected collections can double as floral containers, such as a Chinese purse arranged with gardenias and vanity trinkets filled with violets.

Opposite: Shades of the same color easily tie together a mix of flowers. Here, a lusterware pitcher holds roses, tulips, and dahlias in varying degrees of pink.

159

# Containers

With a little imagination, just about anything in the house can become an anchor for flowers. The container and the flowers go hand in hand and should complement one another, so choose a vessel that is appropriate for the form, color, and scale of the bouquet. It's generally not appropriate to put modern-looking calla lilies in a lusterware pitcher, any more than it is to put delicate tea roses in a black-and-white striped vase. Take proportion into consideration. Flowers such as violets and lilies of the valley will get lost in a large container, while long-stemmed roses or hollyhocks will overpower a little one.

Large arrangements in garden urns or tall cylindrical vases may be suitable for entryways, mantels, and consoles — but not for the dining-room table. Smaller

arrangements work particularly well on a cocktail or bedside table. Their portability allows for easy movement from room to room, wherever a spot of color is needed. A romantic might choose a tea caddy to hold pink and orange dahlias, fill the creamer and sugar bowl from a Georgian silver tea service to the brim with pink roses, or find a bouquet of purple violets just the right size for an antique Minton teacup. An etched wine goblet or Victorian lemonade cup that has been relegated to the back of a cabinet due to a chip on its rim can have a second life as a container for petite arrangements. If you prefer Asian-inspired furnishings and fabrics, chocolate cosmos arranged in white Chinese takeout cartons impart a sense of humor.

Floral shops understand the appeal of storing flowers in galvanized metal buckets. It provides an easy way to keep flowers fresh before arranging them, but it also communicates a feeling of effortless bounty. The buckets look right at home when

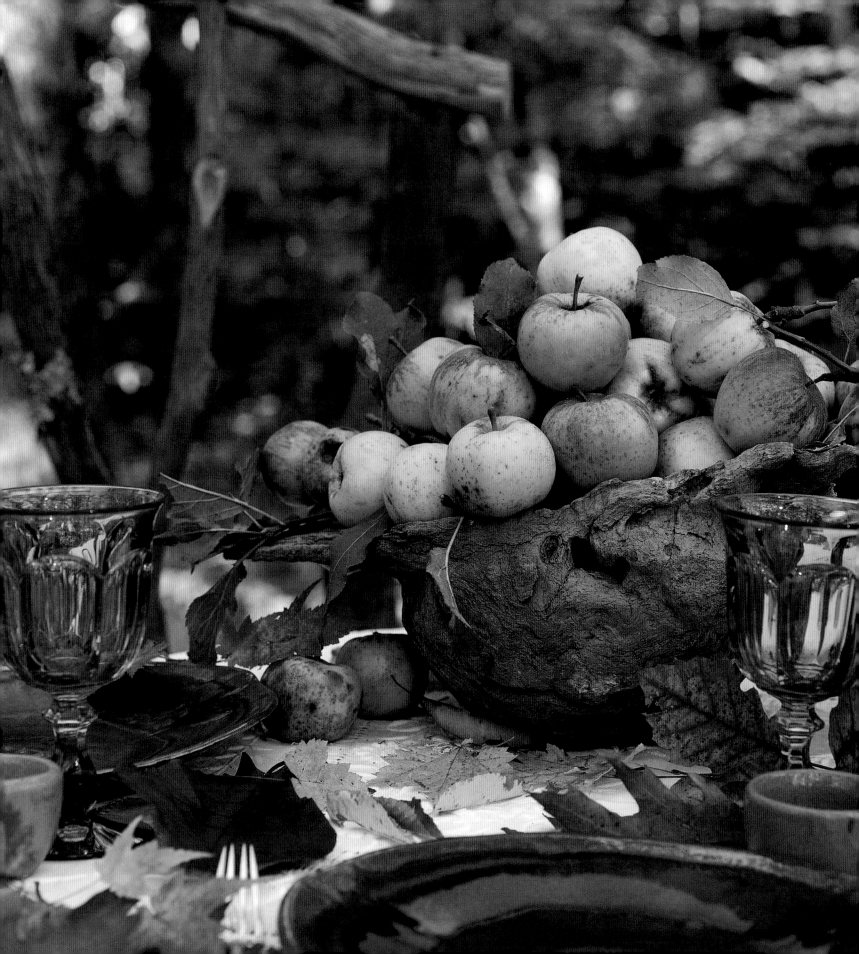

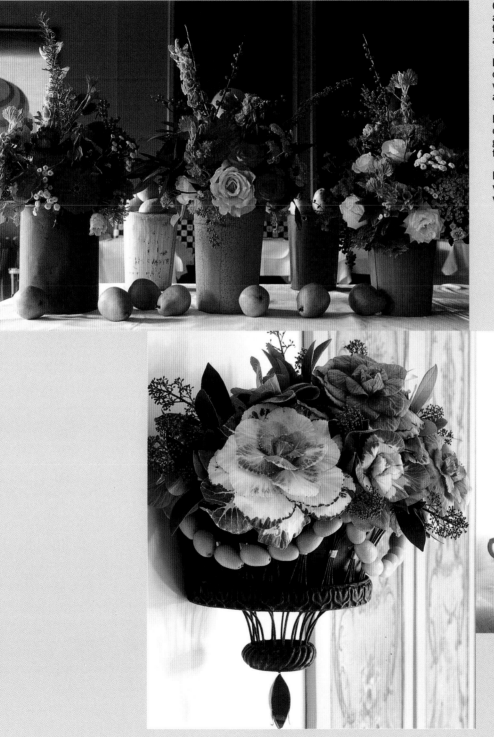

Opposite: Fallen leaves and a basket of apples are all that is needed to decorate an outdoor table in autumn.

Left: Bartlett pears surround colorful sap buckets filled with gerbera daisies, roses, and bells of Ireland.

Below left: Ornamental kale, orchids, and a kumquat garland dress up a sconce for a party.

Below: A nineteenth-century vegetable box finds a new vocation as a planter.

163

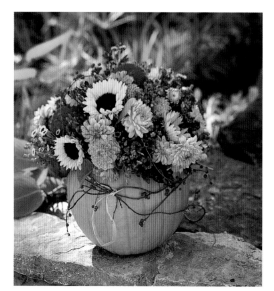

For fall, a scooped-out pumpkin becomes a seasonal accent when filled with dahlias, sunflowers, and berries in autumnal hues.

Opposite: Ablaze with mango-colored calla lilies, dahlias, cockscomb, roses, and hydrangeas, this arrangement will dry prettily in place. Any gaps can be filled in with a few fresh flowers to create a centerpiece that will last through the season.

used on top of or below a casual console table, or placed on a garden-room étagère. Painted sap buckets in playful colors like lime green and robin's-egg blue add a cheery note and evoke the look of bouquets that have been freshly cut from the garden, even if their origin is the wholesale market on the corner.

Most everyone has glass cylinders and vases — they seem to multiply when stored in a closet — and these can be a great start for unassuming arrangements. Stems will show through the glass, so choose flowers that have good, woodsy stalks and be sure to cut the stems cleanly. Twisting the stems in a circular pattern will give the arrangement as much interest below the waterline as above. Colored marbles or stones can transform clear containers and are also useful for anchoring bouquets. Sliced oranges or lemons rimming the inside of a glass bowl provide a sunny summer look; the same container filled with fresh cranberries will produce a completely different effect during the holidays.

## Seasonal Arrangements

Successful arrangements take into account the essence and form of each individual flower. Nature need not be overdesigned. The trend has moved away from using a plethora of hothouse flowers toward what is fresh, natural, and available in season. It is possible to create an element of surprise without shocking the eye. And bigger isn't always better; sometimes all it takes is a single rose bending from a classic crystal bud vase to appreciate every leaf, petal, and even thorn of a flower. Many appealing arrangements hardly look "arranged." Flowers look most impressive when they are displayed in a manner that respects their inherent qualities and beauty, rather than one that exhibits the ego and demands of the arranger. Bouquets can be made with a single type of flower, a variety of

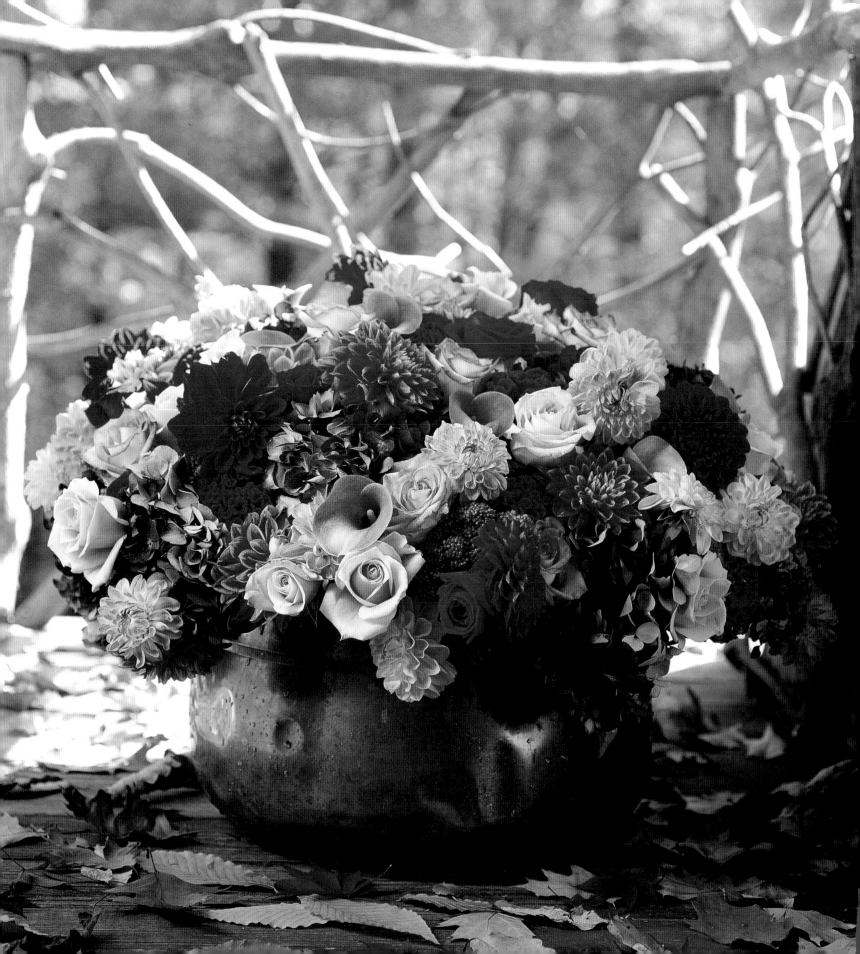

flowers in the same shade, or a fanfare of colors and blooms that mimics the wild beauty of a country garden.

Just around the time we can't bear to put on our heavy coats and gloves for yet another dreary day, daffodils and tulips start to poke their heads through the cool ground to remind us that hope springs eternal and warmer days are on the way. Branches of forsythia, dogwood, and cherry spread their flowers, enticing us to clip an armful to bring inside for a sculptural display. White tulips, long a favorite with decorators, nod their heads from flower beds and look refreshing bowing out of ironstone pitchers. Violets and pansies, with their shorter stems, can peer out of eggcups or water glasses. Some of the most fragrant flowers in nature — lilies of the valley, hyacinths, and lilacs — make appearances in spring gardens. Bring their aromas indoors to render potpourri and scented candles unnecessary.

Earthy materials can refresh interiors just coming out of the winter doldrums. Blades of grass may signify hard labor for lawn-mowing gardeners, but surprisingly, they offer vast and easy decorating potential, especially when there are few things blooming in early spring flowerbeds. Plant ryegrass seeds in a terra-cotta pot or ceramic cachepot, and soon a sculptural centerpiece emerges. Pick up a pot of ornamental grass from the nursery and top it off with a garden topiary form. Moss can be mounded in silver biscuit boxes or compotes.

In summer, the heat intensifies— and so do the colors of the garden. Everything from linen dresses to no-cook meals to our pared-down interiors reflects our desire for looseness, lightness, and plenty of cool breezes. Floral arrangements should also be light-handed but

Forced bulbs such as purple hyacinth can bring a dash of springlike color to interiors suffering from the winter doldrums.

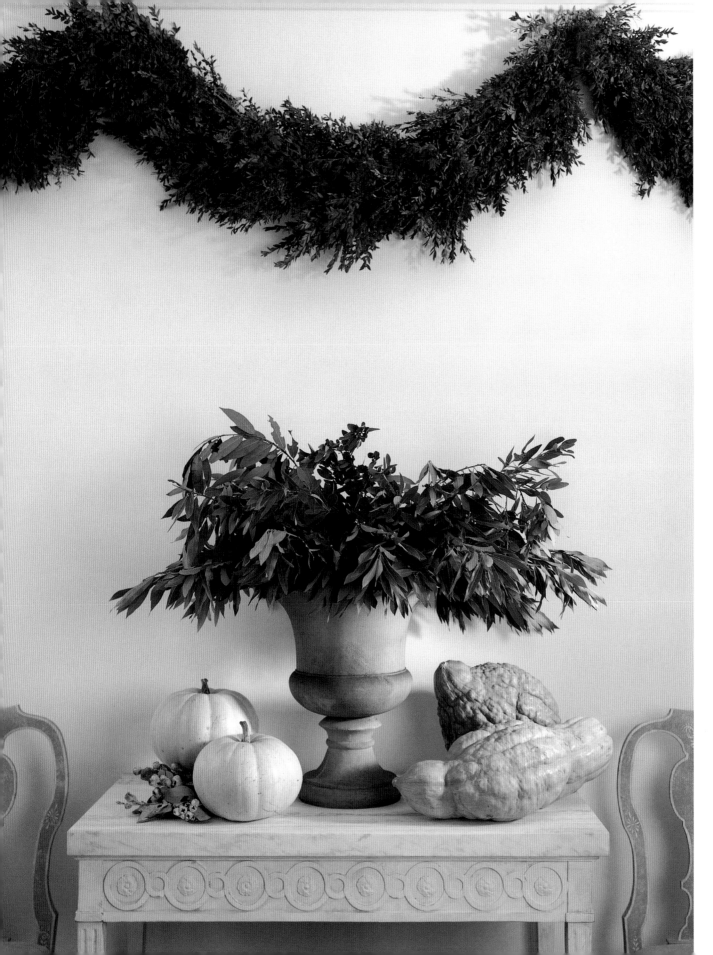

The crisp contrasts of green and white look especially fresh in winter. On a marble-topped table, winter squash and white pumpkins resemble pieces of sculpture next to a stone urn filled with bay leaf branches. A juniper garland tops off the composition.

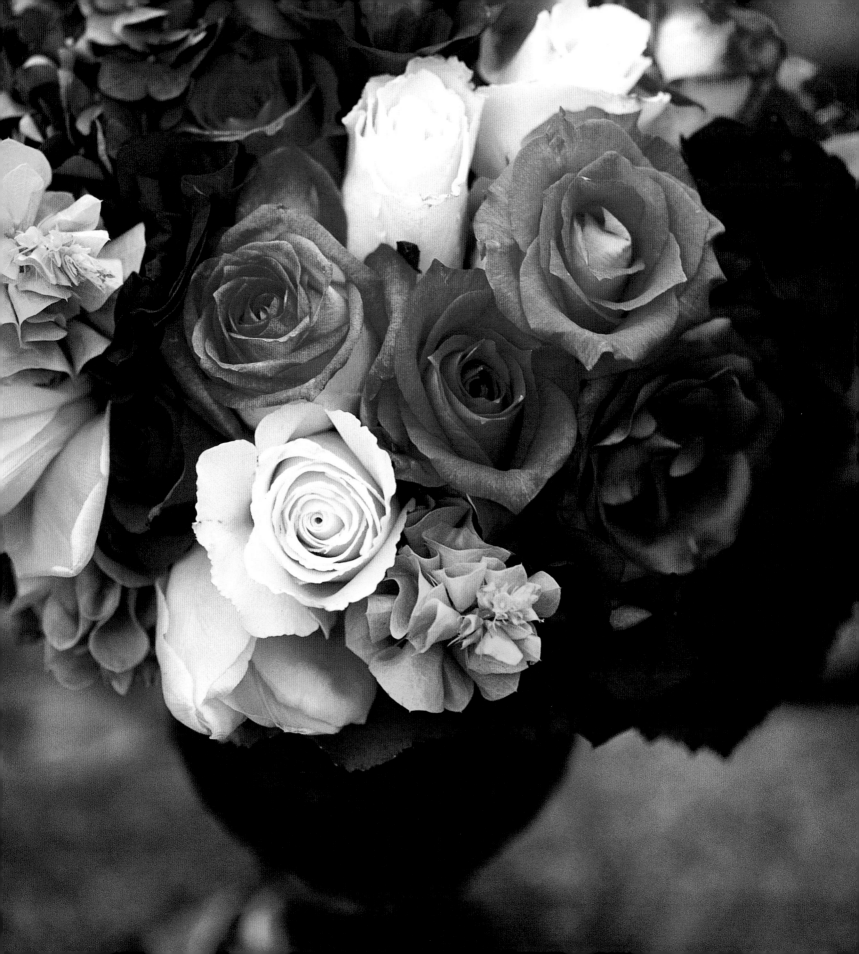

abundant, in keeping with the carefree attitude of the season.

Gardeners can flaunt their talents with an arrangement made from backyard foliage such as hosta, philodendron, elaeagnus, palm, and nandina. Their leafy blades and shoots look at home whether gathered in silver urns, rustic pottery, or bamboo containers. Play up line, texture, and shape while staying true to the nature of the materials. Clip different ferns and fill a cluster of clear vases to adorn a glass-topped table — it will almost appear as if the greenery is floating in air. Or magnify the impact of each frond by submerging the ferns in water-filled glass cylinders that are capped off with round, floating candles.

Look to herbs to create easy, tasteful bouquets that will fill your house with summer flavor. Fresh herbs snipped from the garden make noteworthy arrangements for the kitchen. Not only do they provide a wonderful scent, but the chef will also have them handy for flavoring or garnishing dishes. Line up a collection of small amethyst bottles on a windowsill and fill them with rosemary or mint. A cobalt blue water glass will provide a striking contrast to a bundle of parsley.

Fruits and vegetables make colorful alternatives to flowers. Arrangements can be as easy as a trip to the farmers' market or produce aisle of the grocery store. Tomatoes stacked in a ceramic mixing bowl or woven basket make a casual table centerpiece and will look delectably appealing — in fact, don't be surprised if the "arrangement" disappears in a day or two, as nothing tastes more like summer than a sliced garden tomato. Artichokes, pears, and green apples (a favorite with photo stylists) also look pretty on their own, especially when heaped in a contrasting container, such as a silver bowl or a crusty garden pot.

Autumn signifies the slowing down of new growth, as plants and leaves leisurely find their way back to the earth. But it's also a time for rejuvenation. A walk through the woods in crisp fall air will yield a number of surprises: a cluster of galax, a clump of moss, a riot of color in the trees.

Flowers blooming in an autumn garden mimic the fiery reds, yellows, and or-

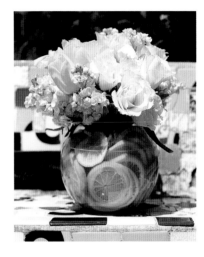

If you don't have an eye-catching vase at hand, create one. Sliced lemons give a clear glass bowl a punch of interest. The monochromatic mound of tulips, roses, and stock repeats the shape of the container.

Opposite: Although this black urn is actually a small one, a tight cluster of tulips, roses, and hydrangeas provides an illusion of large-scale abundance.

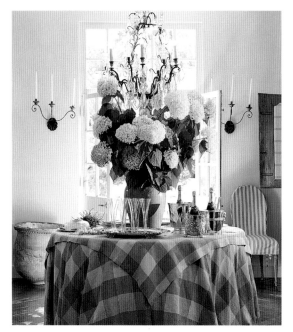

For a summertime wedding party, a mass of white hydrangeas in an earthenware urn is in keeping with the tone of the checked linen tablecloth.

anges of falling leaves. In the South, many roses take a second turn at blooming, yielding an abundance of blossoms to fill enamelware pitchers or olive jars. Gourds such as pumpkins and squashes spilling out of a cornucopia or from a twig basket add a touch of harvest color to the table. Scooped-out pumpkins make containers that are seasonally appropriate and becoming counterparts to arrangements of roses or zinnias.

There may be no time of the year when we need flowers in our interiors more than winter, when much of the garden is dormant and cold temperatures keep us from spending a great deal of time outdoors. It's a great season for forcing bulbs, such as fragrant hyacinths and paperwhites, and for incorporating flowering plants, such as orchids or kalanchoes, in containers around the house. The holidays have become synonymous with poinsettias, and although some style setters have proclaimed them to be hopelessly out of fashion, they are an easy way to enliven a room, especially en masse (just remove the foil wrappers and bows and use cachepots or terra-cotta pots). There are a number of varieties — with new ones emerging every year — in colors that range from white to yellow to pink and, of course, the standard red.

## Working with a Floral Designer

Some people just have a knack with flowers. Although the uncomplicated, natural way of arranging flowers is one that can be learned with practice and is something many of us feel comfortable doing, there will be times when we need to turn to a professional for help. Perhaps you're planning a wedding, chairing a charity gala, or just need a traffic-stopping centerpiece for a party. The best leads come from inquiring about arrangements you've admired or from friends who have hosted similar events. When preparing for a party, an in-home consultation is ideal

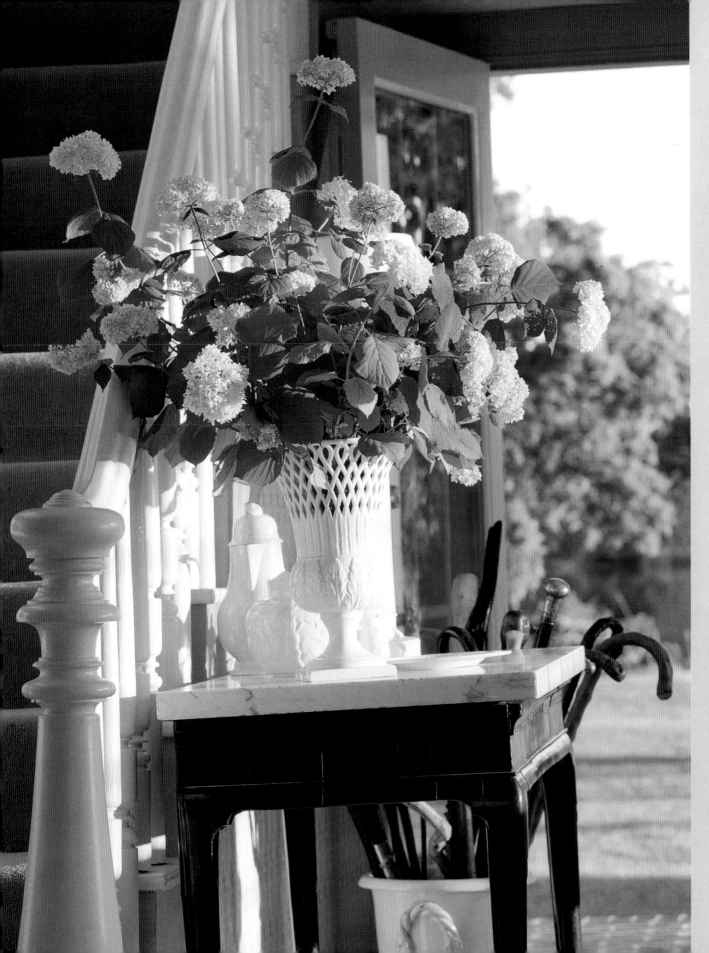

A reticulated ceramic urn calls for a large-scale arrangement, such as this loose bunch of hydrangeas that greets weekend guests in the entry of this coastal home.

171

Right: Layers of texture enliven this winter arrangement of white roses, bay leaf, and cedar.

Far right: On a console, porcelain candelabra with angel and artichoke motifs flank a composition of fresh artichokes in a clay pot.

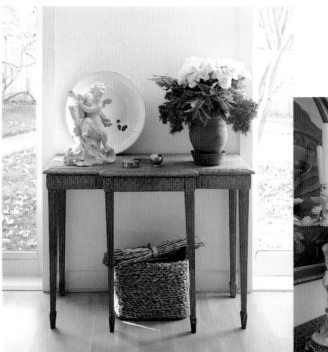

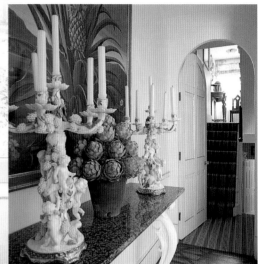

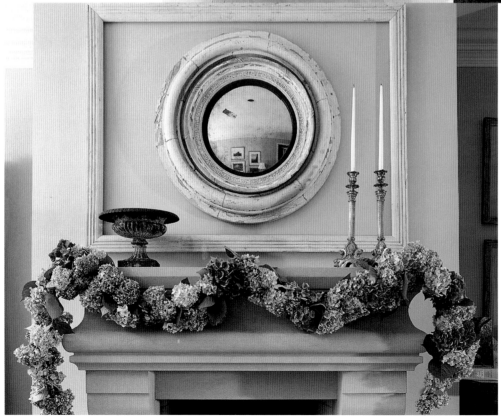

Left: For a special occasion, flowers need not be limited to the dining room or buffet. Here, a lush garland of hydrangeas drapes across a stone mantel, making it a focal point in the room even though the fireplace is not in use.

for discussing focal points to concentrate on and for showing any personal containers that you wish to be used. If the event is to be held at a restaurant or rented site, an on-site walk-through will give the floral designer a feel for the color and scale of arrangements needed.

Sending a bouquet to an out-of-town friend celebrating a birthday or recuperating in the hospital brings its own special challenges. It becomes especially crucial to be able to express your likes and dislikes by telephone to a florist in a different

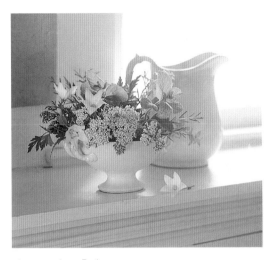

On a mantel, yarrow, wormwood, flat-leaf parsley, mint, and rosemary transform a simple ironstone compote into a sophisticated floral container.

location, whether you find one through word-of-mouth or by a wire service. It is important that you both speak the same language — we're talking design and horticultural language here, not Spanish or French — so it's a good idea to familiarize yourself with a few terms and styles to aid in the communication process. Know whether you want to send an English country bouquet (a loose grouping of wildflowers, grasses, and garden flowers) or a Flemish-style composition inspired by the still-life paintings of the old masters. A Japanese ikebana form (minimalistic and angular) will be quite different from a Della Robbia composition of fruits and greenery (named for a fifteenth-century family of Italian craftsmen).

If your idea of a bouquet includes old-fashioned tea roses rather than American Beauties mixed with baby's breath and floral fern, be sure to say so. Relay personal details, such as the recipient's passion for the color purple or an affinity for anemones, and above all avoid sending a cookie-cutter arrangement. A simple bouquet of daisies in an interesting container will be much more appreciated than a paint-by-numbers design. Refer to the "Flowers in Season" box (page 174) for a list of flowers that the designer is likely to have readily available. When given parameters of particular colors, style, and budget, the best floral designers will create a look that is a genuine and thoughtful reflection of your taste — almost as if you had arranged the flowers yourself.

# Flowers in Season

These will vary according to growing zone, but here is a reference guide to flowers that will usually be growing in the garden or readily available at floral shops during each season:

**Spring**

Anemone

Columbine

Daffodil

Dogwood

Forsythia

Foxglove

Freesia

Hyacinth

Larkspur

Lilac

Lily of the valley

Pansy

Peony

Poppy

Primrose

Stock

Sweet pea

Tulip

Viburnum

Violet

**Summer**

Allium

Black-eyed Susan

Calla lily

Cosmos

Daisy

Delphinium

Gardenia

Gerber daisy

Gladiolus

Hydrangea

Iris

Lisianthus

Petunia

Poppy

Queen Anne's lace

Rose

Salvia

Snapdragon

Statice

Zinnia

**Fall**

Amaranthus

Dahlia

Goldenrod

Marigold

Rose

Sunflower

Zinnia

**Winter**

Amaryllis

Eucalyptus

Hellebore

Holly berry

Hyacinth

Narcissus

Pansy

Poinsettia

Rose hip

174

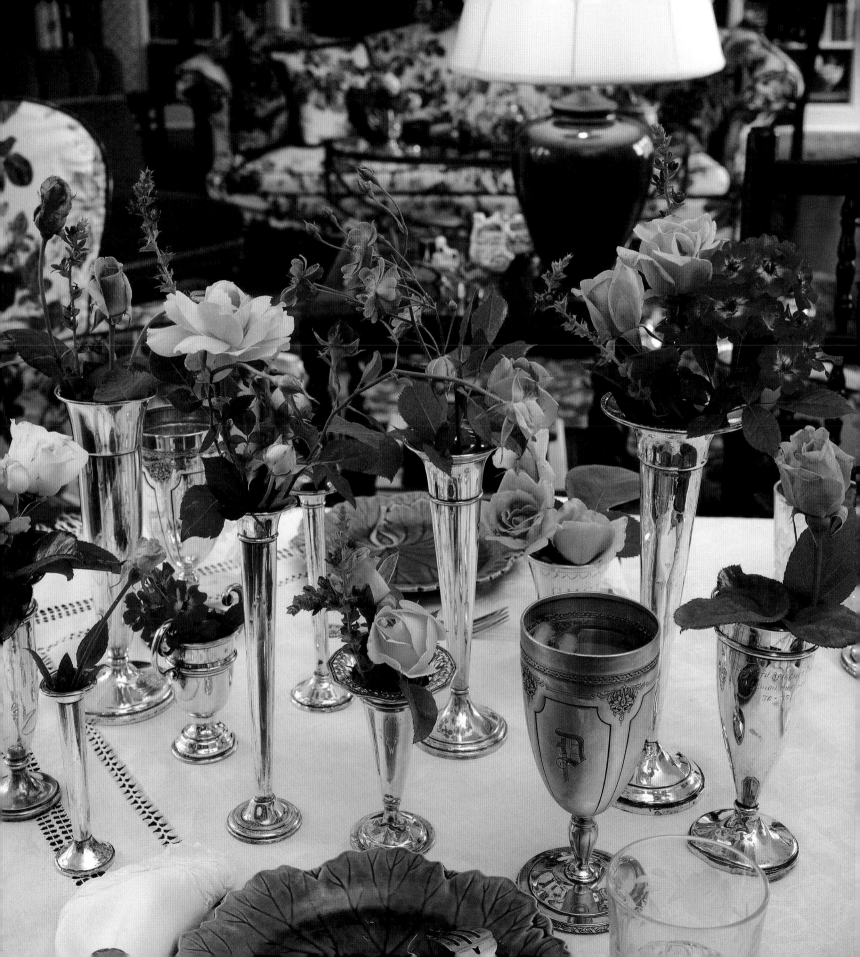

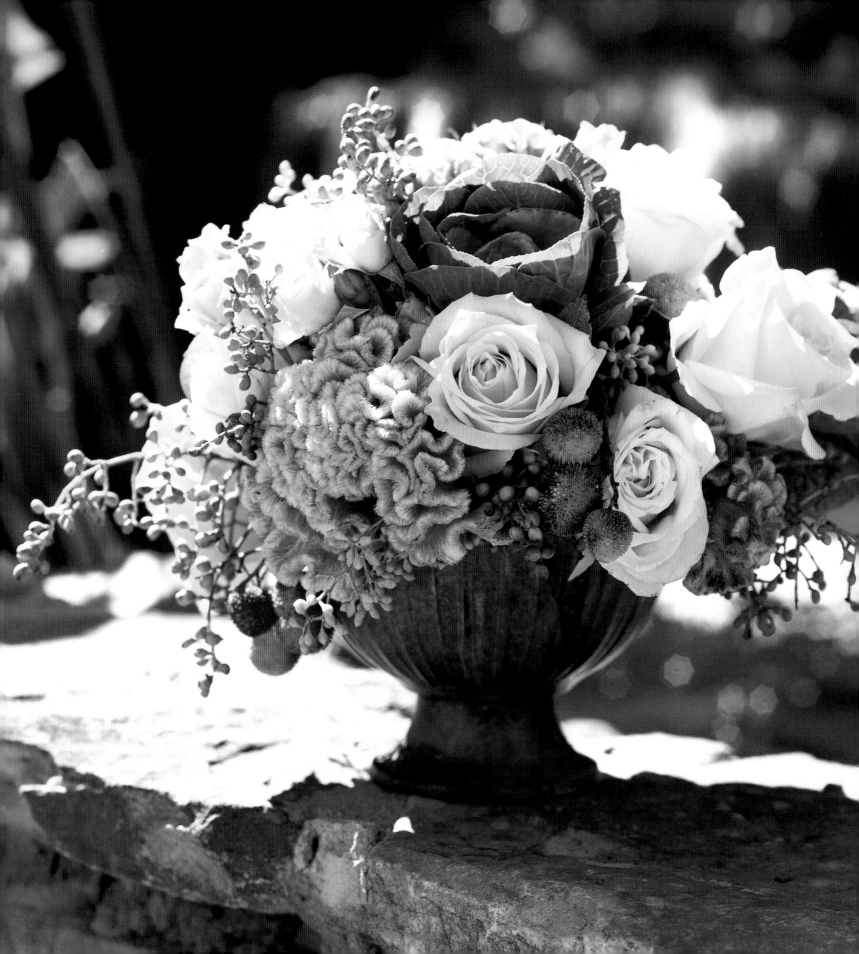

# Conditioning Flowers

- Harvest flowers in the early morning or evening. Flowers cut in the heat of the day will be droopy with stress from the sun.

- Immediately after cutting flowers, immerse the stems in a bucket filled with room-temperature or slightly warm water.

- Once inside, fill the kitchen sink or potting trough with water and recut the stems underwater. This keeps air bubbles that will hinder the stems' ability to absorb water from forming.

- To avoid rot, remove any foliage that will be submerged below the waterline of the container.

- Put the flowers back into the bucket and add commercial flower food. Place the bucket in a cool place, but avoid the refrigerator, as it will dry out flowers. Give the flowers a few hours to drink before you start arranging.

- Make sure that the container that will be used for the arrangement is clean. Wash it thoroughly with water and bleach if necessary to remove any bacteria.

- Fill the container with tepid water and add commercial flower food. Some people swear by an aspirin or a bit of lemon-lime soda.

- Change the water in the container daily to keep it from becoming murky, adding flower food each time.

Opposite: A textural combination of cockscomb, cabbages, roses, and berries is arranged in a patinated iron container that is appropriate for an outdoor setting.

Below: Small arrangements have larger impact when grouped together. Vintage mercury glass vases hold garlic, hyssop, oregano, and white bee balm.

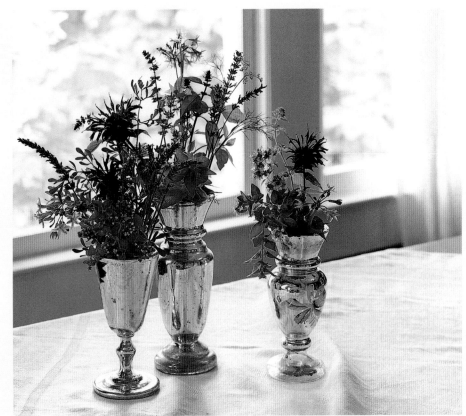

# Resources

## TABLEWARE MANUFACTURERS

Call or visit these Web sites for a retailer near you.

### China

Annieglass
800/347-6133
www.annieglass.com

Bernardaud
800/884-7775
www.bernardaud.net

Lynn Chase
800/228-9909
www.lynnchasedesigns.com

Jean-Louis Coquet
800/993-2580

Cottura
800/348-6608
www.cottura.com

Gien
800/845-1928
www.gien.com

Richard Ginori
212/213-6884
www.ginori.com

Haviland Limoges
800/793-7106
www.havilandlimoges.com

Herend
800/643-7363
www.herendusa.com

Hermès
800/238-5522

Calvin Klein
800/294-7978

Ralph Lauren
212/642-8700

Robert Haviland & C. Parlon
800/993-2580

Mottahedeh
800/242-3050
www.mottahedeh.com

Raynaud
732/751-0500

Rosenthal
800/804-8070
www.rosenthalchina.com

Royal Copenhagen
800/351-9842
www.royalcopenhagen.com

Royal Worcester
800/257-7189

Spode
888/363-7272
www.spode.co.uk

Tiffany
800/843-3269
www.tiffany.com

Anna Weatherley Designs
732/751-0500

Vietri
800/277-5933
www.vietri.com

Villeroy & Boch
800/845-5376
www.villeroy-boch.com

Wedgwood
800/677-7860
www.wedgwood.com

### Crystal and Glass

Baccarat
800/845-1928

Daum
212/355-2060

Hoya
800/654-0016
www.hoyacrystal.com

Calvin Klein
800/294-7978

Kosta Boda
800/351-9842
www.kostaboda.se

Lalique
800/993-2580
www.lalique.com

Ralph Lauren
212/642-8700

Moser
800/267-2155
www.moser-glass.com

Orrefors
800/351-9842
www.orrefors.com

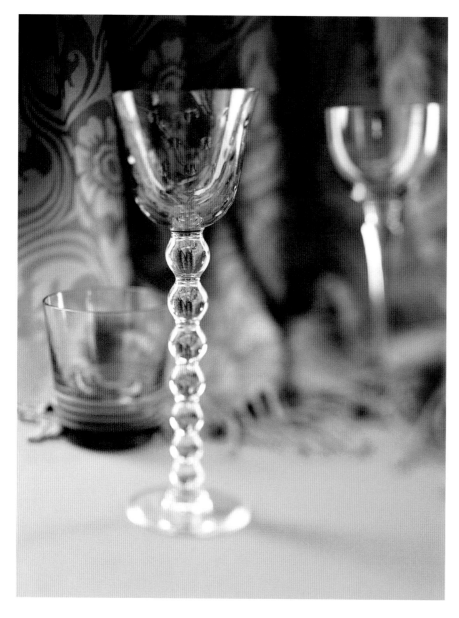

William Yeoward
800/818-8484
www.williamyeowardcrystal.com

**Linens**

Anichini
800/553-5309
www.anichini.com

Dransfield & Ross
212/741-7278

Frette
800/353-7388
www.frette.it

Ann Gish
805/498-4447

Leron
800/953-7669
www.leron.com

Palais Royal
800/322-3911
www.yvesdelorme.com

Porthault
212/688-1660

Pratesi
212/689-3150
www.pratesi.com

The White House
888/942-7528
www.the-white-house.com

**Silver**

Buccellati
800/223-7885
www.buccellati.com

Christofle
914/328-1002
www.christofle.com

Royales de Champagne
800/347-7774

Saint-Louis
800/238-5522

Salviati
212/725-4361

Steuben
800/424-4240
www.steuben.com

Union Street Glass
888/451-7752

Waterford
800/677-7860
www.waterford-usa.com

Georg Jensen
212/759-6457
www.georgjensen.com

Gorham
401/333-4360

Ercuis
732/751-0500

Lunt
800/242-2774
www.lunt-silversmiths.com

Puiforcat
800/993-2580

Reed & Barton
800/343-1383
www.reedandbarton.com

Tiffany
800/526-0649
www.tiffany.com

Towle
617/561-2200
www.towlesilver.com

Wallace Silversmiths
617/561-2200
www.wallacesilver.com

## ANTIQUE TABLEWARE

These shops offer a great selection of an-
tique and vintage china, crystal, silver,
and linens.

As You Like It Silver Shop
3033 Magazine St.
New Orleans, LA 70130
504/897-6915

Bardith Limited
901 Madison Ave.
New York, NY 10021
212/737-3775

Beverly Bremer Silver Shop
3164 Peachtree Rd.
Atlanta, GA 30305
404/261-4009

Country Dining Room Antiques
178 Main St.
Great Barrington, MA 01230
413/528-5050

Fortunoff
681 Fifth Ave.
New York, NY 10022
212/758-6660

Green Garzotto
4445 Travis St., Suite 101
Dallas, TX 75205
214/528-0400

H. Moog Antique Porcelains
2300 Peachtree Rd. NW,
Suite B-105
Atlanta, GA 30309
404/351-2200

Island Trading Company
105 N. County Rd.
Palm Beach, FL 33480
561/833-0555

The Linen Ladies
98 Milwaukee Ave.
Bethel, CT 06801
203/798-8596

Lucullus
610 Chartres St.
New Orleans, LA 70130
504/528-9620

M. S. Rau Antiques
630 Royal St.
New Orleans, LA 70130
504/523-5660

Phyllis Tucker Antiques
2919 Ferndale Place
Houston, TX 77098
713/524-0165

Replacements, Ltd.
1089 Knox Rd.
Greensboro, NC 27420
800/737-5223

S. J. Shrubsole
104 E. 57 St.
New York, NY 10022
212/753-8920

Seidenberg, Inc.
836 Broadway
New York, NY 10003
212/260-2810

Wakefield Scearce
525 Washington St.
Shelbyville, KY 40065
502/633-4382

# Acknowledgments

## Photo Stylists

Cindy Manning Barr: 154, 156, 157 (top right), 173, 177

Joann Barwick: 52

Anne Bean: 45

Lydia E. DeGaris: 4, 58, 60 (right), 66, 79, 89, 126, 129, 131, 137, 142, 143, 145, 147, 163 (bottom right), 178, 181, 183

Barbara Fierros: 132, 133, 136

Kerry Moody: 116 (left), 119, 146

Virginia D. Moseley: 56, 57, 68, 69, 70, 71, 72, 73

Mary Jane Ryburn: 44, 45, 46, 54, 55, 61, 62, 67 (left), 75, 97, 99, 113 (top), 114, 149, 150, 157 (top left), 168, 169

Sara Slavin: 8, 127, 138, 139

Rebecca Sowell: 179, 180

Patrick Tandy: 68, 69, 70, 71, 72, 73, 107 (left)

Ashley Johnson Wyatt: 10, 31, 137, 184

## Flowers and Table Settings

Atelier A Workshop, 3419 Milton Ave., Dallas, TX 75205, 214/720-7290: 44, 55, 75

Avant Garden, 4514 Cole Ave. #4, Dallas, TX 75205, 214/559-3432: 62, 67

David Bell, David Bell Antiques, 1655 Wisconsin Ave. NW, Washington, DC 20007, 202/965-2355: 32, 167, 172 (top left)

Paul Bott, Bott & Company, P.O. Box 1662, El Dorado, CA 95623: 162, 165

Robert Comans, The Buckhead Floral Company, 314 Pharr Rd. NE, Atlanta, GA 30305, 404/842-0505: 113 (bottom left), 116 (right)

Becky Davis, P.O. Box 668, Folly Beach, SC 29439, 843/588-3490: 66

Angela DeWree, Angela & Company, 505 Arlington, Houston, TX 77007, 713/880-3613: 80

Dr. Delphinium Designs, 5806 Lover's Lane, Dallas, TX 75225, 214/522-9911: 159 (left)

Ryan Gainey, Ryan Gainey & Company, 2973 Hardman Ct. NE, Atlanta, GA 30305, 404/233-2050: 104 (right)

Carol Garner, 3727 Gilbert #B, Dallas, TX 75219, 214/526-4205: 103, 120, 124, 160, 161, 163 (bottom left)

Rusty Glenn, 2114 Farrington, Dallas, TX 75207, 214/742-3001: 114

Harold Hand, 4620 Southern Ave., Dallas, TX 75209, 214/522-2120: 102, 110

Jimmy Hartley, Flowers by Sandy, 2015 Union Ave., Memphis, TN 38104, 901/276-4495: 105, 125

Elizabeth House Flowers, 1431 South Blvd., Charlotte, NC 28203, 704/342-3919: 63

Lee James, Lee James Floral Designs, 809 N. Mills Ave., Orlando, FL 32803, 407/897-5300: 115

David Kurio, David Kurio Floral Designs, 4302 Airport Blvd., Austin, TX 78722, 512/467-9947: 100

Jon Martinez, Masterpiece Flowers, 3169 Cahaba Heights Rd., Birmingham, AL 35243, 205/969-0705: 113 (bottom right)

Tom Mathieu, Tom Mathieu & Company, 312-D Worth Ave., Palm Beach, FL 33480, 561/655-5880: 17

Dorothy McDaniel, Dorothy McDaniel Flowers, /2560 18th St. South, Birmingham, AL 35209, 205/871-0092: 106, 172 (bottom)

Mark O'Bryan, Tulip Tree, 6025 Highway 100, Nashville, TN 37205, 615/352-1466: 76, 94

Carolyne Roehm, P.O. Box 1247, Sharon, CT 06069, 800/227-6596: 164, 176

Marjory Segal, Well Furnished Garden and Home, 301/469-6879: 48, 59

John Sprinkle, Twigs, 1290 3rd St. South, Naples, FL 34102, 941/262-8944: 64, 65, 112

Sybil Sylvester, Wildflower Designs, 2829 2nd Ave. South, Birmingham, AL 35233, 205/322-1311: 122, 163 (top)

Junior Villanueva, The Garden Gate, 2615 Routh St., Dallas, TX 75201, 214/220-1272: 168, 169

J. Watkins, Ociana Group, 1619 Eckington Place NE, Washington, DC 20002, 202/269-5634: 2–3, 121, 155, 158, 159 (right)

Allan Woods, Allan Woods Flowers / Gifts, 2645 Connecticut Ave. NW, Washington, DC 20008, 202/332-3334: 107 (right)

## Caterers

Affairs to Remember, 680 Ponce de Leon Ave. NE, Atlanta, GA 30308, 404/872-7859: 78

Karen Donatelli Cake Designs, 513 Park Ave. South, Winter Park, FL 32789, 407/740-7933: 115

Patty B. Driscoll, 205/871-3322: 4

Jackson and Company, 707 Hawthorne St., Houston, TX 77006, 713/523-5780: 92

Eric Michael, Occasions Catering, 910 Pennsylvania Ave. SE, Washington, DC 20003, 202/546-7400: 20, 21, 42, 43

Jamie Westendorff, Charleston Outdoor Catering, 1596 Carterette Ave., Charleston, SC 29407, 843/769-6889: 50

## Interior Spaces

# Photography Credits

Ralph Anderson: 178, 179, 180, 181

Gordon Beall: 158, 159 (right), 171

Antoine Bootz: 14, 34 (top), 105, 108, 118, 123, 125

Bruce Buck: 25, 38, 39, 155

Anita Calero: 132, 133, 136

Gary Clark: 172 (bottom)

Langdon Clay: 107 (left)

Cheryl Dalton: 45, 78 (right), 113 (bottom left), 116 (right), 162, 165, 170

Colleen Duffley: 29, 36, 44, 54, 55, 56, 57, 60 (left), 75, 114, 148, 160, 161

Pieter Estersohn: 22, 23, 28, 96, 113 (bottom right), 117, 166

J. Savage Gibson: 12, 20, 21, 41, 42, 43, 76, 77, 82, 83, 84, 85, 86, 87, 88, 94, 95, 135, 163 (top)

Tria Giovan: 2–3, 18, 27, 30, 40, 58, 102, 103, 110, 111, 115, 120, 121, 124, 134, 163 (bottom left)

Mick Hales: 15, 52, 106, 130, 140, 144, 175

Hickey-Robertson: 33, 34 (bottom), 68, 69, 70, 71, 72, 73, 97, 99, 104 (left), 113 (top), 149

Thibault Jeansen: 24

Deborah Jones: 8, 127, 138, 139

Andrew Lautman: 104 (right)

Barry Lewis: 46, 61, 62, 67 (left), 100, 150, 157 (top left), 159, 168, 169

Becky Luigart-Stayner: 4, 79, 89, 126, 129, 131, 142, 145, 147, 154, 156, 157 (top right), 173, 177

Maura McEvoy: 37

William C. Minarich: 7, 13, 49, 50, 51, 53, 60 (right), 63, 64, 65, 66, 67 (right), 74, 80, 81, 92, 93, 112

Emily Minton: 122, 128

Michael Mundy: 16, 26, 35

Howard L. Puckett: 137, 157 (bottom), 164, 176, 183

Angela Seckinger: 10–11, 31, 32, 48, 59, 107 (right), 167, 172 (top left), 184

Andreas von Einsiedel: 172 (top right)

Charles E. Walton IV: 17, 91, 116 (left), 119, 143, 146, 151, 152, 163 (bottom right)

Jonelle Weaver: 78 (left), 90

Deborah Whitlaw: 19, 98, 101

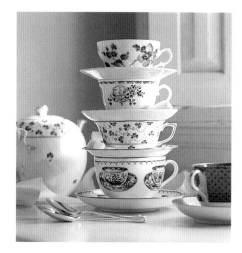

# Author's Note

*Entertaining with Southern Style* is a collaboration of many people. The South is fortunate to have a wealth of talented hosts, floral designers, caterers, and party planners. This book is a direct result of their creativity. A special thanks to Mark Mayfield, the editor of *Southern Accents*, for support, advice, and adjective patrol; Frances MacDougall, senior editor, for her wise counsel and writing contributions — I couldn't have done it without you; Lydia Longshore, entertaining editor, and Lindsay Bierman, design director, who produced much of the material in the book; Dorothy Williams, Betsy Uhrig, and Melissa Langen at Bulfinch Press for all of their insights and efforts to make this book a reality; Tom Morgan, the designer, for making the pages come to life. And finally, all the thanks in the world to my mother, who personifies Southern hospitality, and my father, who (among many other things) taught me how to make the perfect martini — both have greatly influenced my love of entertaining.